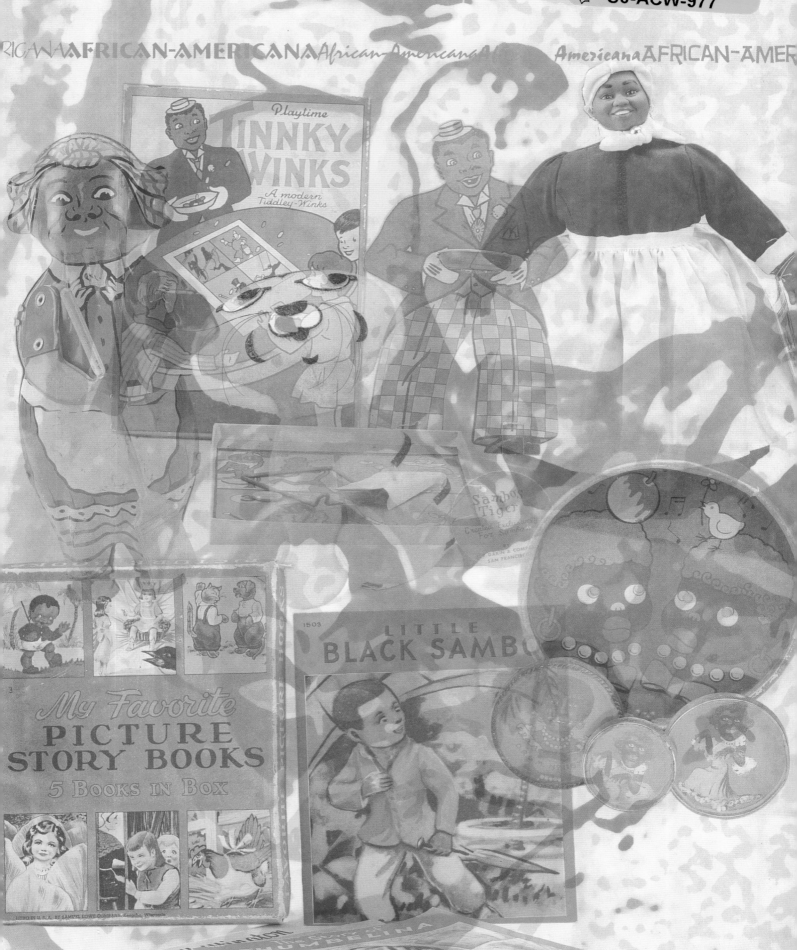

# African-Americana

Schiffer Publishing Ltd ®

4880 Lower Valley Road, Atglen, Pa 19310

Barbara E. Mauzy

Designed by RoS
Type set in Bergell LET/Zurich BT

ISBN: 978-0-7643-3144-2
Printed in China

Schiffer Books are available at special discounts for bulk purchases for sales promotions or premiums. Special editions, including personalized covers, corporate imprints, and excerpts can be created in large quantities for special needs. For more information contact the publisher:

Published by Schiffer Publishing Ltd.
4880 Lower Valley Road
Atglen, PA 19310
Phone: (610) 593-1777; Fax: (610) 593-2002
E-mail: Info@schifferbooks.com

For the largest selection of fine reference books on this and related subjects, please visit our web site at www.schifferbooks.com
We are always looking for people to write books on new and related subjects. If you have an idea for a book please contact us at the above address.

This book may be purchased from the publisher.
Include $5.00 for shipping.
Please try your bookstore first.
You may write for a free catalog.

In Europe, Schiffer books are distributed by
Bushwood Books
6 Marksbury Ave.
Kew Gardens
Surrey TW9 4JF England
Phone: 44 (0) 20 8392-8585; Fax: 44 (0) 20 8392-9876
E-mail: info@bushwoodbooks.co.uk
Website: www.bushwoodbooks.co.uk
Free postage in the U.K., Europe; air mail at cost.

# African-Americana

# Contents

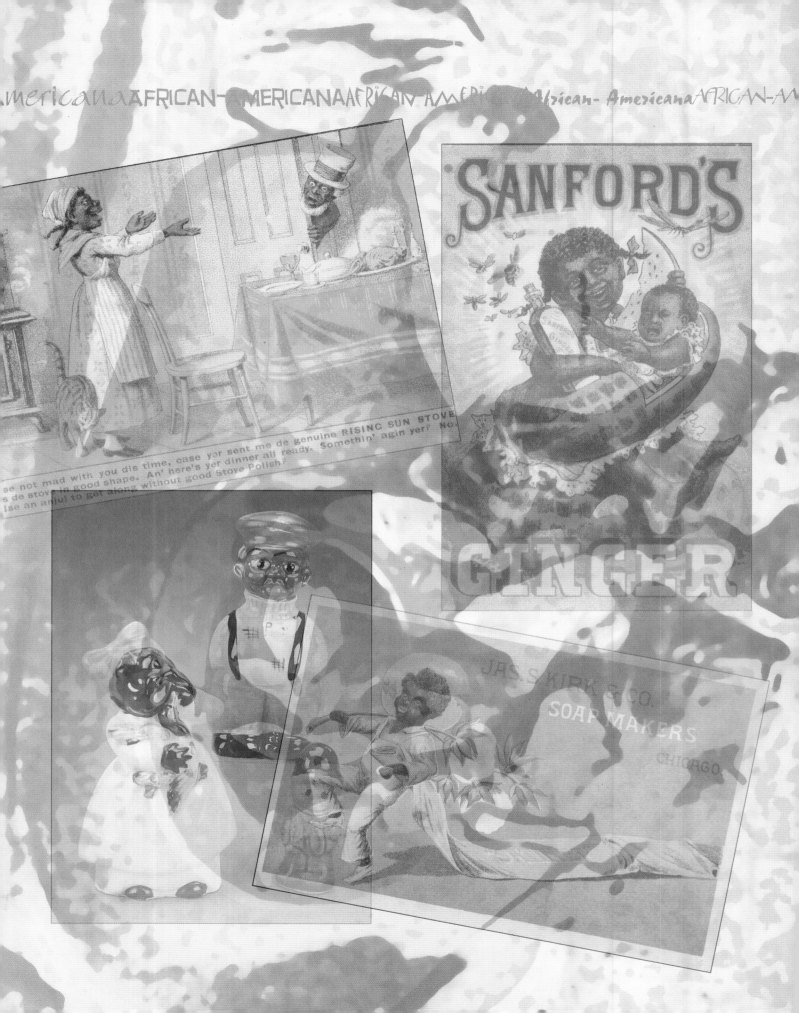

# Introduction

An Historical Perspective

A book on collectibles may not necessarily be the best vehicle in which to examine the relationship of African-Americans and Anglo-Saxon America through the centuries. Certainly the intent of this book is not to make a social statement or take a political view of some kind, but rather to provide a photographic essay celebrating one subject that is popular with contemporary collectors. However a book showcasing African-Americana compels us to at least briefly examine the connection of African-Americans and white America as the items within these pages are borne from Anglo-Saxon America's preconceived ideas and prejudices. It would be negligent to fail to at least acknowledge this association in regard to the history of African-Americans in the United States.

*The Negro in America*, written in 1966, is a nonfiction book that was placed in elementary school libraries across our country and provided an affirmative light on the contributions of African-Americans, finally. Scientists, writers, businessmen, athletes, and more were presented in the positive light they certainly deserved. 1966 was a time of civil turmoil and social evolution when mainstream white America was forced to address civil rights issues as a result of new legislation passed by Congress in 1964. Anglo-Saxon Americans were mandated to eliminate the division between races and the blatant discrimination against African-Americans: separate schools, separate restaurants, even separate restrooms and water fountains, and separate had not meant equal.

Most of the items pictured in this book predate this era of social consciousness. It behooves us to acknowledge an important statement from *The Negro in America*: "Negroes are the only people in the United States whose ancestors did not come to America of their own free will." (p. 6) Africans were stolen from their homes, brought across the ocean in the worst of conditions, and pressed into slave labor. Children were separated from parents, husbands separated from wives, and all were chained and sold with less care or concern than one would show an animal. Slave owners regularly raped female slaves as the children that resulted were worth hundreds of dollars when sold. One cannot begin to comprehend the regrettable miseries cast upon these unfortunate victims.

*Incidents in the Life of a Slave Girl* by Harriet Jacobs provided me with my first real understanding of the terribly cruel existence forced upon slaves. African-Americans were viewed with disdain and seen as creatures lower than any other form of life on this planet. Their value was directly dependent upon what labors they were capable of performing or how much money they would provide to the slave owner when sold. They were a commodity that was bought, sold, and inherited; rare were the occasions when slaves were considered human.

In white society an understanding or appreciation of African-American culture, heritage, and traditions simply did not exist. From the moment the first Africans were captured, taken across the Atlantic Ocean, and deposited on Virginian soil in 1619, the relationship between the races was established as a hierarchy that many African-Americans still fight to overcome almost 400 years later.

The derision felt for African-Americans became reflected in an Anglo-Saxon American culture that embraced stereotypes. African-Americans were considered to be lazy and low-functioning creatures that were easily pleased by simply eating chicken and watermelon. Full lips, tightly curling hair, and other physical characteristics were mocked and exaggerated. A litany of degrading names and terms used to identify African-Americans were added to English vernacular, and even adults could never shed the "boy" or "girl" reference.

The legacy of this appalling history leaves us with a huge variety of concrete reminders of a reprehensible past. The oldest collectibles include items from the slave trade: chains, whips, and other shameful tools of the business. Objects such as these do show up in auctions on rare occasion and they are certainly pieces to be preserved lest we forget the misery brought upon innocent people.

Much of what is collected today stems from more recent days and does not directly involve the slavery issue. "In the early 1800s, display advertising in printed media arrived. Whereas previous newspaper and magazine ads had been limited to short, column-sized ads, now they expanded and included illustrations."[1] African-American images were frequently utilized in advertising during the nineteenth century. Faces with overstated characteristics were commonly featured in print advertisements as well as trade cards. Trade cards were small paper or cardboard advertisements, often whimsical in nature, that were given away by storekeepers to promote products. Although known to have been used in the 1700s, trade cards were most heavily utilized in the mid- to late-1800s when the use of color in printing became practical and affordable. African-Americans were shown endorsing everything from oysters to peanut butter. Trade cards were collected and often preserved in scrapbooks, so today they remain relatively easy to acquire.

With the turn of the twentieth century African-American images were placed

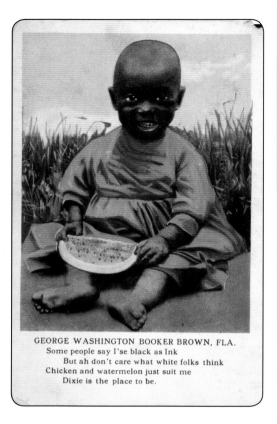

GEORGE WASHINGTON BOOKER BROWN, FLA.
Some people say I'se black as Ink
But ah don't care what white folks think
Chicken and watermelon just suit me
Dixie is the place to be.

on sheet music and lithography. Tin containers of lard, oil, and other products were often decorated with images of African-Americans. Some depictions were flattering, others were not. The use of trade cards waned as magazines became available, but advertisements continued to exploit African-Americans. "By 1900, the (Ladies' Home) Journal's circulation reached one million...The Saturday Evening Post... grew gradually, but acquired a huge $5 million worth of advertising revenues by 1910, with a circulation of over one million. Advertising had now become an established mass-communications form, with nationwide scope, and increasing sophistication and influence...by the end of the 1800s, newspapers and magazines had become part of the U.S. marketing system with the job of 'inducing mass consumption.' Advertisers provided over 2/3 of magazine revenues by 1909."[2]

In regard to African-Americana and advertising, the most notable early twentieth century periodical is *Needlepoint Magazine* which regularly featured full-page Cream of Wheat advertisements in the 1920s. An African-American chef, "Rastus," was integrated into most of the artwork, but sometimes black cupids or black children were pictured. Rastus was usually serving Cream of Wheat to white folk, relegated to a subservient position but always smiling as this was all he needed to do to be content. The advertisements were usually realistic artistic renditions as opposed to degrading caricatures, an unusual circumstance for this time and for advertising with African-Ameri-

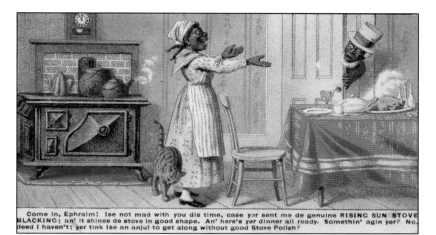

Come in, Ephraim! Ise not mad with you dis time, case yor sent me de genuine RISING SUN STOVE BLACKING; an' it shines de stove in good shape. An' here's yer dinner all ready. Somethin' agin yer? No, deed I haven't; yer tink Ise an anjul to get along without good Stove Polish?

can images in general. According to the B&G Foods, Inc. website, the current owners of Cream of Wheat, "Many of the most famous American artists of the 'Golden Age of Illustration' were commissioned by the Cream of Wheat Cor-poration. Happily their paintings remain not only as examples of fine art but as a charming reflection of family life during the early twentieth century."[3] Of course there may be some who might question this state-ment regarding "a charming reflection of family life." Regardless, we now have a litany of collectible advertisements.

The real Cream of Wheat chef was Frank L. White who passed away in 1938 in Leslie, Michigan, and was buried in a grave that remained unmarked until June 2007. A stone now provides his name along with an image of the Cream of Wheat chef.

Toys and games of the early 1900s of-ten integrated African-American images. Again, the vast majority of these pieces were negative portrayals with names like "Alabama Coon Jigger" and artwork that emphasized stereotypes.

The use of African-American images, mostly insulting and debasing in nature, continued until the commencement of World War II. Our coun-try's participation in this war affected all forms of manufacturing as, dur-ing the Second World War, American society became wholly focused on a victorious end to the war. Factories were retooled and manufac-turing was principally directed toward a suc-cessful conclusion of the war with the production of arms, ammunition, airplanes, tanks, and so

"THEY ALL DO IT"

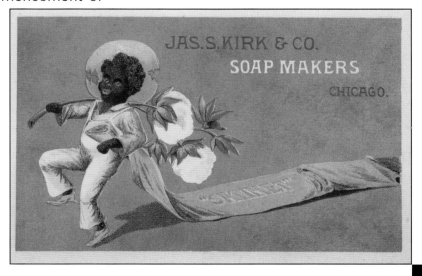

JAS.S.KIRK & CO. SOAP MAKERS CHICAGO.

on. Objects for the home simply weren't being produced until the cessation of hostilities.

Most of the kitchen collectibles presented in this book are post-WWII with the resumption of non-military manufacturing in America, Europe, and Japan. European manufacturing was largely bolstered by the Marshall Plan. Named for U.S. Secretary of State George C. Marshall, this economic strategy was designed to create economic recovery in Europe motivated by the philosophy that strong economies led to strong, stable governments. Between 1948 and 1952, Americans provided sixteen European nations $13 billion in assistance along with technological support towards economic recovery.

By the start of WWII Japan had successfully established a strong industrial economy that allowed it to produce the equipment needed to wage war. During the American occupation, 1946-1952, Japan benefited from American aid receiving $1.8 billion in support. Constitutional changes to create a Japanese democracy were put into effect, and with this new legislation came reforms to manufacturing including a significant growth of unions. "During the Occupation, the professional managerial class were expected to devise a reformed capitalist order. Managers stressed the importance of jobs, workers, and the state over profit. Firms were considered communities comprised of capital, management and labor, where each member of this triad would benefit from company profits, have a voice in corporate administration, and replace stockholders. This focus on harmonizing relationships between labor and capital had roots in the pre-war days."[4] The reconstruction of Japanese factories did not include assembly-line production as that required a greater financial commitment than America was willing to provide. Compared to the $13 billion of assistance given to Europe, $1.8 billion might seem a pittance, but European aid was distributed among sixteen countries.

Post WWII aid brought Japanese manufacturing back to life, to a point. Without assembly-line factories more work had to be completed by hand. This brings us to much of what is presented within these pages; there is a plethora of ceramic and china items made in Japan that are painted by hand. These items were "cold painted," the paint was applied by hand but not fired-on to bake the coloration/glaze onto the surface which would have produced a more permanent finish. The "cold painted" description is frequently used in the picture captions within this book.

Domestically, plastic became the "modern" material as Americans moved into the 1950s, and many items that had once been produced in metal or ceramic materials in America were now being manufactured in plastic. An interesting assortment of African-Americana in this material is pictured. One can safely assume vintage hard plastic objects that offer no manufacturing information were made in the U.S.A. Most of these items were kitchen-related: shakers, memo holders, and so on.

By the 1960s the civil rights movement was in full swing and the initial twinges of being politically correct had been felt. A willingness to begin to accept, at least on some levels, African-Americans as equals to Anglo-Saxon Americans had started and what was manufactured during this era reflected newly-emerging social values. African-American images that promoted stereotypes disappeared as children of different races were pictured in the same circumstances engaged in the same activities. The use of derogatory names in print vanished and so did the production of what is currently seen as collectible. Even "Little Black Sambo" evolved; he became known as "Little Brave Sambo." As pieces featuring black faces became identical to items featuring white faces the production and collectability of African-Americana ceased.

It is interesting to note that currently reproduction African-Americana is prolific and ongoing. There are so many versions of the well-known McCoy Mammy cookie

jar (the original is pictured in this book) that is it virtually impossible to create a comprehensive listing. What's new is old, what's old is new. Some things never change, but hopefully the ugliness behind the collectability of African-Americana has disappeared forever.

### Why Collect African-Americana?

Collecting is like having sex. You remember the first, you remember the most recent, and everything else gets lost in the haze of forgetfulness. I certainly recall the first piece of African-Americana that I purchased and have noted it in the caption under that picture. I was excited about acquiring that first item, a small creamer, because it had a face, but not just any face, a face with a big smile looking directly at me and I felt a surge of happiness that caused me to smile back.

Having engaged in numerous conversations with other collectors of African-Americana it seems the sense of joy felt when looking at one's collection is something we all share. A row of smiling Mammy and Chef salt and pepper shakers causes us to grin in return. To many the "kitchen-y" collectibles are feel-good pieces. Most collectors never consider the prejudice and malice behind a great deal of these things or the pain that may have been felt by an African-American forced to endure the presence of degrading images in stores, in magazines, even on packages of food.

Once a collector has acquired a row of shakers (or other items) one is naturally compelled to study one's possessions. As many of the kitchen items were hand painted (cold painted) no two are exactly alike. One has a bigger smile, another is gazing to the left, another has more polka dots on her kerchief, and so on. These variations only feed one's need to collect; a true collector can justify each shaker or each ashtray, or whatever as being different because of these variations.

Certainly individuals who invest in a collection hope that the finances spent amassing treasures eventually pay a divi-

dend by increasing in value over time. An article in a February 2006 edition of *Business Week* magazine indicated that the growing affluence of African-Americans has positively affected the value of African-Americana. Not only are more individuals collecting African-Americana, but institutions as well have come to appreciate the historic aspect of these images and items. In light of the volatile economy that exists at this writing it is difficult to predict what will and won't increase in worth. I always counsel collectors to buy what they like because they will be living with it and looking at it. If an item or a collection becomes more valuable, consider that a wonderful event, but it should not be the primary motivation for bringing an item into one's home.

Many early images of African-Americans are downright repulsive, and the use of the "n" word and other equally unacceptable language was rampant. A few items that one might find objectionable by today's politically correct standards are provided as it would be remiss to fail

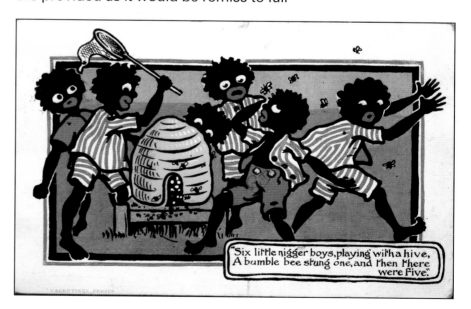

"Six little nigger boys, playing with a hive, A bumble bee stung one, and then there were five."

A 1907 postmark is on this "n" word postcard.

to acknowledge their existence. These items were produced, purchased, and happily displayed for decades, so ignoring them in the twenty-first century would be failing to fully acknowledge the history behind this genre. One must make

a determination as to what is acceptable to one's own sensibilities. If you feel exhibiting an object would cause someone to be uncomfortable perhaps you might want to reconsider either purchasing it or displaying it.

As with all vintage memorabilia there are a finite number of pieces. Glassware breaks, paper may deteriorate, but African-Americana has faced a unique dilemma. "According to African-American student and dealer of Black Americana Gerald Diggs, one of the primary reasons many of the once-abundant items are now scarce, and therefore largely unknown to most Americans, is that many of them were bought by wealthy African-Americans in the 1970's and promptly destroyed. Diggs, who is black, sees this as a tragedy for many reasons. 'In my opinion these things were important to both whites and blacks because they force us to be honest with ourselves and our feelings to each other,' said Diggs. 'The ugliness of hate is only truly broached and dealt with when you bring yourself face to face with it. The destruction of these derogatory pieces serves to turn a social monster that could be faced honestly into a silhouette that hovers over us all, ever more powerful without challenge.'"[5] Therefore, there is a diminishing amount of vintage African-Americana, a situation unique to this one area of collecting. In a healthy economy when the supply of something decreases while the demand remains consistent or increases, the values should also increase.

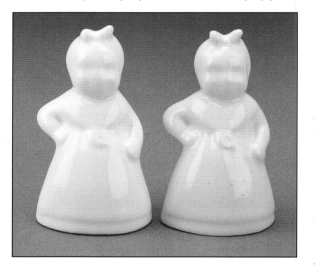

Mammy shakers. This pair is unique because there are no colorful details. Were these originally sold as found or have all of the cold painted details been washed away? This plain set would have little interest to most collectors. Pottery. $25 pair.

## A General Look at African-Americana

The vast majority of vintage African-Americana items were produced for the kitchen. One can conjecture the reasons. During the Depression items for the lady of the house were "free" with the purchase of a good or service to promote sales. The kitchen was the central room in the home, so what better place to focus one's marketing strategies. A home might not have a parlor, library, and, perhaps, even a bathroom, but every house offered some configuration of a kitchen. Whatever the explanation, we are left with a fascinating array of kitchenware which will be presented in greater detail.

Salt and pepper shakers are among the most easily-found collectible, most having been made in Japan. They are largely china, sometimes pottery, with hand painted features. As this was cold paint (the color was not fired or glazed onto the item) these details were not durable, so condition is paramount when selecting something for purchase.

Another important element to consider when selecting shakers is rarity. Obviously shakers that are more difficult to find will be of higher value.

Original stickers and labels always add to the value of a collectible. It's

not that hard to find stickers/labels marked "JAPAN," but it is difficult to discover an original manufacturer's sticker or label.

F & F Mold & Dye Works of Dayton, Ohio, manufactured some of the most recognizable hard plastic collectibles: shakers, syrup dispensers, creamers, and sugars in the 1950s. These were premiums acquired by buying Aunt Jemima products and mailing the required proof of purchase with a nominal amount of money. Seventy-five cents was the cost of three spice shakers.

Additional F & F products are pictured, but this provides a sample of some items Mother could have purchased for a minimal investment after buying the correct products.

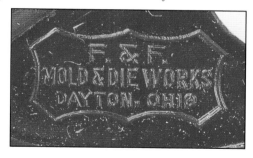

This marking is molded into the bottom of all vintage F & F pieces with the exception of the sugar lids and recipe boxes.

This is the mark found on F & F reproductions. Some even newer issues are marked "Miss Martha" and are not vintage 1950s. Values suggested are for true, vintage F & F pieces.

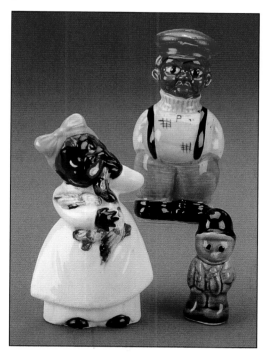

Three uniquely different salt or pepper shakers; all of these are considerably less common than many shakers. As rarer pieces that are singles, it will be challenging to complete the pairs. **Left:** Mammy with a Duck, 5.25" tall, base marked in green "MADE IN JAPAN," china with cold painted details. $40. **Back/middle:** Man in Suspenders, 4.75" tall, no manufacturer's information, known to be made in Japan, china with cold painted details. $40. **Right:** Tiny Man in Green, 2.75" tall, no manufacturer's information, known to be made in Japan, china with cold painted details. $25.

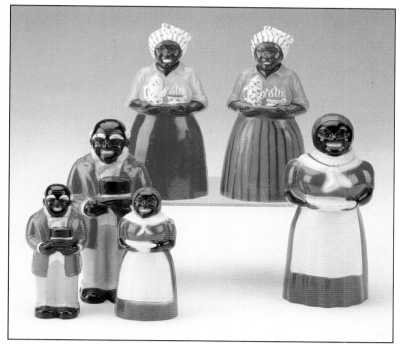

**Back row:** Luzianne Coffee Mammy pepper shakers in red and green. Luzianne Mammy shakers have holes aligned as "P" or "S" to indicate what seasoning is inside and are only found in this 5.25" size. These plastic shakers were acquired by purchasing Luzianne Coffee and Chicory. $150 each. **Middle row, far left:** Uncle Mose pepper shaker in the only color originally created. A matching Aunt Jemima salt shaker is available and would have been acquired through an Aunt Jemima offer. These plastic shakers are 5.25" tall. $35 each. **Middle row, far right:** Aunt Jemima plastic syrup dispenser, 5.5" tall. She was a premium through Aunt Jemima products. $65. **Front row, far left:** Uncle Mose and Aunt Jemima plastic shakers in the only color originally created and available through an Aunt Jemima promotion. These are about 3.5" tall. $20 each.

The history of Aunt Jemima is worth noting. The following timeline is directly from the Aunt Jemima website (http://www.auntjemima.com/aj_history/) and presents the earliest years as they relate most closely to the collectibles presented in this book.

1889   Chris Rutt and Charles Underwood of the Pearl Milling Company developed Aunt Jemima, the first ready mix.

1890   R.T. Davis purchased the struggling Aunt Jemima Manufacturing Company. He then brought the Aunt Jemima character to life when he hired Nancy Green as his spokeswoman.

1914   The image of Aunt Jemima was so popular that the company was renamed the Aunt Jemima Mills Company.

1926   The Quaker Oats Company purchased the Aunt Jemima Mills Company.

1933   For the Chicago World's Fair in 1933, the advertising planners decided to bring the Aunt Jemima character back to life. They hired Anna Robinson, described as a large, gregarious woman with the face of an angel. She traveled the country promoting Aunt Jemima until her death in 1951.

1937   Quaker's first registration of the Aunt Jemima trademark occurred in April, 1937.

1955   From the mid 1950's until the late 1960's Aylene Lewis was hired to portray Aunt Jemima at the Aunt Jemima restaurant in the newly opened Disneyland.[6]

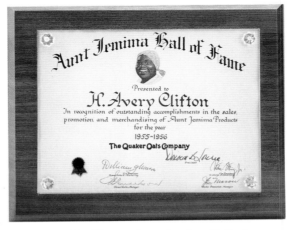

Employee Certificate: Aunt Jemima Hall of Fame, 10" x 8.25"; The Quaker Oats Company, 1955-1956. Too rare to price.

The 1949 recipe book *Aunt Jemima's New Temptilatin' Recipes* provides more history:

Gracious living was the keynote of life at Higbee's Landing where, legend has it, Aunt Jemima was a mammy cook. Even in those days the fame of Colonel Higbee's cook spread far and wide throughout the South. Guests flocked to the home of her master to taste the delicacy for which Aunt Jemima was famous. That delicacy was pancakes – light, fluffy and gold-brown – which the smiling Aunt Jemima prepared herself in the great kitchen. The sight of the delicious pancakes, topped with melting butter and rich, golden syrup, brought forth such enthusiastic praise that Colonel Higbee would call Aunt Jemima herself in from the plantation kitchen and praise her before his guests.[7]

Was Nancy Green hired to represent an actual slave from Colonel Higbee's plantation, or was she simply paid to create a personality? The timeline is a bit vague on this issue, but Higbee's mammy's basic story is reiterated in the 1952 recipe book *Aunt Jemima's Magical Recipes*. Based on historical evidence it is highly unlikely that the mammy chef was brought from the kitchen to stand before plantation guests to receive commendations.

Today's collectors search for virtually any vintage Aunt Jemima item, and a good assortment is shown in this book. Perhaps the most elusive item of all is provided here: an award presented to an employee of

The Quaker Oats Company. So much of what is collected today was originally a premium related to the promotion of Aunt Jemima products, making this employee's certificate a truly unique item.

One thing that cannot be overlooked is the portrayal of and even the creation of "Mammy" as she is a figment of the white imagination, and Aunt Jemima was simply another Mammy. Female slaves were beaten, raped, and underfed. The image of a delightfully contented, overweight, smiling Mammy is a fantasy promoted by slave owners, partially to hide the sexual assaults as who would rape an obese woman? This myth continued to be perpetuated following the abolition of slavery. "White men created the Mammy image so white women would not have to fear that the Jezebel black woman would lure their weak-willed white men away, so that white women would not have to fear that these 'temptresses' would wreck their already in turmoil white home life, therefore, Aunt Jemima was created to give the South an image of tranquil, docile, happy ex-slave black people who only lived to serve the white people's bottomless needs."[8]

There were seven women who portrayed Aunt Jemima for The Quaker Oats Company, and it is worth recognizing them here and validating their work: Nancy Green (1834-1923), Anna Robinson ( ?-1951), Edith Wilson (?-1981), Ethel Ernestine Harper (?-1981), Rosie Hall (1900-1967), Aylene Lewis ( ?-1964), Ann Short Harrington (1900-1955).[9]

Aunt Jemima wasn't the only restaurant based upon racial stereotypes. Sambo's Restaurants were established by Sam Battistone and Newell Bohnett, nicknamed "Bo." The names Sam and Bo were merged and the restaurant's name was agreed upon: Sam + Bo=Sambo, so they based their venture on the story of "Little Black Sambo" and the pancakes referenced therein. The original restaurant opened in Santa Barbara, California, in 1957 and a reputation for ten-cent coffee, good pancakes, and friendly service propelled the enterprise into a 1,200-location success. However, the connotations brought on by the Sambo name contributed to the demise of this empire as our nation attempted to eliminate racial stereotypes in the 1970s. Today items from the restaurant are quite collectible.

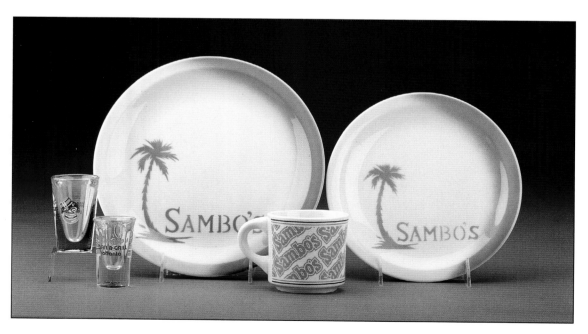

Dinnerware and glassware from Sambo's Bar and Grill. **Plates:** 10" and 8.5" by Jackson China, Falls Creek, PA. $60 each. **Shot glasses:** just over 3" tall and 2.75" tall, from the Atlanta, Georgia location. $40 each.

Wooden nickels were given to customers for use during a future visit to a Sambo's location. Some nickels or tokens were designated for specific locations while others were valid anywhere. Today the nickels that are designated for one restaurant are more collectible, and condition does matter. Collectors seek clean, easy-to-read nickels whose wood is not split or damaged.

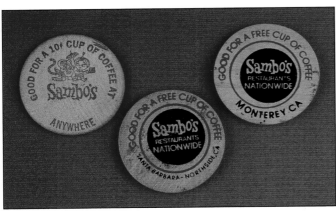

Sambo's tokens/nickels. 1.5" diameter, wood. **Left:** "GOOD FOR A 10c CUP OF COFFEE AT ANYWHERE." **Middle:** "GOOD FOR A FREE CUP OF COFFEE SANTA BARBARA-NORTHSIDE, CA." **Right:** "GOOD FOR A FREE CUP OF COFFEE MONTEREY CA." Tokens/nickels good for use anywhere, $10 each; location-specific tokens/nickels, $20 each.

As stated earlier, African-American images were frequently used to promote a variety of products, and occasionally there would be a bit of logic influencing the choice to use a black face on a package. Five vintage packages are shown, all with an African-American image. The sugar canister shows a man toiling in a cane field, so this design is somewhat appropriate, albeit the man would have been slaving to the point of exhaustion with an overseer ready to beat him at any time.

Red Cap Cleaner would have implied that the black dirt would be removed, hence the use of a black face. Carter's Musilage was produced by an ink company that regularly used a black face on labels of black ink, so this image is consistent with others used by this company. Mascot Baking Powder might be based on opposites – baking powder is white, the image on the label is black. Banania is a tropical item so it would seem more appropriate to utilize a native's image here than on many other products.

Incorporating natives into the package designs of all sorts of items provides a huge assortment of images, largely insulting in nature. Natives were used in advertising as the Banania tin, as salt and pepper shakers, as decorative figurines, and more. Occasionally natives were pictured as cannibals, again capturing the most negative characteristic possible and then emphasizing it in what was to be interpreted as a whimsical portrayal.

The assortment of products found with a black image is endless, which attests to the success of this genre that entices the interest of collectors. African-Americana includes countless objects created in various materials, and some were actually purposeful.

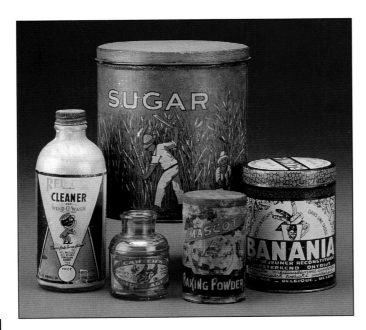

**Back:** Sugar canister, 5" diameter, 5.75" tall, lithography on tin. $75. **Front left:** Red Cap Cleaner, 6" tall, C.M. Kimball Co., Boston, Mass., glass bottle with paper label. $65. **Front second from left:** Carter's Musilage, 2.75" tall, The Carter's Ink Co., Boston, New York, Chicago, glass bottle with paper label. Note: the image on this label was also used on a trade card. $45. **Front second from right:** Mascot Baking Powder, 2" diameter, almost 3.5" tall, The C.F. Ware Coffee Co., Dayton, O., tin with paper label. $50. **Front right:** Banania, 3" diameter, 4" tall; unknown Belgium manufacturer, all information on this can is provided in French and German, lithography on tin. $45.

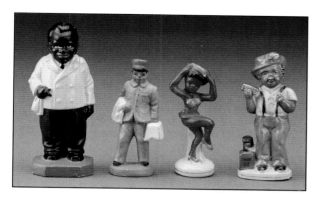

Four figurines illustrate the variety of images that were produced. **Far left:** Waiter, 5" tall, bottom stamped in blue: "COLOURED WAITER MADE IN BAVARIA Made in Germany," composition. $45. **Second from left:** Porter (from a train set), 3.75" tall, bottom stamped in purple: "JAPAN," chalkware. $30. **Second from right:** Dancer, 3.75" tall, bottom stamped in orange: "MADE IN JAPAN," china with cold painted details. $18. **Far right:** Shoeshine Boy, 4.25" tall, bottom stamped in orange: "JAPAN," china with cold painted details. $18.

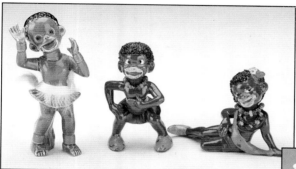

Three native figurines all feature demeaning details. **Left:** Bottom lip protrudes a full .25", 5.25" tall, no manufacturer's information, thought to be made in Japan, china with cold painted details and fur. $18. **Middle:** 4" tall; no manufacturer's information, thought to be made in Japan, china with cold painted details and glass beads. $18. **Right:** 4.75" long, 3.25" tall with an exaggerated mouth, bottom stamped in black: "MADE IN JAPAN," redware. $18.

Shown are three different creamers that are described in greater detail within the pages of this book. The small creamer on the right is the first piece of African-Americana purchased by the author in the 1980s at an estate auction for $9.

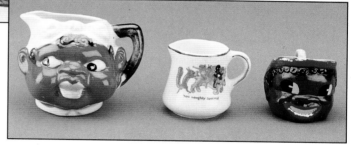

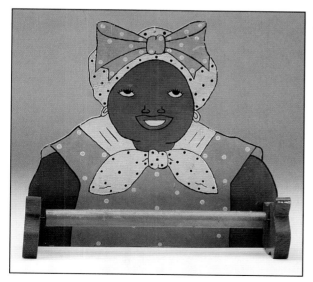

Towel holder, 13" x 12", hand crafted, wood. $65.

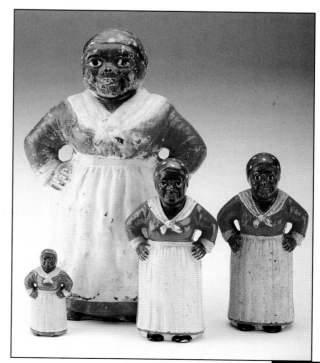

Cast iron Aunt Jemimas were American-made and available in a variety of sizes for specific purposes: 9" tall doorstop, $200; 5.5" tall still banks in dark and light skin tones, $100; 2.5" tall paperweight, $120.

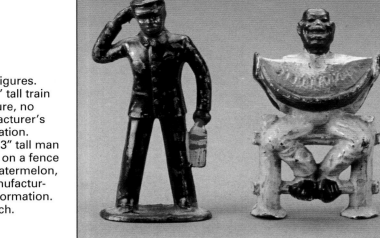

Metal figures.
*Left:* 3" tall train set figure, no manufacturer's information.
*Right:* 3" tall man seated on a fence with watermelon, no manufacturer's information. $30 each.

Many objects with African-American images were created for children. A variety of dolls, games, and toys were produced starting in the mid-1800s. These topics are presented in greater detail, but suffice it to say that although dolls tended to be more realistic than the images utilized elsewhere, many graphics used in toys and games would now be viewed as offensive.

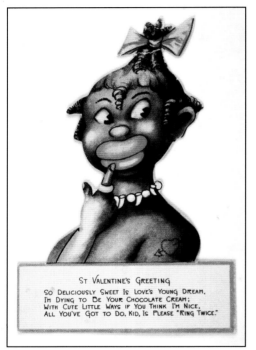

ST VALENTINE'S GREETING

SO DELICIOUSLY SWEET IS LOVE'S YOUNG DREAM,
I'M DYING TO BE YOUR CHOCOLATE CREAM;
WITH CUTE LITTLE WAYS IF YOU THINK I'M NICE,
ALL YOU'VE GOT TO DO, KID, IS PLEASE "RING TWICE."

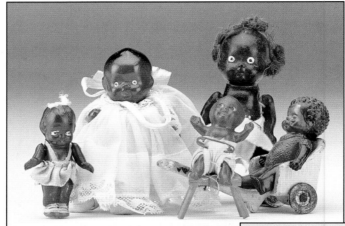

Dolls were manufactured in an assortment of sizes in a mixture of materials: bisque china, fabric, plastic, celluloid. These dolls are 4" or smaller, and each is detailed in the doll section.

Even a child's Valentine presented an opportunity to portray an African-American in the most negative light imaginable.

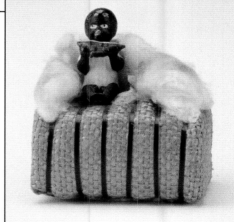

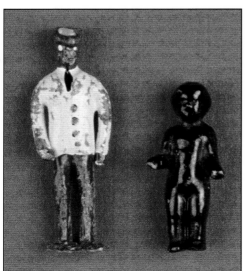

*Left:* 1.5" tall porter for use with a train, no manufacturer's information, metal. $30.
*Right:* 1.25" tall baby, no manufacturer's information, plastic. $10.

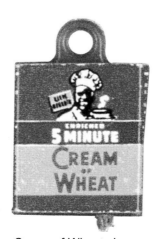

Cream of Wheat charm. .75" tall, no manufacturer's information, some kind of premium, plastic with paper. $35.

Watermelon-eating child on bale of cotton. Bale: 2" x 2.5" x 1.25", bisque child: 1.5" tall, no manufacturer's information, marked: "I Am From DIXIE Miniature Cotton Bale Souvenir New Orleans, La. These were marketed as souvenirs that were "educational" toys. $30.

## Reproduction Information

It seems that whenever something gets popular reproductions follow. There is no way to provide authoritative, complete information regarding reproductions, but some general information should assist anyone contemplating a purchase.

**Coon Chicken Inn collectibles.** These have been reproduced and there are many items that are available that are not actual memorabilia from the 1925-1950s restaurants. The website: www.coonchickeninn.com will provide definitive information on new versus old.

**F & F hard plastic.** As previously discussed most items are clearly marked with their insignia. More information follows where F & F items are pictured.

**Cast iron.** Newly produced items are usually less carefully made. If there are multiple pieces comprising an item these pieces in reproductions usually don't fit as tightly together as original items would. New cast iron is sometimes produced to have an old, weathered look as with the small paperweights shown side by side.

**Paper.** A good magnifying glass used to be the best tool for discerning reproduction paper as one would be able to discern dots on reproductions resulting from the printing process. Technology has advanced to such a level that the government is constantly changing our dollar bills, so there is no way for collectors to stay ahead of motivated forgers. The best source for buying paper would be through a knowledgeable and reputable dealer.

The following information is from www.oldimprints.com:

How do you distinguish a genuine old print from a modern reproduction? The more you look at old prints the easier this becomes. Most reproductions of old prints produced by modern means have a flat appearance which contrasts with the crispness and depth of tone of the old print. It is this quality of printing which will make you gravitate to the genuine old print. 1. Look at the print through a magnifying glass. The majority of reproductions of old prints are produced by photomechanical means and can easily be distinguished by the pattern of lines and dots visible through the magnifying glass. A regular grid pattern of dots indicates a photo-offset reproduction. Of course, prints produced since the late 19th century may have originally been printed by this technique. A more recent development in color reproduction is xeroxing. When seen in magnification, a color xerox print is identified by parallel lines of color. Examine old prints and become familiar with the look of different techniques. Lithographs have an irregular granular pattern (contrast the granular look of a genuine old Currier and Ives print with the dot grid pattern of a twentieth century Currier and Ives calendar print). Engravings and wood engravings are both linear in pattern -- reproductions of these processes lack the crispness of the original.[11]

The same reproduction technology is being applied to fabrics; new tea towels and tablecloths are being created.

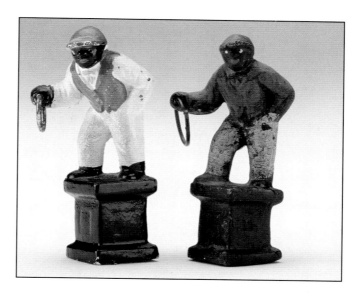

3.75" tall cast iron paper weights. *Left:* Original, 3.75" tall, no manufacturer's information, known to be made in America, original sticker/label on base with $2 price tag. *Right:* Reproduction, note the white dots for eyes and intentional "aging."

Reproduction fan. 8.5" x 13.5", no manufacturer's information, advertisement for "Club Plantation 911 N. Vandeventer St. Louis 3 Floor Shows Nightly Strictly White Patronage Only Franklin 7244-9605," cardboard and wood. Two clues that this is new: the phone number has eight digits and the staple attaching the paper fan to the wooden handle is shiny and new. $5.

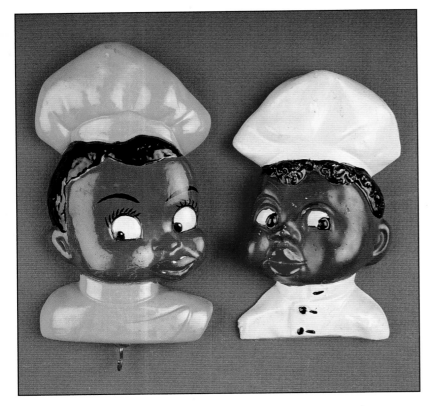

Plaques with hooks (for hanging pot holders) and those without hooks were made in a variety of motifs, but almost always in chalk.
**Left:** yellow chef for pot holders, no manufacturer information. $50.
**Right:** white chef wall plaque, no manufacturer information. $40.

**Chalkware.** Many items were made in chalk including banks, figurines, and wall plaques from the late 1940s through the 1970s. Some wall items were simply decorations while others had hooks for displaying pot holders. Chalkware has not been reproduced, but there are newer ceramic items made to imitate chalkware.

**China and pottery.** There is a seemingly endless variety of new cookie jars being made in the U.S. and China. Simply Googling "new mammy cookie jar" will result in 26,000 hits. Most old items were made in the United States and Japan and many were marked. The details on vintage china and pottery are usually hand painted and are cold painted so the features of faces are not fired-on. Wear and aging would be even to all colors; crazing would not be seen in one color. The unglazed edge should have some wear and/or dirt. Again, buying from a knowledgeable, reputable dealer would be in a collector's best interest.

**Endnotes**
[1] http://afe.easia.columbia.edu/japan/japanworkbook/modernhist/occupation.html
[2] http://usinfo.state.gov/products/pubs/marshallplan
[3] http://www.creamofwheat.com/creamofwheat/cow_history.asp
[4] http://www.trivia-library.com/a/history-of-advertising-in-the-1800s-or-19th-century-part-1.htm
[5] http://www.alternet.org/story/10480/
[6] http://www.auntjemima.com/aj_history/
[7] Aunt Jemima New Temptilatin' Recipes, 1949.
[8,9] http://www.kathmanduk2.wordpress.com/2007/05/16/towards-the-end-of-aunt-jemima
[10] http://www.ext.nodak.edu/extnews/newsrelease/2003/013003/04plains.htm
[11] http://www.oldimprints.com/OldImprints/antique_prints_maps.cfm

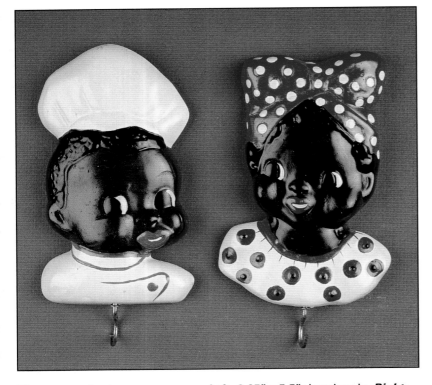

These ceramic plaques are newer. **Left:** 3.25" x 5.5"; handmade. **Right:** 3.75" x 5.5"; handmade. $20 each.

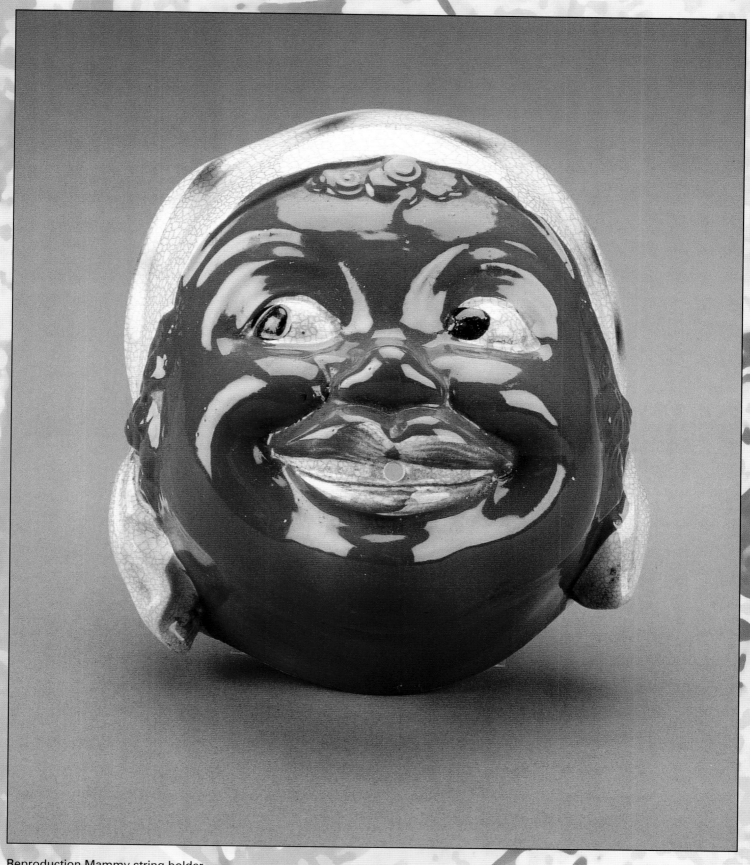

Reproduction Mammy string holder,
5.5" x 6.5", stamped in black "JAPAN."
Note the crazing only in the white glaze.
Controlled wear, deterioration that effects
only one color, is deliberately created
thus indicating a newer item. $20.

## Ashtrays

The relationship of man and tobacco begins in 1000 BC when it was, as a plant native to the Americas, smoked and chewed by the Mayans. Use of this plant gradually spread north and south. The first European smoker was Rodrigo de Jerez, a companion of Christopher Columbus, in 1493 when exploring current-day Cuba. Upon returning to Spain and smoking a cigar in public he was arrested and imprisoned for three years by the Spanish Inquisition.

As the use of tobacco spread so did the need to contain one's ashes but this wasn't really addressed until the 1800s. Victorians, known for frills, fussiness, and having a plethora of items each designed to do a singular task, brought the use of ashtrays into the home. Of course there were various sizes, shapes, and designs to meet the many needs of Victorian smokers.

The economic prosperity of America during the 1920s saw many changes in our country particularly regarding women. Women finally achieved the ability to vote and many became "flappers," confident young women interested in enjoying pleasures that had previously been reserved strictly for men: smoking and drinking. Companies involved in manufacturing ashtrays developed smaller, more delicate and fashionable examples to appeal to these new consumers while men's ashtrays continued to be heavy and bulky. Cigarette ashtrays in general were all smaller than cigar ashtrays and during this period most were leaded glass, a material that was durable enough to withstand the heat of a burning cigar or cigarette.

Advertising ashtrays were produced after World War II. They were such an inexpensive item to manufacture that many businesses utilized the ashtray as a form of self-promotion. Casinos, hotels, and restaurants regularly gave ashtrays to customers. The 1950s is considered to be the peak period of interesting ashtray design.

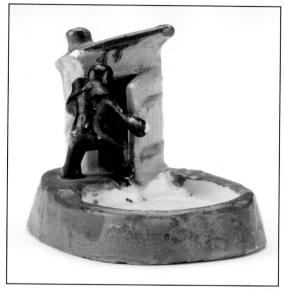

Man at Outhouse. 3" wide, 3" tall, no manufacturer's information, thought to be made in Japan, bisque china with cold painted details. $20.

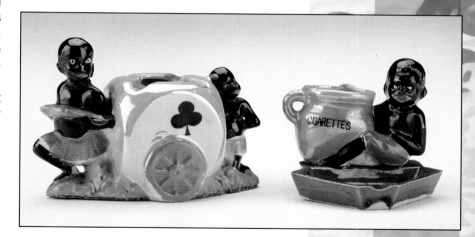

*Left:* 5" wide, 3.5" tall, base marked "MADE IN JAPAN," china with cold painted details on top of glazed base. $20 *Right:* 3" wide, 2.75" tall, base has original paper tag/label that is impossible to read, known to be made in Japan, china with cold painted details on top of glazed base. $15.

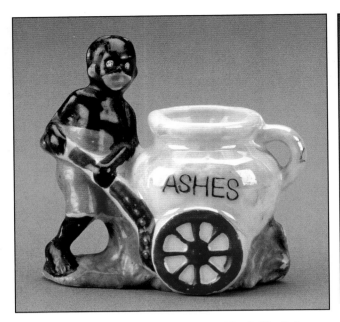

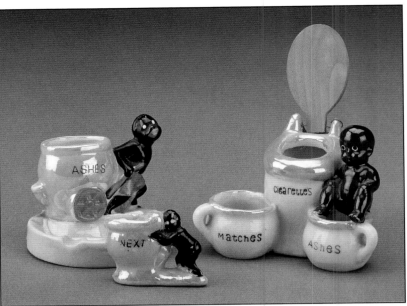

Man with ashes pot on wheels. 3.5" wide, 3.5" tall, bottom stamped in black "MADE IN JAPAN" and "JAPAN," embossed into back of pot, china with cold painted details. $25.

Luster ashtrays. **Left:** Man pulling wagon marked "ASHES," 3" wide, 2.5" tall, no manufacturer's information, known to be made in Japan, china with cold painted details on top of glazed base. $20. **Middle:** Baby pushing a potty marked "NEXT," 1.75" wide, 1.5" tall, base stamped in black "MADE IN JAPAN," china with cold painted details. $15. **Right:** Baby with potties and a toilet with a wooden lid, 3.5" wide, 2.5" tall, base stamped in red "JAPAN," china with cold painted details including "MATCHES," "cigarettes," and "ASHES" on top of glazed base. $25.

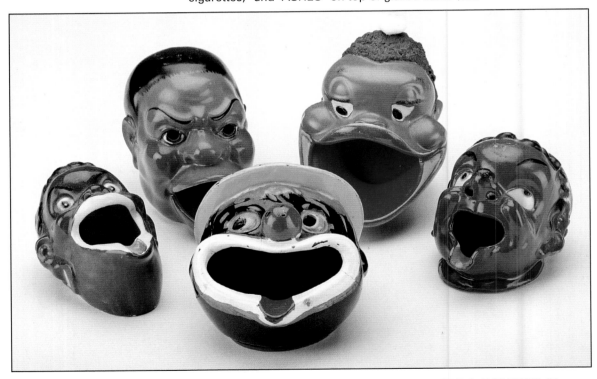

**Center:** Clown ashtray. 5" long, 4" wide, 3.5" tall, base stamped in gold paint: "D.E.S. PAT. PEND.," known to be made in Japan, redware with cold painted details on top of glazed base. $20. **Back Left:** Minstrel. 3.5" long, 2.5" wide, 2.5" tall, base embossed "PATENT TT" with original paper tag/label "JAPAN," china with cold painted details. $30. **Second from left:** Native with enormous lips. 4.5" long, 2.5" wide, 3.5" tall, base stamped in red: "HAND PAINTED JAPAN," china with cold painted details. $30. **Second from right:** Native with bone in hair. 6" long, 3.5" wide, 3" tall, base marked: "SISSY RUBIN 1963," this was made in a ceramics studio, china. $25. **Back right:** Boy wearing orange and yellow striped cap (cap not seen at this angle). 4" long, 2.5" wide, 2.75" tall, base stamped in black "MADE IN JAPAN," china with cold painted details. Designed in such a way that when a cigarette is perched on his lip the second hand smoke will rise through his nostrils. $45.

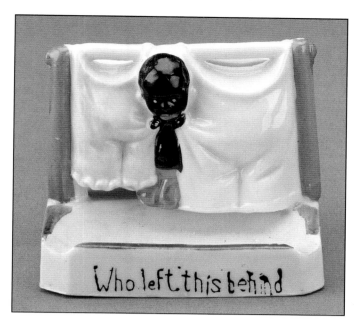

Child peeking through laundry. Almost 3" wide, 2.5" tall, base stamped in black "MADE IN JAPAN," front marked "Who left this behind," bisque with cold painted details. $25.

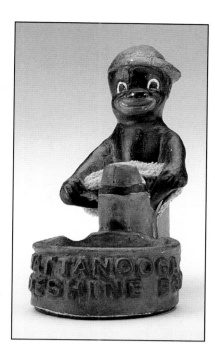

CHATTANOOGA SHOE-SHINE BOY. 2.75" wide, 5.25" tall, no manufacturer's information, real terry cloth is held between his hands, chalkware. $60.

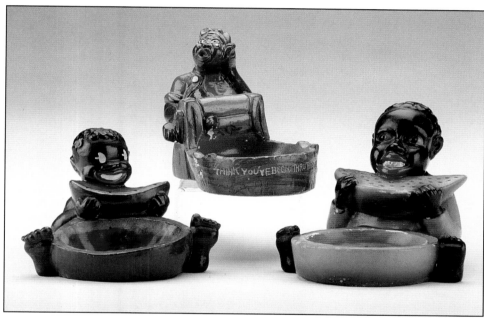

*Left:* Boy with watermelon. 5" wide, 3.75" tall, back of pants marked in black " DESIGN PATENT No. 152.521," chalkware with original $1.00 price penciled on base. $30. ***Middle, back:*** Washerwoman. 3.5" wide, 4.25" tall, no manufacturer's information, front marked: "THINK YOU'VE BEEN THROUGH THE WRINGER?" chalkware. $75. ***Right:*** Man with watermelon. 4.75" wide, 4" tall, back of pants have molded-in mark: "c G u 18240," chalkware with original $1.00 price penciled on base. $40.

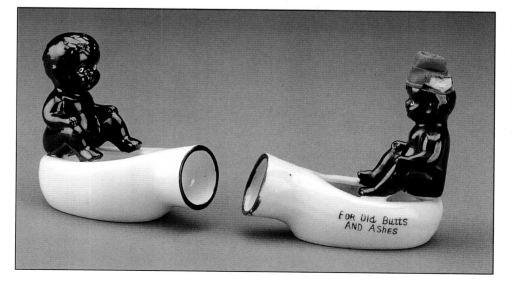

Babies on bed pans. *Left:* 3.5" long, 3.5" tall, embossed on bottom "OCCUPIED JAPAN," china. $20. *Right:* 3.5" long, 3.5" tall, base stamped in black "JAPAN," side marked "FOR Old Butts AND Ashes," china. This baby is wearing a rubber cap and has a hole strategically placed between his legs. To activate: remove the cap, fill the baby with water, and squeeze the hat to make him water the hot ashes. $35.

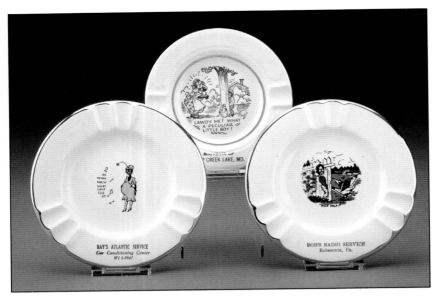

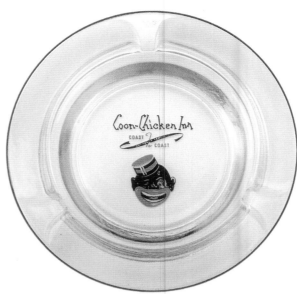

Plate-like ashtrays. **Left:** "AH NEVAH KNEW WHAT LOVE CUD DO-O." 6", marked: "THE 'SABINA' LINE Warranted 22K, Made in U.S.A." **Middle/back:** "LAWDY ME! WHAT A PECULIAR LITTLE BOY!" 5.25", no manufacturer's information, thought to be made in America. This ashtray was a "SOUVENIR OF DEEP CREEK LAKE, MD." **Right:** "HELP HELP!!" 6", marked: "THE 'SABINA' LINE Warranted 22K, Made in U.S.A." The ashtrays on the left and right were gifts from "BOB'S RADIO SERVICE Robesonia, Pa." There were other adult-oriented humorous ashtrays courtesy of Bob's Radio that featured white folk and a Native American. $20 each.

Coon Chicken Inn. 4.25" diameter, no manufacturer's information, glass. REPRODUCTION. $10.

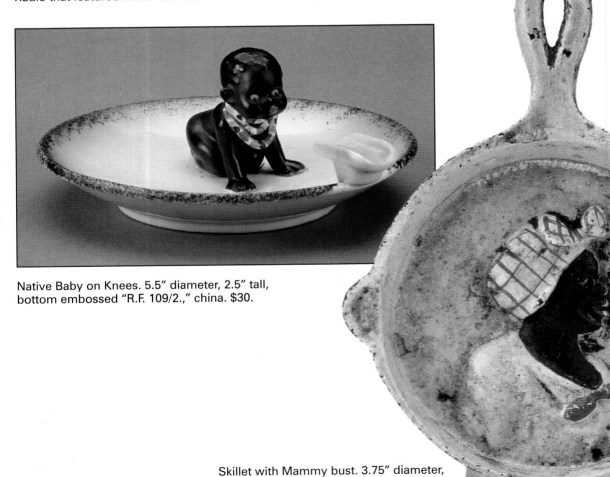

Native Baby on Knees. 5.5" diameter, 2.5" tall, bottom embossed "R.F. 109/2.," china. $30.

Skillet with Mammy bust. 3.75" diameter, 5.75" long, no manufacturer's information, thought to be made in America, cast iron. $50.

## Barware: Tools, Bottles, and Bottle Stoppers

Living and entertaining at home took on new dimensions in the 1950s. This was the era that introduced built-in kitchen countertops, breakfast nooks, and rec rooms. Built-in bars were certainly a part of the new in-home features and pictured here are a variety of whimsical items that would have been available in the 1950s and 1960s for use at one's bar.

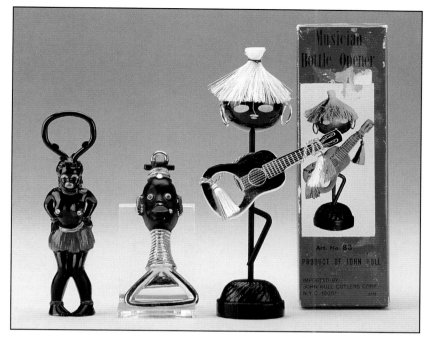

Three figural openers. *Left:* 5.75" long, original sticker/label on back: "MADE IN JAPAN," cast iron with rhinestone embellishments. $30. *Middle:* 4.5" long, original sticker/label on back: "FABULOUS BOUTINE originals by Robert," metal with rhinestone embellishments. $20. *Right:* overall: 7.25" tall, opener (guitar): 4" long, marked "IDEAL D. PATENT JAPAN." Box marked: "Musician Bottle Opener Art. No. 83 PRODUCT OF JOHN HULL IMPORTED BY JOHN HULL CUTLERS CORP. N.Y.C. 1001 JAPAN." Native has a magnet in the center to secure the metal guitar opener. $10, add $2 for box.

Two figural openers. *Left:* Alligator biting a man. 4.75" long, 3.25" tall, no manufacturer's information, presumed to be made in America. $85. *Right:* Banjo player. 2.5" wide, 2.75" tall. No manufacturer's information, presumed to be made in America. $65.

Zulu warrior bar tool toters. *Left:* Toter with original box. Box: 14" x 6" x 4.5", figure: 11.5" tall, felt base marked "JAPAN," redware with cold painted details on top of glazed base. Shown with all of the bar tools. Note the photography on the box has an opener positioned to hide the cork screw that was to represent his penis. The barware tools included with this set are a strainer, double jigger, ice tongs, bar knife, spoon-pick, cheese knife-bottle opener, and cork screw. Pristine, unused condition, $45; add $15 for original box in good condition. *Right:* 6.5" tall, no manufacturer's information, known to be made in Japan, redware with cold painted details on top of glazed base. This is missing one earring and the bar tools he would have held which included a cork screw that was to represent his penis. As shown, $12; if complete, $35.

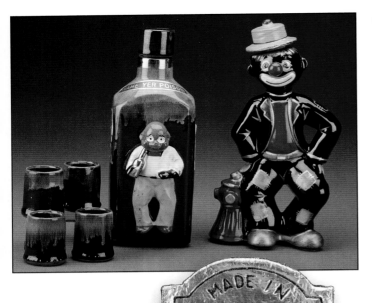

**Left:** "NAME YER POISON" bottle with 1.75" whiskey tumblers. 8.75" tall, original sticker/label on base: "MADE IN JAPAN." Sticker on one side: "Jungle Juice Distilled Gin THIS JUICE IS SEX YEARS OLD BOTTLED IN BARN." Sticker on another side: "PRESERVES BODIES POMPOM JUICE El Stinko PRESERVE HAND PAINTED JAPAN." Redware with cold painted details. The man on the front of the bottle is dimensional as he sticks out 1". $50 with whiskey tumblers; shot glasses alone of nominal value. **Right:** Clown. 9" tall, original sticker/label on base: "THAMES MADE IN JAPAN Hand Painted" and base stamped in gold: " D.E.S.PAT.PEND." Redware with cold painted details. This bottle has been found in the original box marked: "02/443 1 SET." Note: the matching whiskey tumbler is pictured with the tumblers. $40.

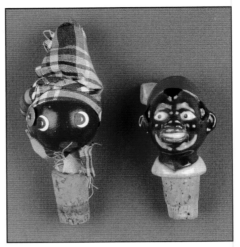

Sticker on bottom of clown bottle.

**Left:** 4" tall, no manufacturer's information, wood and fabric on cork. $15. **Right:** 3.5" tall, no manufacturer's information, china with cold painted details on cork. This is hollow with a spout incorporated into the cap allowing one to pour the beverage while placed on the bottle. $65.

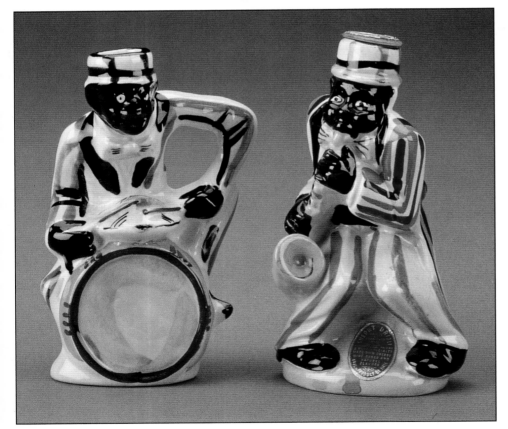

Liquor bottles in pottery. **Left:** Drummer: 4.75" tall, marked "Exclusive Drioli MADE IN ITALY" and marked in green: "37." **Right:** Saxophone player: 5.25" tall, base stamped in brown: "Exclusive Drioli MADE IN ITALY." This is a decorative bottle of cherry wine that was made and bottled in Italy. $35.

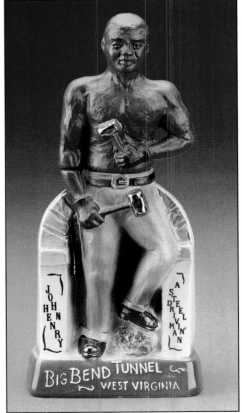

John Henry A Steel Drivin' Man. 13" tall, Regal China. This is a 4/5 quart bottle that contained 86 proof Beam Bourbon Whiskey; it commemorates the Big Bend Tunnel, West Virginia. $75.

## Books — Cook Books and Recipe Books

The earliest cookbook is from circa 1500 BC Babylon. This tablet of clay provides recipes for fancy meals that might have been served at a celebration or some kind of party.

Through the 1700s individuals employed as cooks would have been illiterate and therefore unable to read a recipe. The employer would have read recipes to the cook and these would have been general directions, a pinch of this or that rather than specific quantities.

The first American cookbook, *American Cookery*, was published in 1796 in Hartford, Connecticut, by Amelia Simmons at a time when mother would have been cooking over a fireplace. Simmons's book was extremely popular and enjoyed multiple revisions over a thirty-five year period.

Other cookbooks followed in the early 1800s, still with general directions. Often these books included household hints and suggestions, making them valuable books to own as they were broad in the information they contained. Cook stoves became a more common commodity in the 1850s and cookbooks for the successful use of these new appliances followed.

The first all-electric kitchen was displayed at the World's Columbian Exposition in Chicago in 1893. The stoves and ovens were the first cooking equipment ever to offer a thermometer and now more accurate, specific recipes could be written and followed, but it wasn't until the early 1920s that measuring spoons and measuring cups became commonplace in an American kitchen.

From the 1920s on cookbooks became a familiar item. Many food manufacturers promoted their goods by offering cookbooks that utilized their products.

The cookbooks featured here are regional in nature offering recipes from the South. The decorative covers and the artwork within the cookbooks make them collectible. The Copper Cookbook has a unique history which is provided.

## THE COPPER COOK BOOK

The following comes from the front of the book:

Hereby Hangs the Tale…

The Copper Cook was a warm, humorous soul who fully believed the "way to a man's heart is through his tummy." For many years she cooked for an old Southern family and when the young man of the family announced his intentions to marry she was filled with misgivings, and rightly so, about his bride's culinary abilities. After six months of tireless effort, she presented to them her wedding gift-a notebook filled with recipes that were bound to insure their happiness.

That notebook has been reproduced here just as the Copper Cook wrote it, in her own quaint way, complete with diagrams, misspelled words, colloquialisms, and even her signature at the end of each recipe to give it that personal touch.

A small glossary has been provided to facilitate its reading, but if read aloud, the words will become quite clear.

The Copper Cook will brighten up your meals, your over-the-fence conversation and, of all things, your kitchen wall!

Just So You'll Know…
- Folk means fork
- Youke or yoke is yolk
- Ingreatings must be ingredients
- Shorting is shortening
- Castrole would be casserole
- Rench is, of course, rinse
- Atlin must be Italian
- Bool is ball or bowl
- Coleden means colander
- Hool is hole
- Rool would be roll
- Doue is, of course, dough"

Recipes read as follows: "Let you waffel iorn git real hot and bake as much as you need. What left place in you ice box until next day and you can make hot cakes or cook as fresh waffels."

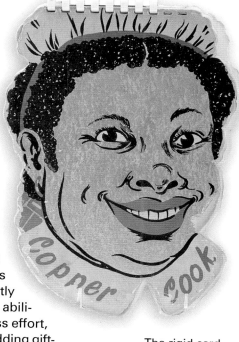

The rigid cardboard cover is a silver metallic finish and the book is cut to be shaped like the Copper Cook's face. 550 San Francisco Ave., Long Beach, Calif., 8" x 11"; cardboard cover, plastic ring binding, c. 1950 by Mary E. Lentz. $40.

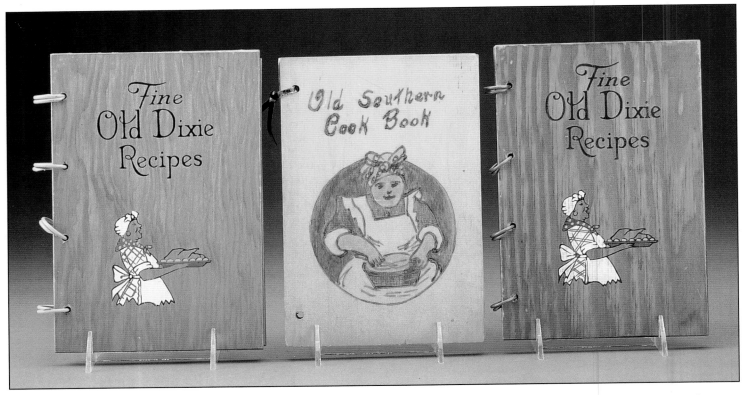

Three cook books with wooden covers. 6.25" x 9.25". **Left:** "Fine Old Dixie Recipes" on cover, A Three Mountains Product. *Middle:* "Old Southern Cook Book" on cover, handmade. **Right:** "Fine Old Dixie Recipes" on cover, A Three Mountains Product. Inside all three covers: "Southern Cook Book," Culinary Arts Press, P.O. Box 915, Reading, Pa., c. 1939, Black and white illustrations are scattered throughout. The "Southern Cook Book" is bound in all three wooden covers. $30 each.

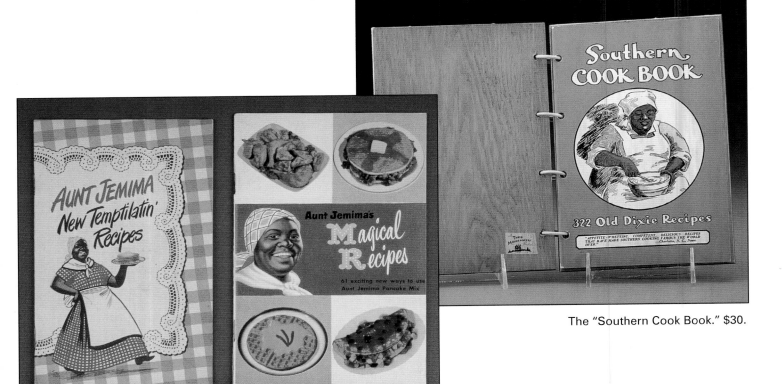

The "Southern Cook Book." $30.

**Left:** just under 4" x 6"; c. 1949. $30.
**Right:** just over 4" x 6.25" c. 1952. $20.

# Brushes

Figural brushes were considered a novelty item; they were to be whimsical yet practical. Obviously the brushes pictured here are variations of African-Americana, but wooden figural brushes were also made as Mexicans, penguins, and more. The earliest of this type of brush was produced with natural bristles and was probably from the mid- to late 1930s while newer brushes were made with nylon bristles. All are thought to be made in the United States.

There is a little history regarding figural brushes. Earliest ones were produced in Europe with porcelain tops of ladies' bodies and dogs' heads. These African-Americana brushes would have been the common person's version of an elegant accessory.

This is the end panel found on the bottom of the cellophane tubes. The cardboard tube is unmarked.

#600

made by
WOONSOCKET BRUSH CO.
WOONSOCKET, R.I.

Three brushes with original packaging. *Left:* 4.5" tall woman with red trimmed natural bristles. $65. *Middle:* almost 7.75" tall Porter with natural bristles. $65. *Right:* 4.5" tall woman with polka dotted natural bristles. $65. Plain, natural bristles are the most common; trim, mixed colors, and polka dots add to the value of a brush as does finding original packaging.

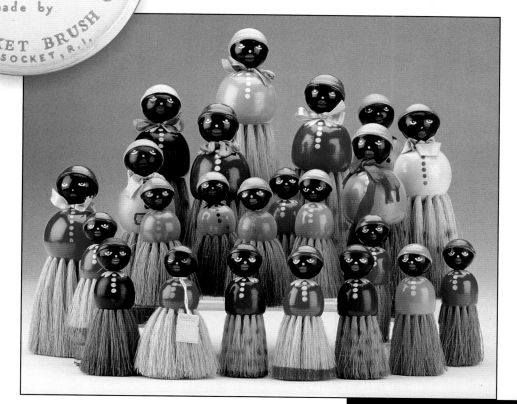

No two 4.5" tall and 7" tall brushes are the same. Careful scrutiny will reveal polka dots, trimmed, and plain bristles as well as diversity in color and shape. Some bristles are aligned in a straight arrangement and others are flared often to replicate a skirt. Plain bristles, $40 each; decorated bristles, $50 each.

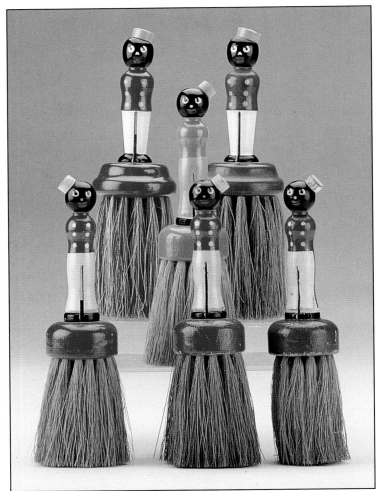

Six Porters with natural bristles. The green Porter in the *back/middle* has green and natural bristles and the red one in the *back far right* has red and natural bristles; the others have all natural, uncolored bristles. Uncolored, natural bristles, $50 each; colored bristles, $55 each.

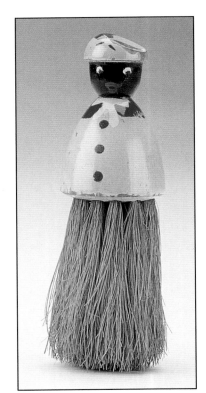

5.75" tall with natural bristles. $50.

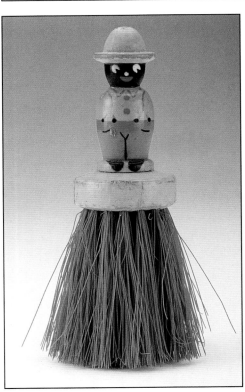

7.75" tall with plastic bristles. $50.

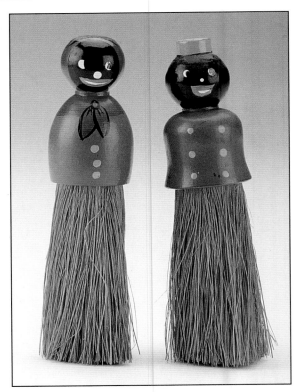

Matched pair: Porter and Mammy. About 5.5" tall with light green natural bristles. $50 each.

## Buttons, Pinbacks, and Mirrors

R.F. Outcault created The Yellow Kid, the first successful comic strip character to be featured in American newspapers. Introduced in *Truth* magazine in 1894 and then featured in *The New York World* newspaper beginning in 1895, The Yellow Kid was so popular he is credited for augmenting newspaper sales and spawning an early example of pop culture.

Cigarettes and chewing gum companies started including The Yellow Kid pinbacks with a purchase of their products and a marketing technique was realized in the late 1890s. It wasn't until circa 1910 that pinbacks were again offered with cigarette purchases, and for a second time comic strip characters were featured, Mutt and Jeff, Katzenjammer Kids, and more, on celluloid pins in black and white and in color.

The use of button pinbacks as political advertising began in the late 1920s, and the rest is history as more applications of this simple item followed.

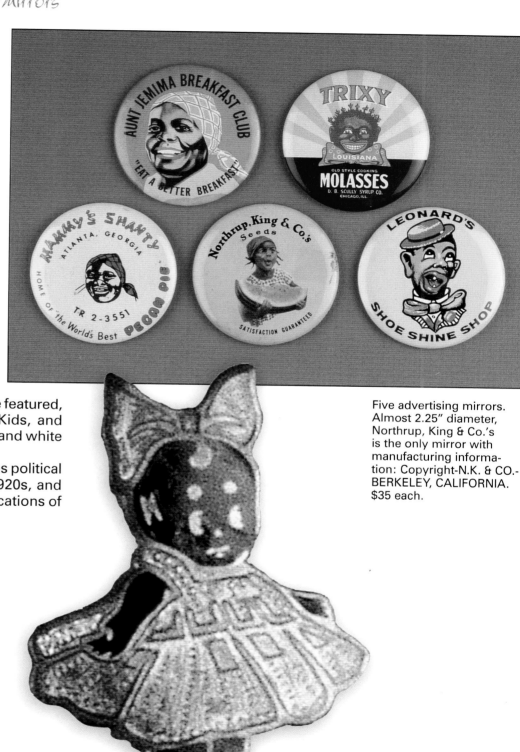

Five advertising mirrors. Almost 2.25" diameter, Northrup, King & Co.'s is the only mirror with manufacturing information: Copyright-N.K. & CO.-BERKELEY, CALIFORNIA. $35 each.

1" tall dressed Kewpie pin. $20.

Aunt Jemima buttons and pin back. All metal. ***Top left:*** Breakfast Club Pin: 2.25" long, ADCRAFTMFG. CO.CHICAGO LITHOGRAPHERS OF AMERICA. $15. ***Bottom left:*** Breakfast Club Mirror (not a pin back): almost 2.25" diameter, no manufacturer's information. $35. ***Middle:*** Breakfast Club Pin: 4" diameter, GREEN DUCK CO. CHICAGO. $20. ***Right:*** Pancake Club Pin: 3" diameter; ADCRAFTMFG. CO.CHICAGO. $10.

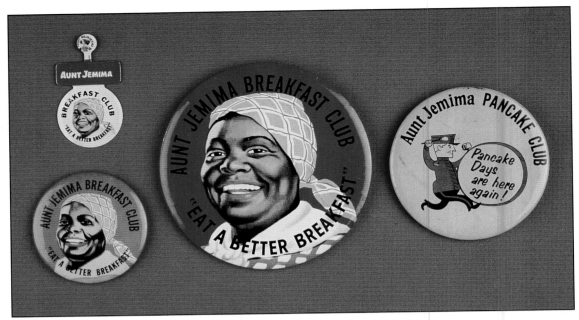

***Top row, left to right:*** 60th CHIZZLE WIZZLE MARCH 13, 14, 16, 1951, 1.5" diameter; DON'T YOU LOVE ME NO MO?, almost 1" diameter, advertisement or premium for Hassan Cigarettes; I RAISE YOU, almost 1" diameter, advertisement or premium for Hassan Cigarettes. $18 each. ***Bottom row, left to right:*** FOR PRESIDENT 1988 JESSE L. JACKSON, 2.25" diameter; JESSE JACKSON. For PRESIDENT, 2.5" diameter, $5 each; TRIXY MOLASSES, 2.25" diameter; $15.

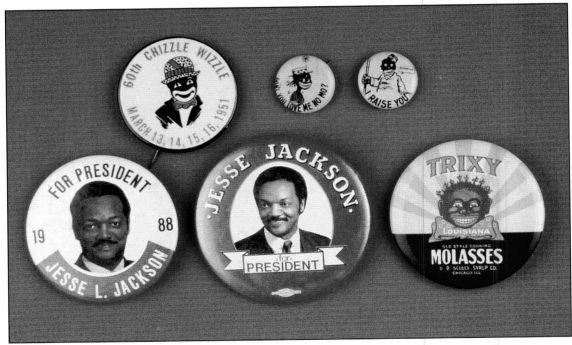

TRIXY LOUISIANA OLD STYLE COOKING MOLASSES D.B. SCULLY SYRUP CO. CHICAGO, ILL. No manufacturer's information on any of these items. ***Left:*** almost 2.25" diameter mirror. $35. ***Middle:*** 3.5" diameter pinback. $20. ***Right:*** almost 2.25" diameter pinback. $20.

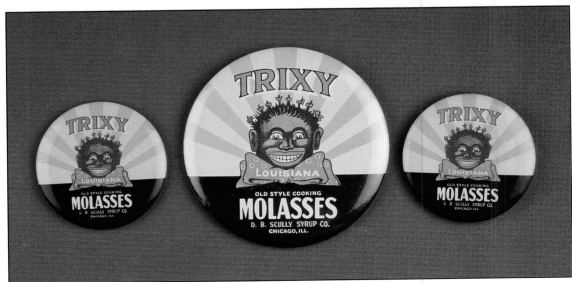

# Clocks and Watches

It is important to note that Westclock made no African-Americana clocks, so any that you might find are carefully contrived forgeries. There is some question regarding the age and legitimacy of any of these clocks. It is known that with the right skills plain clocks can be transformed into themed ones. The timepieces presented here were all acquired prior to 1995, but there is no other information beyond this. As authenticity is an issue, no values are provided. Whether decades old or newly created these clocks and pocket watches are still interesting.

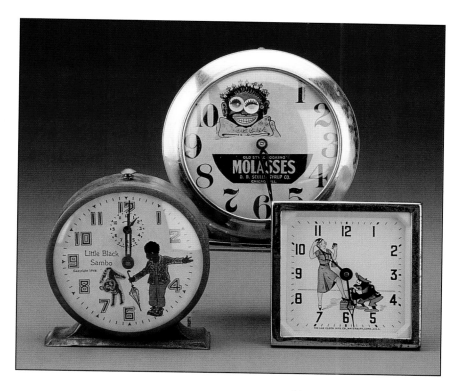

*Above:*
**Left:** "Little Black Sambo." Ingram clock Made in Bristol, Connecticut. Face 4" across, 4.5" tall, copyright 1946 on face. **Middle/back:** "Old Style Cooking Molasses" D.B. Schully Syrup Company Chicago, Illinois, 5.5" across, 5.75" tall, Made in U.S.A., tin case. **Right:** Shoeshine caricature 3.75" square; "THE LUX CLOCK MFG. CO., WATERBURY CONN., U.S.A.," chrome case.

Four clocks. **Back:** "LITTLE BLACK SAMBO" with eight lines of verse, 4.25" across, 4.75" tall, Made in U.S.A., tin case. **Left:** "THE FOUNTAIN OF YOUTH." 4.25" across, 6" tall to top of handle, Robertshaw Controls Company Lux Time Division Lebanon, Tenn., U.S.A., copper Case. **Middle front:** Girl on Chamber Pot. 3.75" across, 4" tall, no manufacturer's information, plastic and tin case with a Bakelite foot. **Right:** "THE FOUNTAIN OF YOUTH. 4.25" across, 6" tall to top of handle, Robertshaw Controls Company Lux Time Division Lebanon, Tenn., U.S.A., tin case.

35

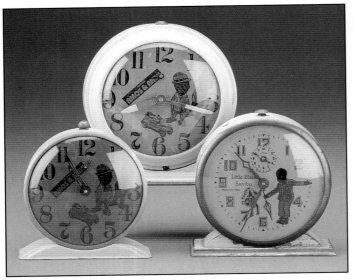

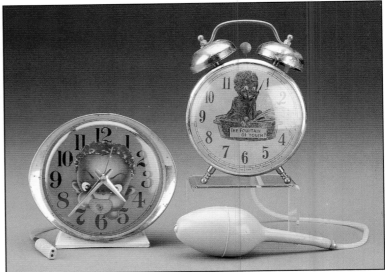

*Left:* "STARRING AMOS AND ANDY." 4.25" across, 4.5" tall, no manufacturer's information, tin case. *Middle/back:* "STARRING AMOS AND ANDY." 5.5" across, 6" tall, no manufacturer's information, tin case. *Right:* "Little Black Sambo" 4.5" across, 5" tall, copyright 1946, tin case.

Two clocks with rubber tubes that add whimsy to each. *Left:* Boy's Face. 5" across, 5" tall, no manufacturer's information. Exhale cigarette smoke into the tube and the smoke will come out through his mouth. *Right:* "THE FOUNTAIN OF YOUTH." 4.25" across, 6" tall to top of handle, Robertshaw Controls Company Lux Time Division Lebanon, Tenn., U.S.A. Place water into the rubber ball, squeeze, and water is sprayed into the face of the individual looking at the clock as the end of the tube is in the alarm bell, tin case.

"LITTLE BLACK SAMBO" wall clock. 8.5" diameter, no manufacturer's information, eight lines of verse on the face, tin case.

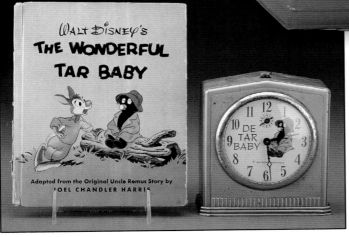

"DE TAR BABY." 5.25" across, 6" tall, c. Walt Disney Productions on face, from the book "The Wonderful Tar Baby," tin case.

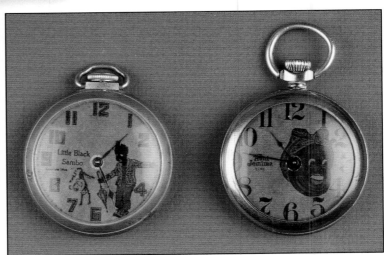

Pocket watches. *Left:* Little Black Sambo: 2" diameter, copyright 1946 on face. *Right:* Aunt Jemima: 2" diameter, no manufacturer's information.

## Coconuts

Coconuts are still being used to craft adorable items and tourist souvenirs. Coconut trees are a versatile plant providing food, clothing, and shelter to those in tropical areas. The three items pictured here are probably not old, but they represent the use of coconuts to create human images.

Purse. 5" tall; no manufacturer's information, lid is hinged and is secured with an elastic band that loops on the button nose; the inside is lined. $10.

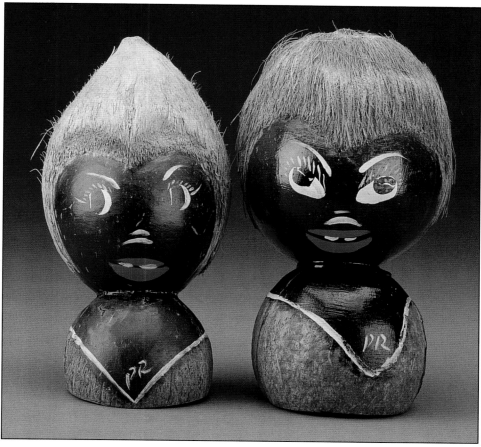

Gal and Guy. 10" tall.
Signed "PR." $8 each.

# Cookie Jars, Candy and Biscuit Jars

Cookie jars have their roots in biscuit jars, first used in England at the end of the 1700s. Used in shops to keep wares fresh, these jars had glass bases and lift-off metal lids. These canister-shaped containers were not used in the United States until 1929 and continued to have glass bases but with metal screw-off lids.

The first American-made cookie jars were created in the 1930s from stoneware, a material already utilized for crocks and jugs. Brush Pottery Company of Zanesville, Ohio, created the first ceramic cookie jars which were marked "Brush U.S.A." The cylindrical form was maintained with leaves or flowers painted onto the base, but soon various styles and forms were introduced, and by the end of the 1930s cookie jars were shaped like animals, people, fruit, and vegetables. Other American companies began to participate in creating these popular containers with the 1940s-1970s as the peak time of production.

McCoy produced the first-ever mammy cookie jar around 1939 and the presentation which follows shows this jar and provides a glimpse of some of the many mammy versions that were created, as once something is popular, competition surely follows. It is interesting to note that in the course of ten years Americans went from no cookie jars of any kind to the figural mammy that initiated a huge surge in the popularity of cookie jars and launched them into becoming a collectible enjoyed for decades.

After World War II plastic became the "modern" material and two mammies from this era are featured. They were premiums that one would have acquired through the purchase of Aunt Jemima products. Although they are more recent than some of the pottery cookie jars they are difficult to find perhaps because they aren't particularly durable.

A single biscuit jar is shown. The difference between a cookie jar and a modern biscuit jar is that a biscuit jar has a handle and a flat lid while a cookie jar has no handle and the lid is usually part of the shape or design of the jar. Biscuit jars remain true to their roots with a cylindrical shape.

A pair of candy jars is also pictured. They resemble a small cookie jar and if the original package hadn't been found the fact that it was actually sold with candy inside might have been lost.

Mammy. 11" tall, embossed on base: "McCoy." This was the original mammy cookie jar, pottery. $350.

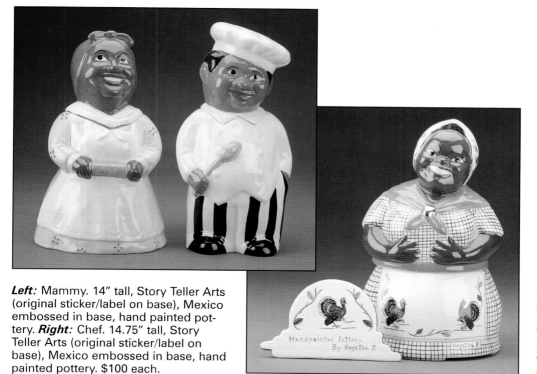

*Left:* Mammy. 14" tall, Story Teller Arts (original sticker/label on base), Mexico embossed in base, hand painted pottery. *Right:* Chef. 14.75" tall, Story Teller Arts (original sticker/label on base), Mexico embossed in base, hand painted pottery. $100 each.

Mammy. 11.5" tall, base stamped in black: "Erwin Pottery Hand Painted Erwin, Tenn.," pottery. Sign: 6.5" long, 4" tall, Handpainted Pottery By Negatha R., pottery. Cookie jar, $150; sign, $40.

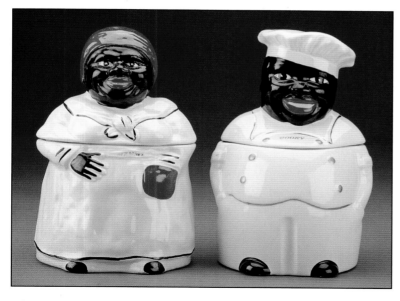

Mammy and Chef. *Left:* "MAMMY," 11" tall, base stamped in gold: "Pearl CHINA CO. HAND DECORATED 22 KT. GOLD U.S.A.," pottery. *Right:* "COOKY," 11" tall, base stamped in gold: "Pearl CHINA CO. HAND DECORATED 22 KT. GOLD U.S.A.," pottery. $350 each.

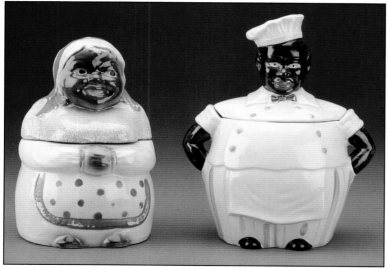

Mammy and Chef. *Left:* 9.75" tall, no manufacturer's information, pottery. $350. *Right:* 11" tall, base stamped in black "MADE IN JAPAN," pottery. $750.

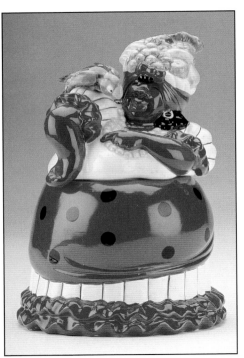

Spice. 13.5" tall, embossed "Treasure Craft, USA" under head along rim, pottery. A matching white girl was made and her name is "Sugar." $125.

Rio Rita. 11.75" tall, base embossed: "cFF"; original sticker/label on base: "FITZ and FLOYD RED LACQUER Hand-painted Surface HAND WASH ONLY WITH SPONGE, DO NOT SCRUB TAIWAN FF." $200.

Santa Claus. 13" tall, bottom stamped in black: "alacarte JCPenney styles for the home," pottery. $75.

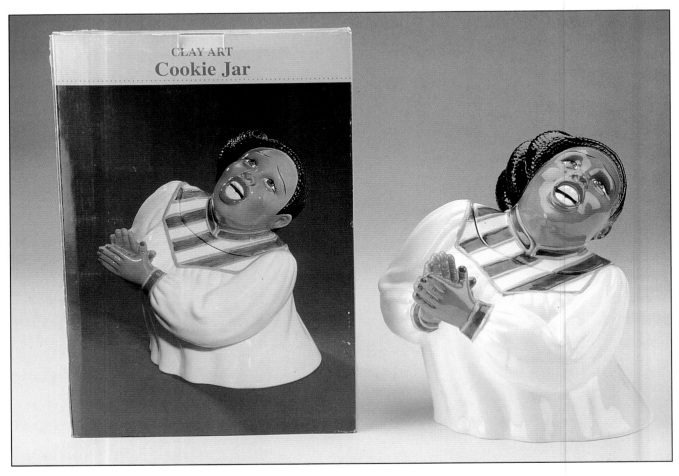

Amazing Grace (#8830). 11" tall, Clay Art circa 1995, pottery. $40; box, $10.

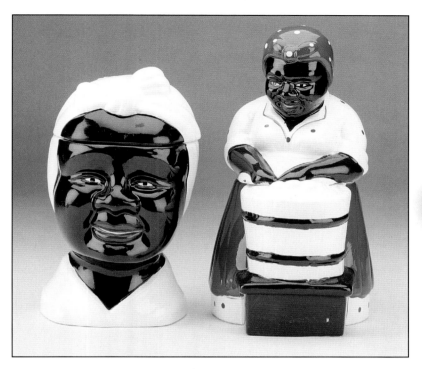

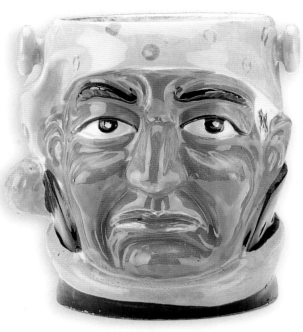

Mammy head and washerwoman. Mammy head: 10" tall, no manufacturer's information. This was found in the original box marked: "ITEM NO. P2029-13 Q'TY: 1 PC MADE IN TAIWAN," pottery. Washerwoman: 11.5" tall, no manufacturer's information, pottery. $75 each.

Biscuit jar: Man's Head. 4.5" diameter, 6" tall, base stamped in black: C in a circle followed by HK, missing lid and reed handle. $125 if complete.

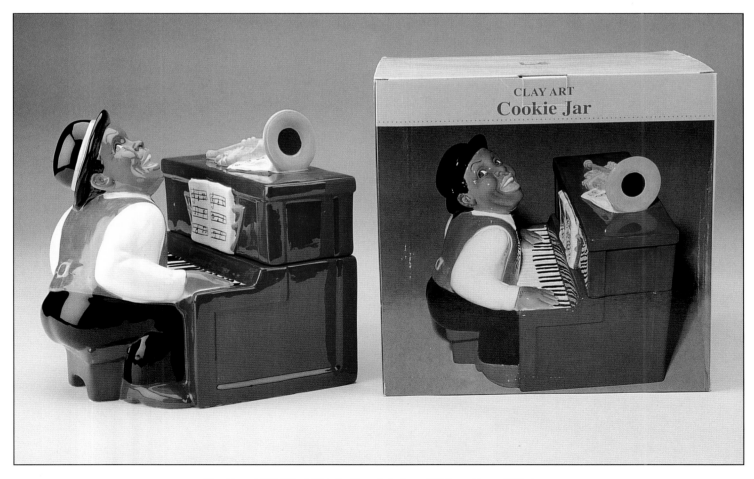

Ragtime (#8832). 11" tall, Clay Art circa 1995, pottery. $40; box, $10.

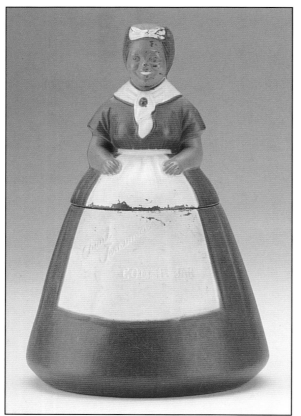

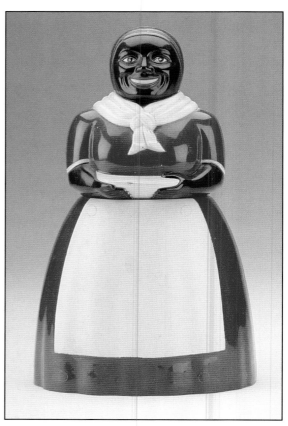

Mammy. 10.75" tall, no manufacturer's information, "Aunt Jemima's COOKIE JAR" on her apron, soft plastic. $300.

Mammy. 12" tall, bottom marked: "AUNT JEMIMA F & F TOOL & DIE WORKS DAYTON, OHIO MADE IN U.S.A.," hard plastic. $200.

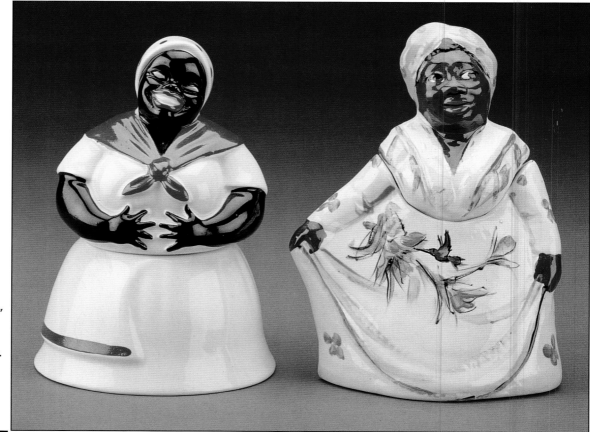

Two Mammies. *Left:* 8" tall, bottom embossed: "DES. PAT. APPLIED FOR," pottery. *Right:* 8.25" tall, back signed: "Rick Wise-carver NO-78-90," pottery. $150 each.

## Creamers and Sugars

Florence Kate Upton (1873-1922) was born in New York to British immigrant parents. Her father passed away in 1889 and financial struggles caused the family to return to England. Florence was residing with her grandmother when she decided to write a children's story. Upon investigating the attic she located five wooden German dolls and she named two Peg and Sarah Jane, and one African-American doll which she named "Golliwogg," (note the use of the double "g") and the main characters of her story were identified. Florence's mother, Bertha, wrote the story that Florence brought to life with her illustrations. It is worth noting that "wog" is British slang for "a person of color, especially a person from northern Africa or western or southern Asia." (http://www.answers.com/topic/wog)

The first book, *The Adventures of Two Dutch Dolls*, was published in 1895 and by the early 1900s Golliwog toys followed. As Florence had not patented her creation some manufacturers simply dropped one "g" and began creating soft toys and more. The Teddy Bear was invented in 1903 so there were two new toys for children and in England both Golliwogs and Teddy Bears became staples until the 1960s. Other authors incorporated Golliwog characters, but unlike Florence Upton's Golliwogg's lovable disposition these often possessed negative personalities and characteristics.

After Golliwogs were removed from stores and shelves many vintage items were destroyed in an attempt to purge the negative stereotypes that had been promoted.

A Golliwog is shown on the middle creamer in the grouping at the top of the page.

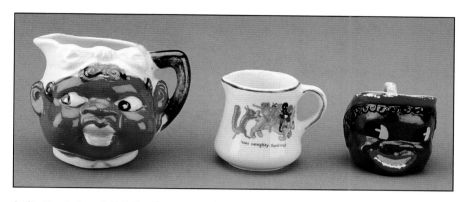

**Left:** Man's head. 2.75" tall at spout, base stamped in black "HAND PAINTED JAPAN," china with cold painted details. $50. **Middle:** "You naughty Squirrel" with Golliwog and other nursery toys, 2" tall at spout; base marked "CORO-NAWARE S. HANDCOCK & SONS STONE-ON-TRENT ENGLAND," pottery. $65. **Right:** Man's head. 2" tall at spout, no manufacturer's information, presumed to be made in Japan. $35.

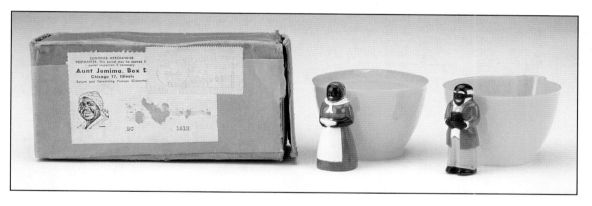

Aunt Jemima and Uncle Mose creamer and sugar. Lid: 3" diameter, bases: 3" diameter, 2" deep, figures: 2.25" tall, bottoms marked: "F & F MOLD & DIE WORKS, INC. DAYTON, OHIO MADE IN U.S.A. "These were a premium through Aunt Jemima Pancake Mix, plastic. Set, $150; original mailer box dated 1953, $25.

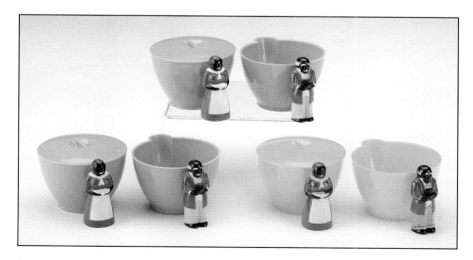

Aunt Jemima and Uncle Mose creamers and sugars. Lids: 3" diameter, bases: 3" diameter, 2" deep, figures: 2.25" tall, bottoms marked: "F & F MOLD & DIE WORKS, INC. DAYTON, OHIO MADE IN U.S.A." These were a premium through Aunt Jemima Pancake Mix, plastic. Shown are the only colors in which these were manufactured. Values for each set: yellow: $150; blue: $300; green, $450.

## Cruets and Condiment Jars

The word "cruet" comes from the French language but is derived from a Germanic word for flask. Used for oil and vinegar, two ancient liquids, locating a history of these vessels was fruitless. The first stands for cruets were introduced circa 1720 and were made in pewter.

Cruets have been made from wood, metal, glass, pottery, china, and crystal. Shown here are pottery and china examples with figural mammies and chefs; none are easily found. Certainly Mother needed salt and pepper shakers so these are abundant, but utilizing oil and vinegar cruets would have been more elegant than many homemakers cared to be.

A condiment is "an aromatic mixture, such as pickles, chutney, and some sauces and relishes, that accompanies food" (www.glutenfreeda.com/glossary.asp) and shown here are two decorative approaches to one's presentation. Although a rather obscure piece of kitchenware, the condiment jar is a part of several well known producers of glass and pottery such as Princess House's glassware and Holt-Howard's Pixieware. In comparison to the hundreds of unique salt and pepper shaker designs and styles, African-American condiment jars are few and far between.

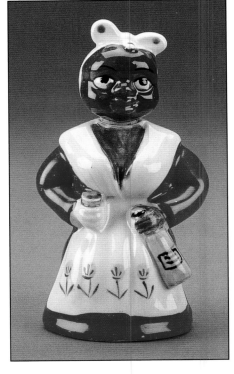

Mammy. 7.25" tall, no manufacturer's information, known to be made in Japan, china with cork at the neck. $200.

Chef. 3.5" tall, bottom stamped in black: HAND PAINTED JAPAN, china with cold painted details. $120.

Chef. 4.5" tall, no manufacturer's information, presumed to be made in Japan. China with cold painted details. Three pieces: head (lid), body (base), tongue (serving spoon). $150.

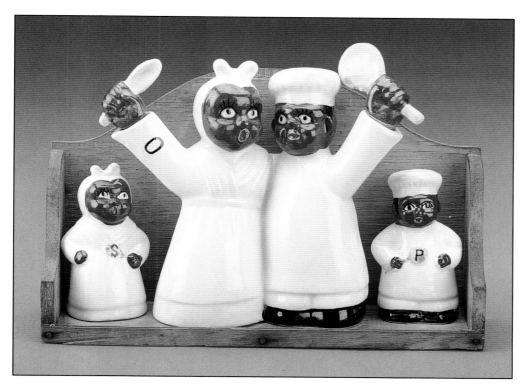

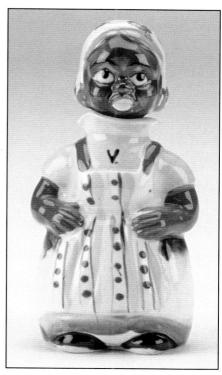

Mammy and Chef Set. Wooden rack: 8.5" wide, 2.25" deep, 5" tall, no manufacturer's information. Cruet (Oil and Vinegar are one piece): 5.5" tall, no manufacturer's information. Remove elevated hand with spoon in order to dispense the liquid. Shakers: 3" tall, no manufacturer's information. Set: $125.

Vinegar Bottle. 5.25" tall, black marks on bottom impossible to read. Obviously there should be an oil bottle and one could reasonably assume it would be a man/chef. $65.

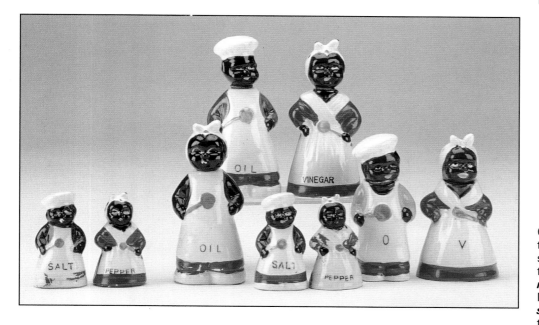

Chefs and Mammies. All items in this grouping are china with bases stamped in black "JAPAN" except for the cruet set on the far right. **Back row:** Cruets: Chef (Oil), 5.75" tall, Mammy (VINEGAR), 5.5" tall. **Far left, small shaker set:** Chef (Salt), 3.25" tall, Mammy (PEPPER), 3.25" tall. **Left of center:** Cruet: Chef base, Mammy head (OIL), 5.25" tall (as a "marriage" of pieces, this has a value of $40). **Small set second from right:** Chef (SALT), 3.25" tall, Mammy (Pepper), 3.25" tall. **Far right:** Cruets: Chef (O for Oil), 5" tall, Mammy (V for Vinegar), 5" tall. The Chef oil cruet on the far right has the more commonly-seen color on the Chef's sleeves, a pale blue, while the other chefs feature an elusive teal color. This Chef and the matching Mammy have initials for oil and vinegar, a less common style. Although the color is more common, the use of O and V make this as valuable as the teal counterparts. This set has original stickers/labels on the bases of each that read: "G in a triangle, NOV.C. JAPAN." Tall cruets, $100 each. Small shakers, $25 each if perfect.

# Fans

As long as there has been heat there have been fans, but the earliest advertising fan is from 1880 and comes from France. As printing techniques improved and became less expensive, advertising fans came into use in a big way. Earliest fans were decorated on both sides allowing the message to be seen by the user of the fan and those in his/her company.

Most American vintage advertising fans are from the south, and obviously this relates to the climate. Stores, undertakers, and politicians utilized this form of advertising the most, and usually the format or design was as those pictured here: cardboard with a wooden handle. American artwork tended to be straight forward, while French fans from the same period were lovely works of art that also utilized folds and gathers.

7.5" x 11.5", Harley J. Scott Co., Kansas City, MO., photography by A. Scheer, advertisement for "Lee's Cut Rate Store, Mrs. T.D. Lee, owner; Phone 5, Dawson, Ga.," cardboard with a wooden handle. $10.

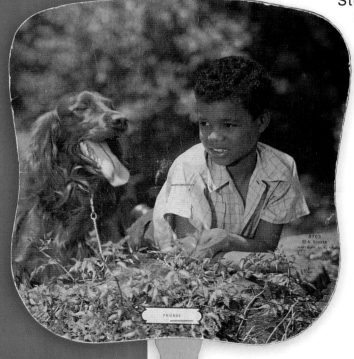

7.5" x 11.75", "FRIENDS," no manufacturer's information, advertisement for "South Miami Drug Store 6806 S.W. 59th Place, South Miami, Fla.," cardboard with a wooden handle. $10.

# Figurines

Every ancient civilization has left a legacy of objects that archeologists continue to discover and interpret, but one thing seems consistent: as soon as ancient man was able to work with tools he was creating figurines. European treasures from 25,000-35,000 years ago have been unearthed, and these may be the earliest figurines known.

Figurines thought to be from about 7,500 BC and mainly of women have been found in the Near East. About 4000–3500 BC, the early inhabitants of Ecuador are known to have created male and female figures carved in stone. Circa 3000 BC, the first ceramic figures — made of clay and fired — were produced in this region. It is believed that many of the earliest renderings were fertility idols.

The Chinese invented hard paste porcelain from kaolin, a pure white clay, and petuntse, a type of feldspar in 618 AD. When mixed and baked at temperatures higher than 2200 degrees Fahrenheit, the result is porcelain. A heritage of beautiful porcelain objects and works of art had begun.

In the 1500s artists in Italy developed a formula for Majolica and artisans in Spain were working with various fired materials, but nothing was as reliable or lovely as the Chinese porcelain.

Augustus the Strong of Saxony (1694-1733) discovered this Chinese formula and commissioned porcelain vases, dinnerware, sculptures, and figurines. One of the most prolific artists of this era was Johann Kändler; about one thousand works of art have been attributed to him.

The rest is history. Different schools of art were developed through the decades that followed and porcelain creations reflected these movements. Different techniques were attempted and utilized such as Dresden artists dipping real lace in porcelain before the firing process.

The figurines shown here represent a variety of materials. Modern man has come a long way from needing fertility idols but we still seem to experience pleasure from the human form. As discussed in the Introduction, a number of the images pictured here have exaggerated features and rely on negative stereotypes while a few are realistic. Some figurines are made of "bisque," unglazed porcelain.

Seated man. 4" tall, no manufacturer's information, presumed to be made in Germany. Unusual details such as a monocle, gold buttons, and a pink necktie are evident, bisque china. $175.

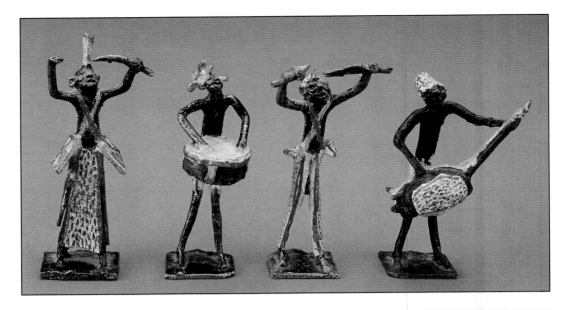

Musicians. **Left:** 5" tall. **Second from left:** hand crafted, 4.5" tall. **Second from right:** 5" tall. **Right:** 4.5" tall. Hand crafted metal with hand painted details. $50 each.

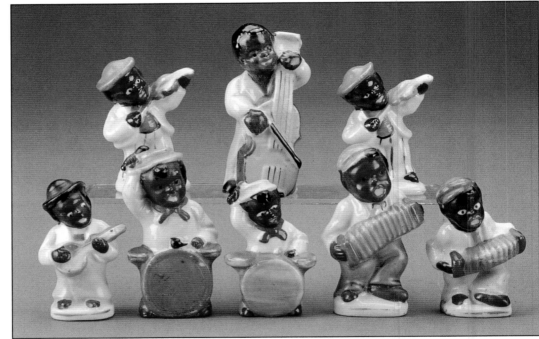

Musicians. **Back row, left to right:** 3" tall violinist marked "MADE IN OCCUPIED JAPAN"; 3.75" bass fiddler marked "JAPAN"; 3" tall violinist marked "MADE IN OCCUPIED JAPAN." **Front row, left to right:** 2.75" tall banjo player marked "MADE IN OCCUPIED JAPAN"; 3.5" tall drummer marked "MADE IN OCCUPIED JAPAN"; 2.75" tall drummer marked "MADE IN OCCUPIED JAPAN"; 3.5" tall accordion player marked "MADE IN OCCUPIED JAPAN"; 2.75" tall accordion player marked "MADE IN OCCUPIED JAPAN." All china with cold painted details. $15 each.

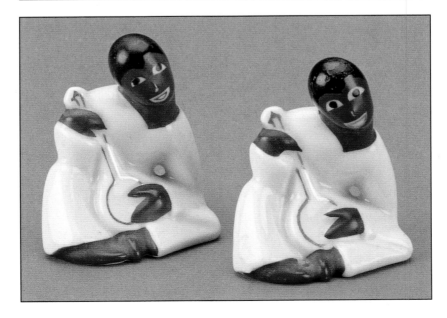

Banjo players. 2" wide, 2" tall, bases stamped in turquoise "MADE IN JAPAN." Modernistic-stylized musicians are made of china with cold painted details. $15 each.

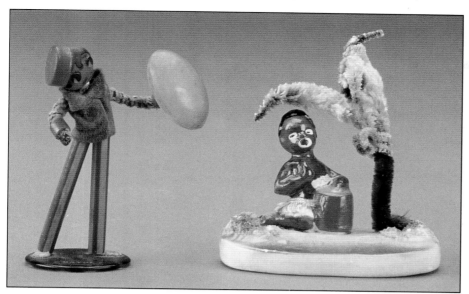

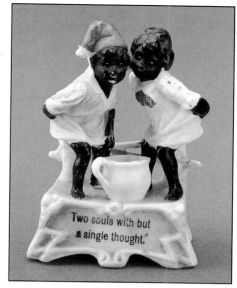

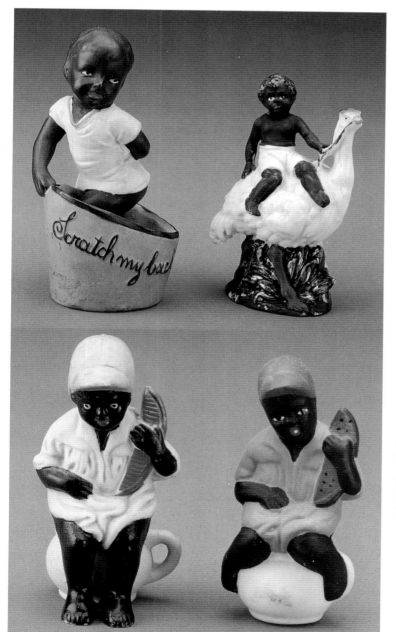

Two boys. *Left:* Scratch my back: 5.5" tall, stamped in black "MADE IN GERMANY," bisque china. $250. *Right:* Boy on ostrich: 4.5" tall; no manufacturer's information, presumed to be made in Germany, bisque china. $175.

*Above, left:*
Figures made using chenille and other materials. *Left:* Waiter: 3.5" tall, base marked "DAVOL." Plastics, celluloid, rubber, and chenille are utilized to create this flexible server. $50. *Right:* Native at the water's edge: 3.5" wide, 3.5" tall, Empress, (original sticker/label on base), Japan. China with cold painted details and chenille. $20.

*Above, right:*
"Two souls with but a single thought." 2.25" wide, 3.25" tall, stamped in orange "MADE IN GERMANY," embossed on bottom: "5706 0," bisque china. $250.

Boys on chamber pots with watermelons. *Left:* 4" tall, base stamped in red "MADE IN JAPAN," bisque china. $40. *Right:* 3.75" tall, no manufacturer's information, presumed to be made in Japan. $25.

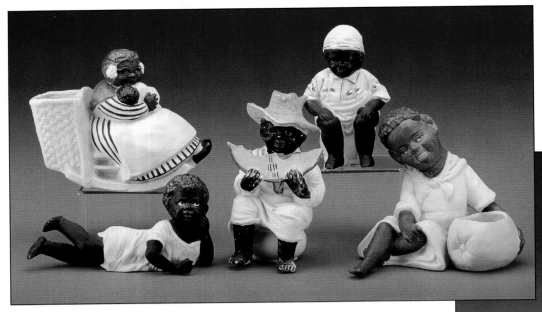

*Below:*
Accordion player. 6" wide, 8.25" tall, no manufacturer's information, presumed to be made in Germany, bisque china. $250.

Five bisque figures, all presumed to be made in Germany. *Back left:* Mammy with infant: 4.5" wide, 4.5" tall, no manufacturer's information. *Back right:* Boy on chamber pot: 4.25" tall; "85" embossed on back. *Front left:* Reclining child: 5" long, 2.5" tall, no manufacturer's information. *Front middle:* Boy sitting on chamber pot with watermelon: 2.75" wide, 3" tall, "R236" embossed on bottom. *Front right:* Girl with watermelon: 5" wide, 4.25" tall, no manufacturer's information. $250 each.

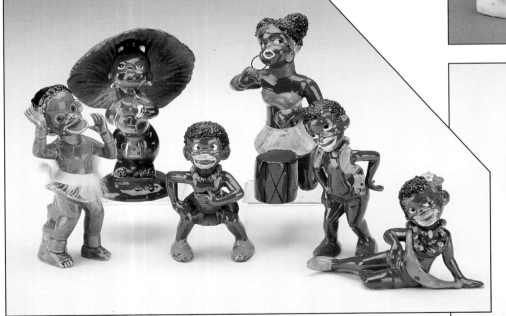

Six natives. *Back left:* 5" tall, bottom embossed: "Josef Originals," original sticker/label on back: "Joseph Originals California," china. $30. *Back right:* 5.25" tall, original sticker/label: "HAND PAINTED ROYAL JAPAN," china with metal and cold painted details. $18. *Front left:* 4" tall, no manufacturer's information, known to be made in Japan, china with cold painted details and glass beads. $18. *Front second from left:* Bottom lip protrudes .25", 5.25" tall, no manufacturer's information, known to be made in Japan, china with cold painted details and fur. $18. *Front second from right:* 4.75" tall, bottom stamped in black "JAPAN," redware. $18. *Front right:* 4.75" long, 3.25" tall, bottom stamped in black "MADE IN JAPAN," redware. $18.

Island Native. 4.25" tall, no manufacturer's information, wood and mixed materials. $10.

Boys shooting craps. 5.5" long, 3.75" tall, original sticker/label on bottoms: "California Creations by Bradley JAPAN." Figures: redware with cold painted details, dice: Bakelite. $150 for the set.

"Little Rascal." Base: 7" x 5.5", 7.5" tall, bottom marked: "nature craft Est 1931 Ref No 855 Little Rascal All des. Reg c l 38 c s," pottery. $100.

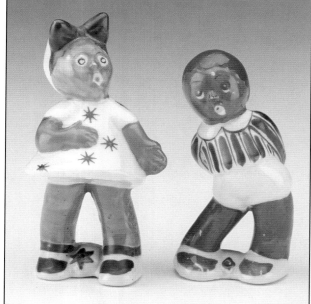

Two children. **Left:** 5" tall, bottom stamped in black "MADE IN OCCUPIED JAPAN." **Right:** 4.25" tall, bottom stamped in black "MADE IN OCCUPIED JAPAN." Both are china with cold painted details. $25 each.

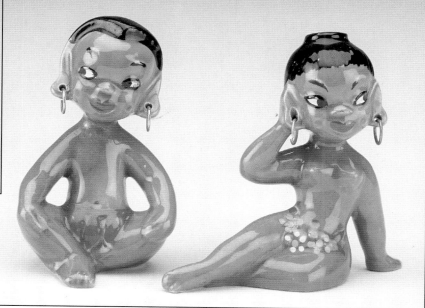

Two natives. **Left:** 3.5" tall, embossed C in a circle on bottom. **Right:** 3.5" tall, no manufacturer's information, china with wire earrings. Known to be Gilmer Pottery, California from the "Happy Cannibal" series, circa 1950. $18 each.

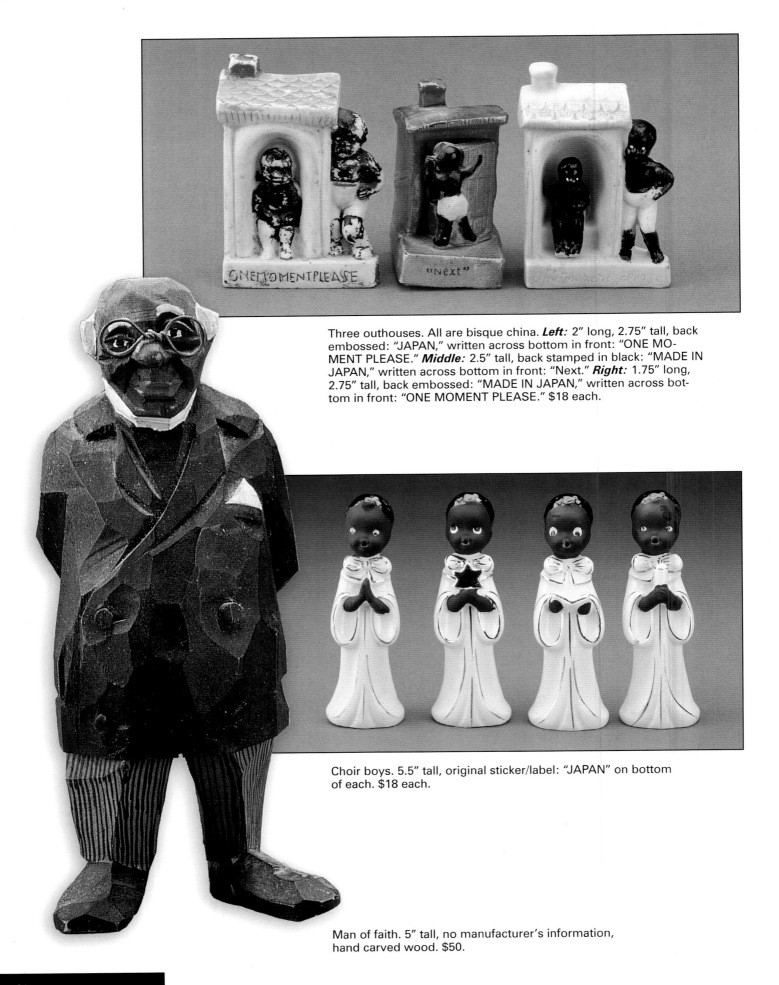

Three outhouses. All are bisque china. **Left:** 2" long, 2.75" tall, back embossed: "JAPAN," written across bottom in front: "ONE MO-MENT PLEASE." **Middle:** 2.5" tall, back stamped in black: "MADE IN JAPAN," written across bottom in front: "Next." **Right:** 1.75" long, 2.75" tall, back embossed: "MADE IN JAPAN," written across bottom in front: "ONE MOMENT PLEASE." $18 each.

Choir boys. 5.5" tall, original sticker/label: "JAPAN" on bottom of each. $18 each.

Man of faith. 5" tall, no manufacturer's information, hand carved wood. $50.

Boy with dice. Base: 2.5" x 1", 1.75" tall, base embossed: "JAPAN PATENT." Figure: plastic; base and dice: Bakelite. $75.

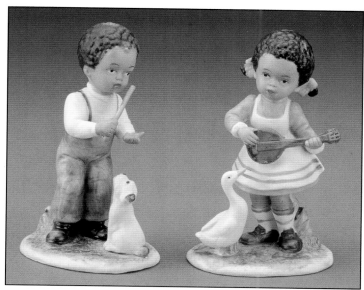

Boy with dog and girl with goose. Both just over 5" tall, bottom stamped in black: "1432" with an o in crossed sabers, original sticker/label on each: "HOMCO MADE IN TAIWAN." Originally sold as a pair, bisque china. $12 each.

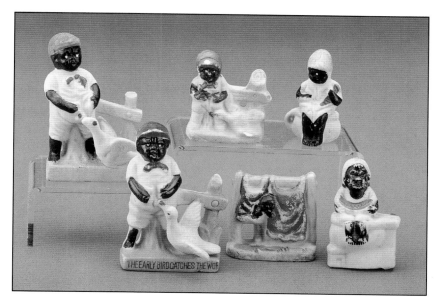

Six bisque boys. **Back left:** 2.75" tall, back is embossed "JAPAN," base has original sticker/label: "BALD EAGLE LOOKOUT SEE 75 MILES" (a central Pennsylvania location). Across the front is embossed: "THE EARLY BIRD CATCHES THE WORM." **Back middle:** 1.75" tall, bottom stamped in black "JAPAN." **Back right:** 2" tall, no manufacturer's information, presumed to be made in Japan. **Front left:** 3" tall, back is embossed "MADE IN JAPAN." **Front middle:** 1.75" tall, no manufacturer's information, presumed to be made in Japan. **Front right:** 2.25" tall, embossed "JAPAN" in middle of back. $18 each.

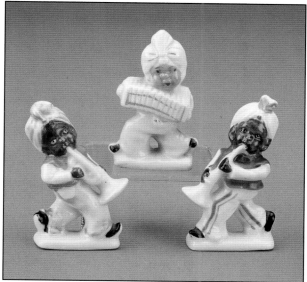

Three musicians. **Left:** 2.75" tall, bottom stamped in orange: "MADE IN OCCUPIED JAPAN." **Middle/back:** 2.75" tall, bottom stamped in black "JAPAN." **Right:** 3" tall, bottom stamped in orange: "MADE IN OCCUPIED JAPAN." $18 each.

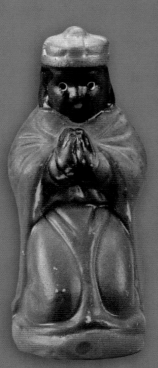

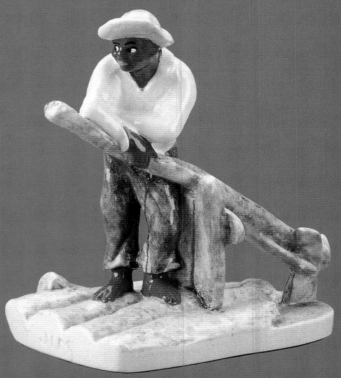

Native female. 5" tall, bottom stamped in purple "MADE IN OC-CUPIED JAPAN." Very offensive exaggeration of features, particularly the ears, lips, and feet. $40.

Wise man from crèche set. 3" tall, no manufacturer's informa-tion, bisque china with cold painted details. $10.

"Jim" on a raft. Character from Mark Twain's "Huck Finn," 2.75" long, 3" tall, marked "COPR 1948 P.W. BASTON." This is a "Sebastian Miniature," china. $40.

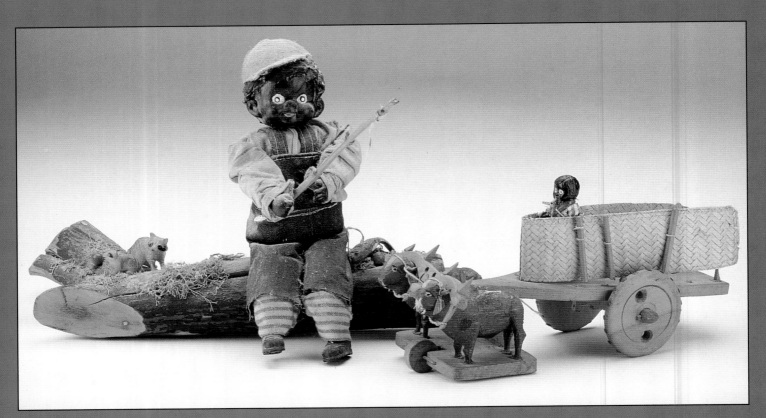

Two folk art figures. *Left:* Fisherman. Log: 13" long, man: 10" tall. *Right:* Ox Cart: 10" long, man: 3" tall. $35 each.

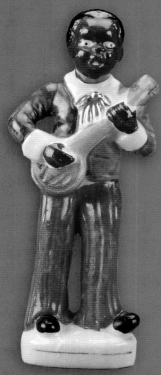

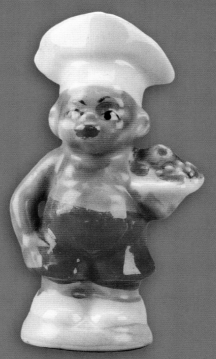

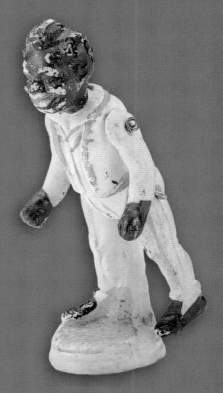

Banjo player. 5" tall, bottom stamped in black "HANDPAINT-ED JAPAN," china with cold painted details. $15.

Native in chef's hat. 3" tall, bottom stamped in red "JAPAN," china with cold painted details. $15. Note: two pairs of salt and pepper shakers are featured utilizing the same chef.

Minstrel. 3.5" tall, no manufacturer's informa-tion, hinged at arms and legs, bisque china. $45.

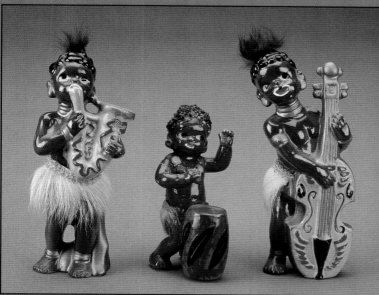

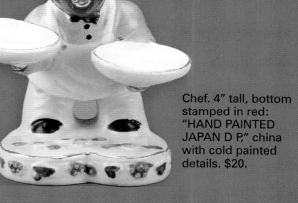

Chef. 4" tall, bottom stamped in red: "HAND PAINTED JAPAN D P," china with cold painted details. $20.

Native musicians. **Left:** Saxophone Player: 6" tall, no manufacturer's information. **Middle:** Drummer: 4.25" tall, bottom stamped in red " MADE IN JA-PAN." **Right:** Base Fiddle Player: 6.5" tall, bottom stamped in red "0L1565." All are china with cold painted details. $15 each.

Woman and man. 5" tall, no manufacturer's infor-mation, china. $20 each.

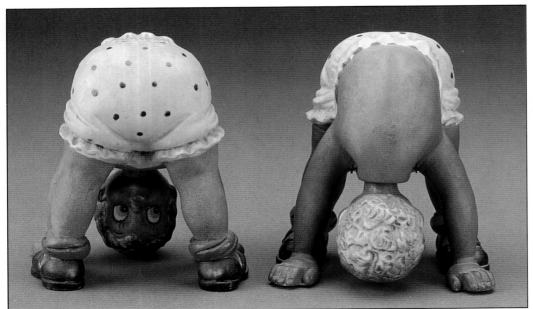

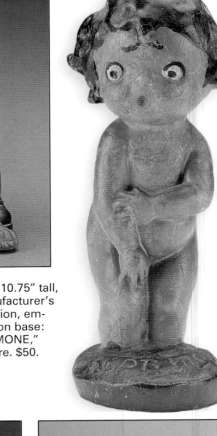

Two kids bending over. 4" wide, 5" tall, bottoms marked in several colors: "Hand Painted LENWILE CHINA ARDALT JAPAN 6529," bisque china. $85 each.

Kewpie. 10.75" tall, no manufacturer's information, embossed on base: "SEPT. MONE," chalkware. $50.

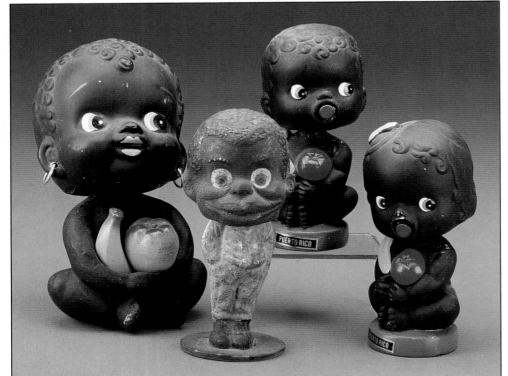

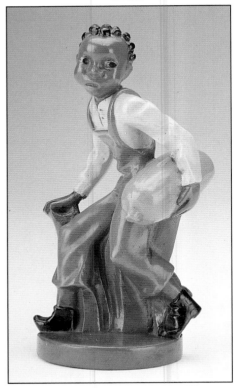

Four figures. These are not marked with manufacturer's information, but the bisque nodders are known to be products of Kenmar made from the 1940s-1955 in Japan. *Far left:* 6.75" tall, bisque china. $20. *Second from left:* 5.25" tall, composition. $125. *Second from right:* 5" tall, Souvenir from Puerto Rico. Magnet in mouth allows him to "kiss" girl on far right, bisque china. $12. *Far right:* 5" tall, Souvenir from Puerto Rico. Magnet in mouth allows her to "kiss" boy second from right, bisque china. $12.

Boy with watermelon. 8" tall, no manufacturer's information, chalkware. $50.

## Grocery Reminder Boards and Memo Boards

Grocery reminder boards were designed to assist Mother in organizing her needs when preparing to go to the grocery store. Typically there are wooden pegs to place by an item in need and the boards are wood.

Memo boards offered a simple solution to needing a pencil and a piece of paper to write a note. Most of these were mammies holding an adding machine tape as the roll of note paper. A pencil was often stored in mammy's hand to represent the handle of a broom. Plastic and wood were most commonly-used for memo boards but chalkware ones can be found.

All of these items were meant to be hung in the kitchen. The colors reflect the palette of the time of their manufacture so they would match Mother's kitchen décor.

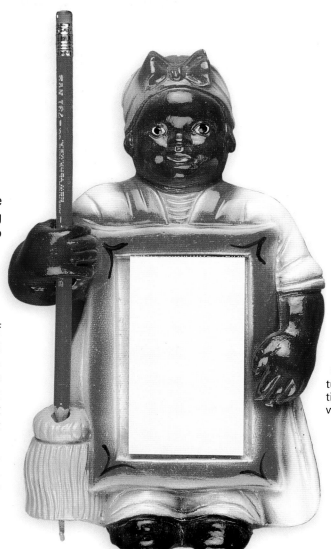

Mammy. 5.5" x 9"; no manufacturer's information, chalkware with paper. $65.

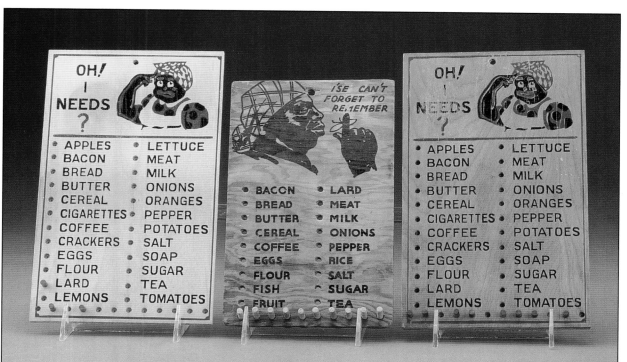

"OH! I NEEDS?" 6" X 9.75", no manufacturer's information, wood. $75 each. "I'SE CAN'T FORGET TO REMEMBER." 5.5" x 9", no manufacturer's information, elusive style, wood. $85.

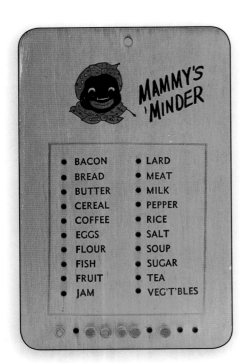

MAMMY'S MINDER. 7" x 11", no manufacturer's information, wood. $75.

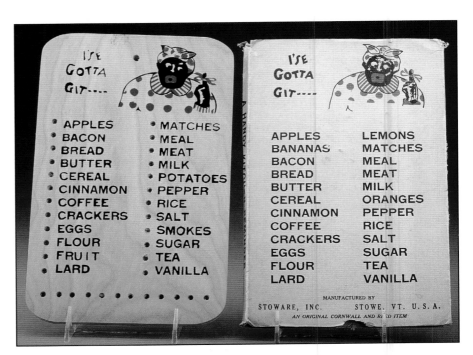

"I'SE GOTTA GIT." 7" x 11", Stoware, Inc.; Stowe, VT. The original cardboard sleeve is pictured on the right, wood. $100.

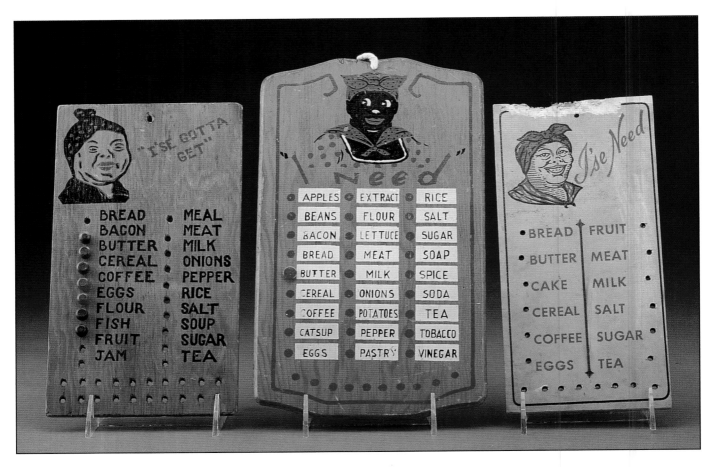

"I'SE GOTTA GET." 5.5" X 10", no manufacturer's information, elusive Mammy (she looks Asian), wood. $75. "I Need." 6.75" x 9.5", no manufacturer's information, unusual grocery board that uses thumbtacks rather than pegs, wood . $85. "I'se Need." 4.75" x 10", no manufacturer's information, mouse chewed, but interesting to see as this has few grocery items from which to select. $85 if perfect.

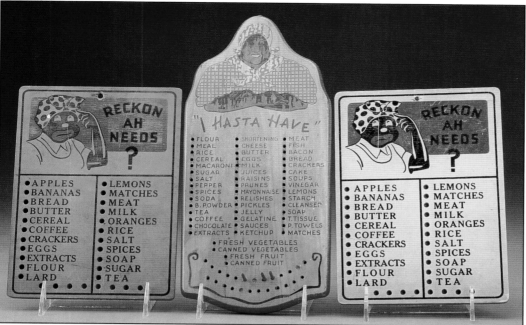

"RECKON AH NEEDS?" 6" x 8.5", no manufacturer's information, wood. $75 each. "I HASTA HAVE." 5.25" x 11.5", no manufacturer's information, extremely rare style with decorative red trim and a multi-colored Mammy. $100.

Mammy Head with Tablet. 4" x 9.5", no manufacturer's information, wood with paper. $40.

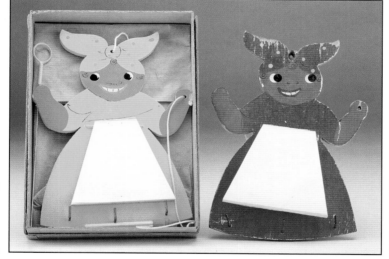

Two Mammies and an original box. 5.5" x 8", no manufacturer's information, wood with paper. Mammies, $50 each; box, $10.

Girl's head – matching set in two colors. *Left:* pink bows 6" x 10.25", no manufacturer's information, the note pad is no longer attached. $25. *Right:* green bows. 4.75" diameter circle, no manufacturer's information, this is designed to hold pot holders from the two hooks. $20.

Mammy. 5.25" x 7", no manufacturer's information, wood (paper missing). $15 as shown, $40 if complete.

Two Mammies. *Left:* green scarves and bristles. *Right:* red scarves and bristles. 5.5" x 10.25", back embossed: "MADE IN U.S.A.," marked in front: "NO. 125 MAMMY MEMO TO REFILL ASK FOR NO. 123F.," plastic with paper. $60 each.

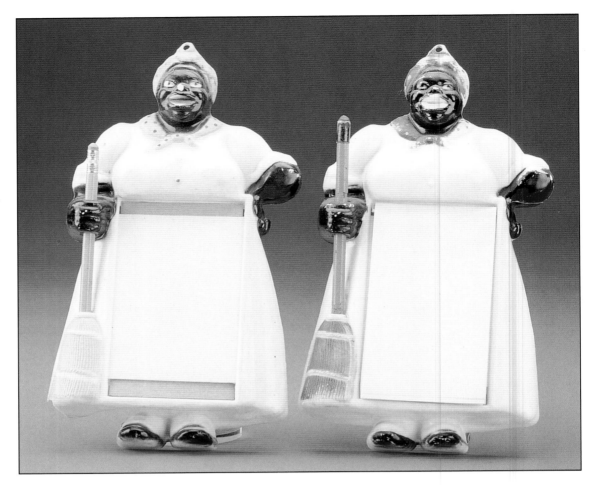

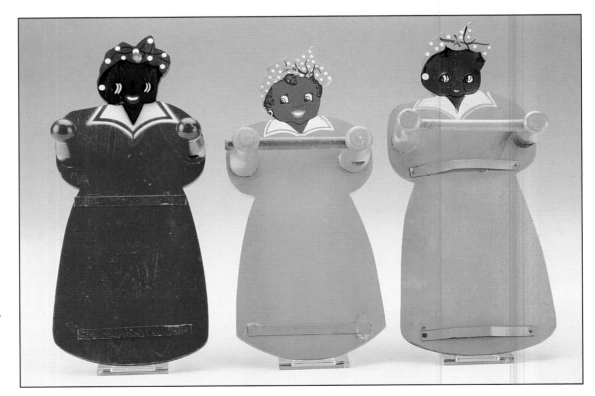

Three Wooden Mammies. *Left:* 4.25" x 10.25", original sticker/label on back: M.G. JAPAN. *Middle:* 4.25" x 9.75", no manufacturer's information. *Right:* 4.25" x 10.25", original sticker/label on back: M.G. JAPAN. $65 each.

I could find no information regarding the initial addition of a laundry room as a functioning entity in American homes. I have several books on kitchens, decorating, and trends from the early and middle twentieth century. *The Home and Its Furnishings* copyrighted in 1953 provides a table of "Wattage Required for Various Electric Appliances Used in the Home" (p. 340). The following information is included: Washing machine with spinner 375 to 1,200 and Washing machine with wringer 375 to 400. There is no entry for clothes dryers and no discussion of a laundry room. In *Better Homes & Gardens Decorating Book* copyrighted 1961 there isn't a mention of anything laundry related even in the section "Other Rooms." Laundry facilities are so important to us now that some homes are built with dual laundry rooms eliminated carrying clothes, towels, bedding, and more to different levels of the house.

The items pictured in this section are often purchased to decorate a laundry room. Grouping several old packages of detergent on a shelf creates an effective and attractive display.

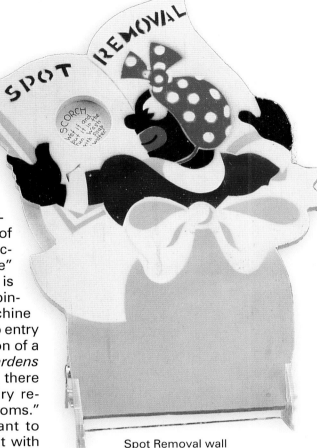

Spot Removal wall decoration for laundry room, 5" wide, 6.25" tall, no manufacturer's information, wood with cardboard circle that provides spot removal information. $75.

*Below,left:*
**Left:** 13" x 15" tall, original tag marked: "FOR SOILED HANKIES AND HOSE THERE'S A PLACE IN MY CLOTHES," fabric. $35. **Right:** 7" x 10" tall, no manufacturer's information, fabric with wooden head and feet. $35.

*Below, right:*
FUN-TO-WASH package. 2.25" x almost 5" x 7.5", The Hygienic Laboratories Inc. Buffalo, N.Y. $65.

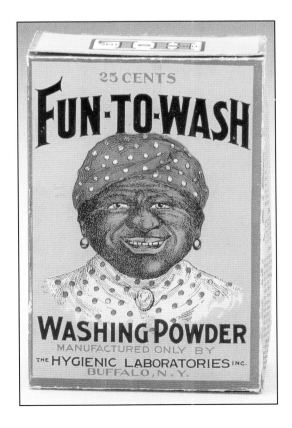

in 1893, built its first washing machine in 1907. 1911 saw the establishment of The Whirlpool Corporation and their production of electric motor-driven wringer washers.

It wasn't until the mid-1930s that washing machine technology, developed by John W. Chamberlain, led to a machine that was able to wash, rinse, and extract water from the items being cleaned. Top-loading automatic washing machines were invented by and manufactured by Whirlpool, but they still utilized wringers until 1953.

The history of drying clothes naturally began by using the sun and wind. The first US patent for a clothes pin was granted in 1832. The U.S. Patent Office granted 146 patents for clothes pin designs between 1852 and 1887.

Clothes drying technology began in Europe in the early 1800s with ventilator drums that were placed over a fire and turned by hand. One of the first dryer patents in America was filed by George T. Sampson in 1892. His invention was similar to the French and British ventilators except that it utilized the heat generated by a stove.

Electric clothes dryers were introduced in 1915, but J. Ross Moore's design of 1935 most closely resembles the turning drum that is now used in dryers. Moore was able to create a machine that was compatible with electric or gas power.

Today about 60% of all American homes have a clothes dryer. I could find no current US data for washing machine ownership, but in 1977 80% of all homes had washing machines. Currently in England 98% of all homes have washing machines.

It is ironic that this section features items for use in a laundry room as the first ones for American homes were rooms in the slave quarters that were operated by the slaves. A wonderful description of laundry rooms from an 1869 deed for Bellamy Mansion in Wilmington, NC follows:

The woodwork was painted white, and the plastered walls were eventually whitewashed. The main entrance opens into a small vestibule from which the stair rises. Flanking the vestibule are a chamber on the west end and the laundry room in the center. Both rooms have fireplaces and chimneys on the back wall. It is not known which slave occupied the first-floor chamber, though some observers speculate that it might have been Sarah, the cook, who was the most prestigious of the domestic slaves. The laundry room still contains the iron wash pot set into a brick base with a fire box for hot coals and a large fireplace. A closet for drying clothes was also warmed by the fire. Separated by a solid brick wall from the laundry room are two privies to the east. Unmentioned (and perhaps unmention-able) by Ellen in her account, these two rooms have five seats each, all with hinged wooden lids. Both are ventilated with mov-able window sash, louvered blinds, and vents up the chimney. Having such facilities in the lower story of a slave quarter was not unusual in the urban South. It is not known which household members used which room, although in general genteel women preferred the privacy of chamber pots or water closets." (www.bellamymansion.org/slave-quarters-history.htm)

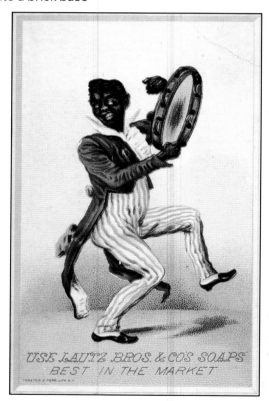

USE LAUTZ BROS. & CO'S SOAPS
BEST IN THE MARKET

J. F. Hussey, Winter-port, Maine Trade card featuring Lautz Brothers & Company's Soaps.

## Laundry Items

Ancient people cleaned clothes by pounding them on rocks at streams and rivers. Evidence of the use of soap begins with the Romans who made it from ashes and animal fat.

The first American patent involving a laundry scrub board was in 1797. The patent actually utilized a scrub board with a very simple mechanism. In 1799 improvements to this basic machine were created in England. The wooden scrub board continued to be the basic tool used by women to clean laundry through the 1800s. Zinc surfaces were introduced after Stephen Rust patented this modernization in 1833. The exact year that glass was introduced as a wash board surface is not known, but it was sometime before 1877. Meanwhile, rotary washing machine technology had already begun; in 1858 Hamilton Smith had patented the rotary washing machine.

William Blackstone of Bluffton, Indiana, created a washing machine for his wife's birthday in 1874, and by 1875 there were more than 2,000 patents for an assortment of gadgets and designs related to washing clothes by Blackstone and others. Blackstone utilized gears and a wooden handle and his invention was so effective he began building and selling washing machines to his neighbors for $2.50 each and success followed to the point of expanding to a factory.

Whenever something is in demand by the public, competition is sure to follow, and it did, keeping the prices down, which was a huge benefit to consumers. Dozens of designs were patented and in 1861 the wringer was invented and added. Wooden tubs were replaced with metal ones, and gas or steam engines assisted the agitation process by the early 1900s. The first electric motor was patented in 1906 and Maytag, a company that had started

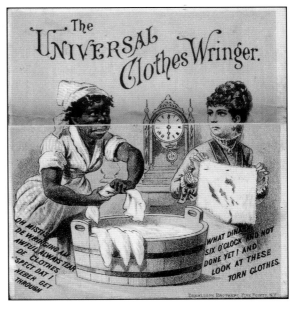

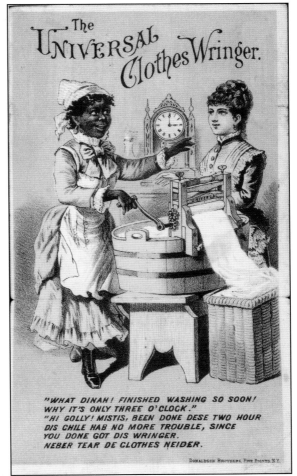

Trade card for The Universal Wringer by C.E. Waldbridge, 297, 299 & 301 Washington, Street; Buffalo, New York.

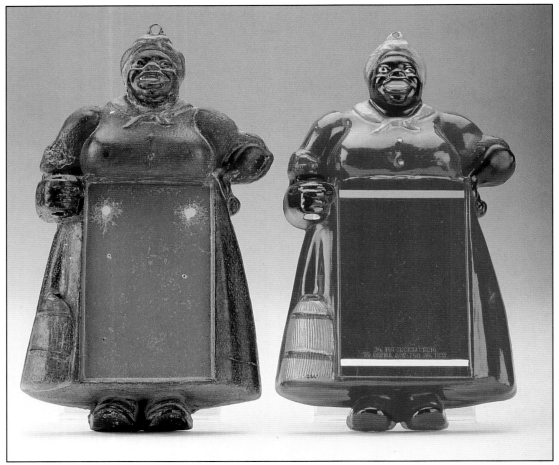

Mammies. **Left:** 4.75" x 10.5", back embossed: "MAMMY MEMO REG. US. PAT. OFF. MADE IN U.S.A. HAMPTON NOVELTY MAFT. CO. INC. HOLYOKE, MASS. PAT. NO. D120724," composition, quite unusual for memo pads. $85. **Right:** 4.75" x 10.5", back embossed: "MADE IN U.S.A.," front embossed: "NO. 123 MAMMY MEMO TO REFILL ASK FOR NO. 123F," plastic. $60.

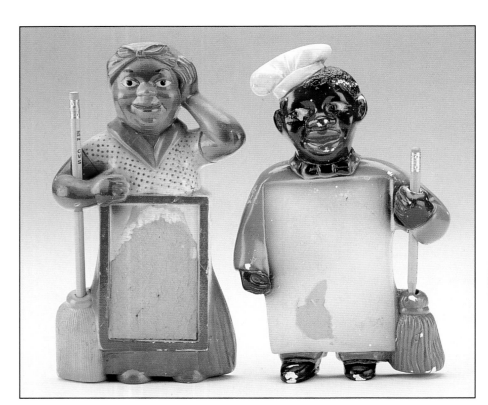

Mammy and Chef. **Left:** 5.25" x 9.75", c. 1954 MILLER STUDIO, INC. **Right:** 6" x 9.75", c. 1949. $65 each if perfect (Chef has many nicks)

Mammy Magic Erase Board. 4.5" x 7.5", no manufacturer's information, cardboard with tissue and cellophane and a ribbon for hanging. $50.

The Gold Dust twins were Goldie and Dustie, characters "who performed as half-dressed, house-cleaning pickaninnies dispensing commercial washing powder." (http://www.jimcrowhistory. org/resources/lessonplans/hs_es_popular_culture.htm) The trademarked twins, owned by M.K. Fairbanks Company of Chicago, were introduced to America in 1884 and became so popular that a radio show "The Silver Dust Twins" aired in 1925 based upon these characters.

The appearance of the twins changed in the twentieth century, evolving from racist images to cutesy. The variations are evident on these packages.

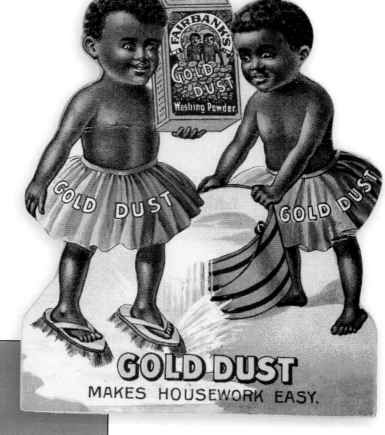

Dye cut trade card for Gold Dust Washing Powder.

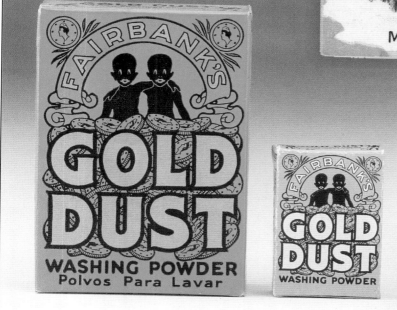

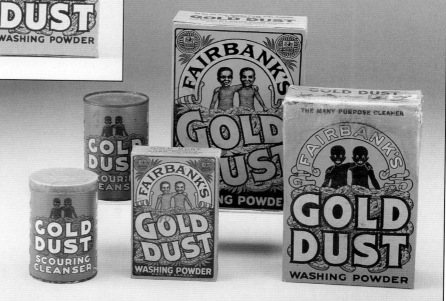

Two Fairbank's Gold Dust Washing packages. *Left:* 1.25" x 3.5" x 4.75", 5 ounces, information provided in English and Spanish. $35. *Right:* .75" x 1.75" x 2.5", sample package dated 1939. $50.

Five Fairbank's Gold Dust Washing packages. Round 14 ounce packages: just over 3" diameter, 4.75" tall. *Left:* metal bottom, rest cardboard. $35. *Right/back:* all metal with paper label. $45. Boxes. *Back:* 3" x 6" x 9". $85. *Front left:* 1.5" x almost 4" x 6". $65. *Front right:* 2.75" x 6" x 8.5". $65.

## Letter Openers

The use of an African-American as alligator bait is discussed in the toy section of this book. It was a commonly-used theme in print advertisements, toys, and even letter openers as shown here.

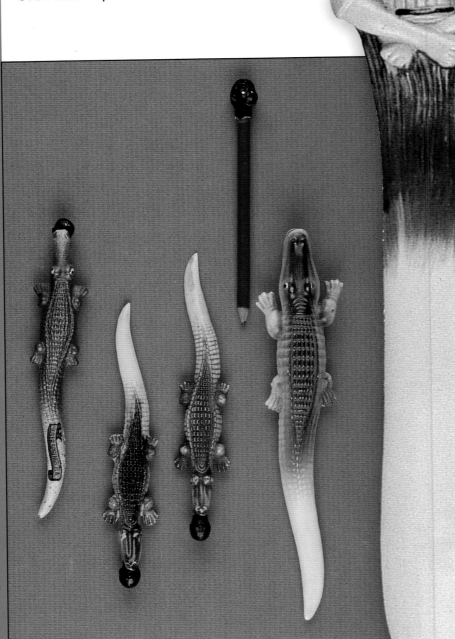

Letter openers with pencils: The boy's head is at the end of a pencil that slides into the alligator whose tail serves as a letter opener. **Top:** Alligator: almost 6" long, "MADE IN U.S.A.," cast iron. $100. **Middle two:** Alligator: 5" long, no manufacturer's information, celluloid. $60 each. **Bottom:** Alligator: 10" long, "DESIGN REG NO. 93652 MADE IN JAPAN," celluloid. $80.

7" long, no manufacturer's information, celluloid. $75.

*Miscellaneous*

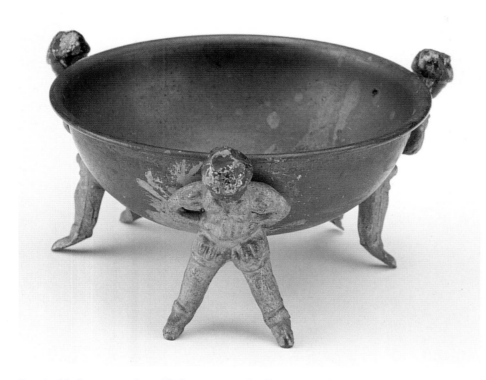

Bowl with figures as feet. 3" diameter, 1.5" tall, no manufacturer's information, clothing of three figures has been crudely repainted in gold, brass. $65 with original coloration.

Cherub TELEPHONE DIALER in original gift box. 3.5" long with 12" long chain and clip/hook, no manufacturer's information. The chain clips or hooks to the telephone and the dialer "SAVES BROKEN FINGERNAILS." $30.

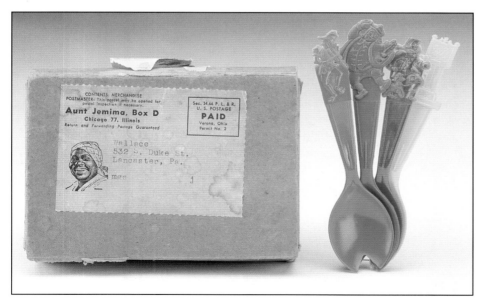

Sporks with mailer box. Box: 3.75" x 1.5" x 5.25", sporks: almost 5" long, backs marked: "F & F MOLD & DIE WORKS DAYTON, OHIO MADE IN U.S.A." This premium from Aunt Jemima depicts various nursery rhymes on the ends of the handles. The value is really in the box, $35.

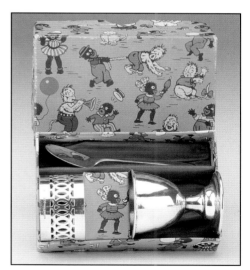

Child's gift set. Box: 2.25" x 3.25" x 5", covered with stylized monkeys and degrading images of children interacting with them. Contents: Spoon: 4.5" long, marked "EPNS"; Napkin Ring: just over 1" wide, 1.75" diameter, marked "H. T&S EPNS MADE IN ENGLAND;" Goblet: 1.75" diameter, 2.25" tall, no manufacturer's information. Box alone: $50; complete boxed set: $100.

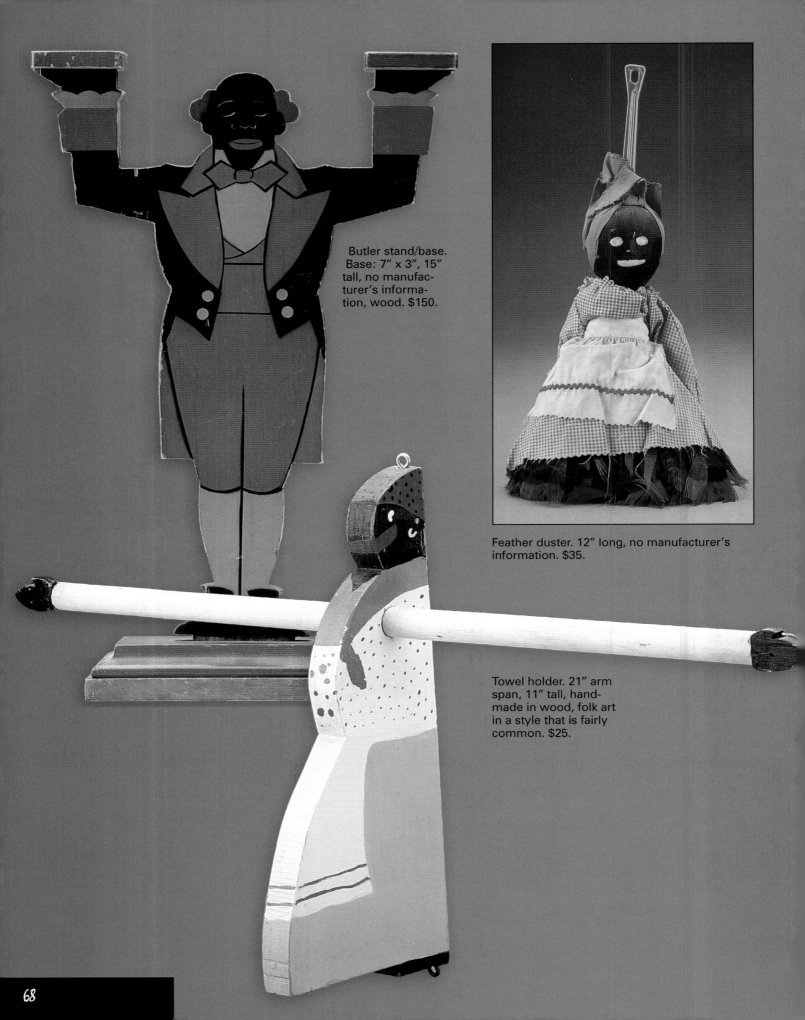

Butler stand/base. Base: 7" x 3", 15" tall, no manufacturer's information, wood. $150.

Feather duster. 12" long, no manufacturer's information. $35.

Towel holder. 21" arm span, 11" tall, handmade in wood, folk art in a style that is fairly common. $25.

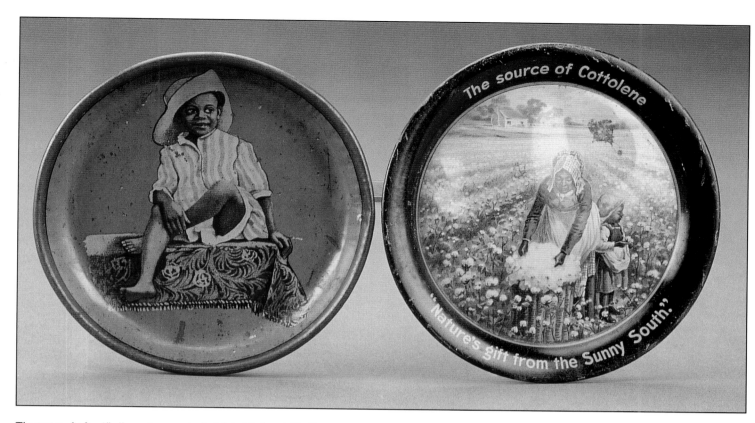

Tip trays. **Left:** 4" diameter, seated child. **Right:** 4.5" diameter, cotton field scene. Both are tin with lithographed images. $100 each.

Shown is the back of the Cottonlene tip tray.

Lighter. 4.5" long, 2.75" tall, no manufacturer's information, redware with cold painted details. $25.

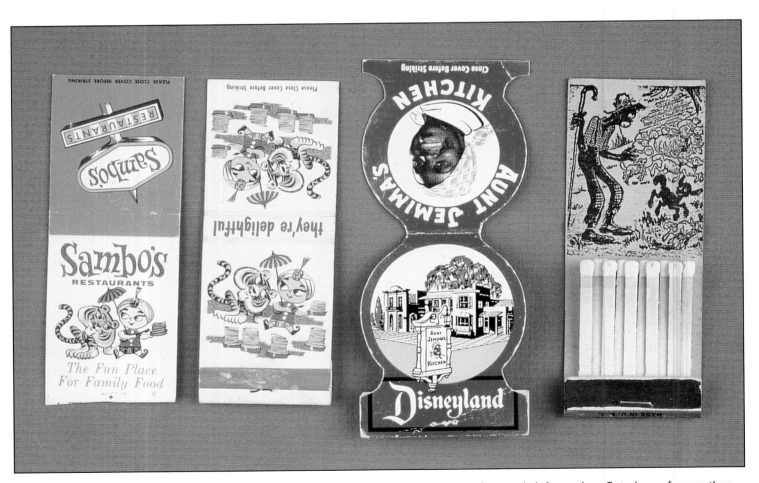

Match books. *Far left:* Sambo's Restaurants, no manufacturer's information. Cut piece of cover thus not complete, $15. *Second from left:* Sambo's Pancakes, Universal Match Corp., Los Angeles. Complete cover, matches missing, $22. *Second from right:* AUNT JEMIMA'S KITCHEN, Universal Match Corp., Chicago. Complete, unused, $35. *Far right:* ROSWELL WOOL & MOHAIR CO. , ROSWELL, NEW MEXICO PHONES 1432, 1433 with artwork inside the cover. Complete, unused, $35.

Mammy in an outhouse. 3.5" x 4.75", no manufacturer's information. Exaggerated lips were meant to contribute to the whimsical nature of this item that served no purpose other than to entertain, wood. $18.

Pen or pencil clip. St. Louis Browns Satchel Page, 1.75" tall. $20.

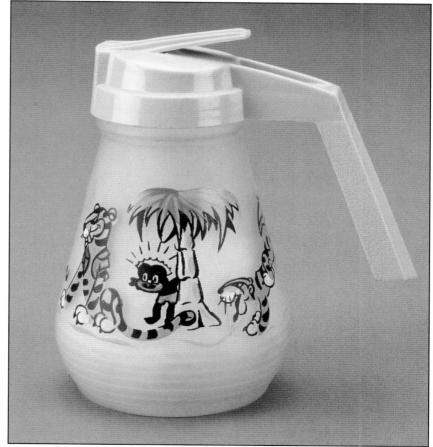

Syrup dispenser. Almost 4.5" tall, no manufacturer's information. Sambo and the tigers encircle the frosted/satinized glass with plastic lid, from Sambo's Restaurant. $150.

Two fishing lures. *Left:*
LUCKY LURE Souvenir
Indian Lake, Ohio. Card-
board backing: 7.75" x
3.5". Note original price of
25c; Lure: 5" tall overall;
plastic figure: 3.25". $100.
*Right:* "HOMO 51" (name
on package, but this is
another version of the
SAM-BO Lure). $65.

Doughnut holder. 11" tall,
no manufacturer's infor-
mation, wood. $20.

Maracas. 10" long,
hand crafted, Handle
numbered: "4/7978,"
gourd and wood. $10.

SAM-BO fishing lure. Box: 4" long; Lure: 3.5" long, no manufacturer's information. A bite from a fish creates tension on the line causing Sambo to move feet-first pulling him through the barrel and revealing what he is made of. A rubber band brings him to attention. Box, $35; Lure, $65.

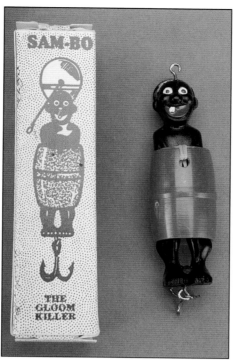

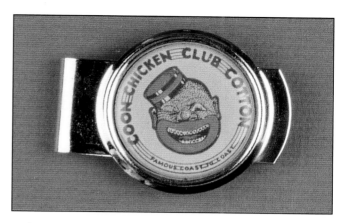

Money clip. COON CHICKEN CLUB COTTON, 2.25" long, marked "U.S.A." REPRODUCTION. $75.

Minstrel toothpick holder. Base 3.5" diameter, 3.25" tall, no manufacturer's information, milk glass. $125.

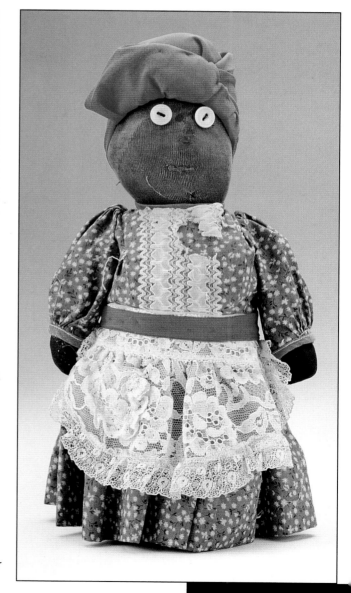

Door stop. 12.5" tall, hand crafted, fabric over weighted bottle. $45.

## Mugs

Toby mugs are named for Toby Fillpot, a British character who enjoyed drinking ale and smoking a pipe at the pub. In the 1760s mugs began to be made that depicted Toby Fillpot and other delightful souls from contemporary British culture.

as a source of excellent bone china, and before the end of the century became known for many different items including character mugs. The word "Royal" wasn't added to the name of the company until King Edward VII (1841-1910) granted the honor of this term in 1901.

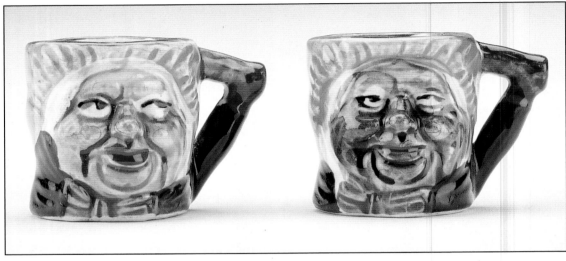

Two Toby-like mugs. 2" tall, 1.5" diameter, bases stamped in black "JAPAN," china with cold painted details. $35 each.

Royal Doulton, named for John Doulton (1793-1873) in 1815, developed a reputation for their beautiful stoneware, mostly after Doulton's son Henry (1820-1897) joined the company twenty years later. By the 1880s the factory in Staffordshire, England became recognized

Today character mugs are often tagged with some use of the word "Toby" even if they are not the genuine Royal Doulton items.

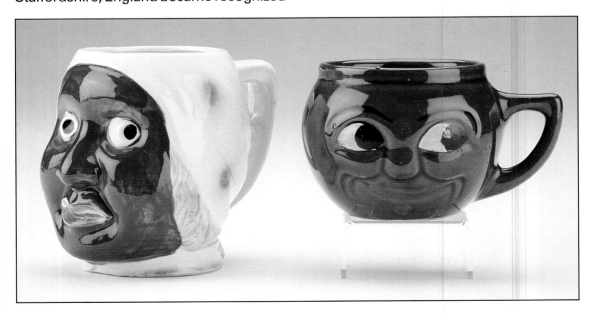

**Left:** Mammy head. 5" tall, 3" diameter, base stamped in black "JAPAN," pottery. $65. **Right:** Whimsical head. 3.25" tall, 3.5" diameter, base embossed "USA," pottery. $30.

## Pancake Cutter

Ancient Romans created a food using milk, flour, eggs, and spices, and these "Alita Dolcia" are considered to be the first pancakes. Some form of pancake has been enjoyed by many cultures through the centuries as the ingredients are so basic. Recipes have been documented from the first century and the thirteenth century.

Colonial Americans enjoyed Indian cakes made with cornmeal as early as 1607. Eighteenth century New England dined on flapjacks and griddle cakes, and Dutch settlers used buckwheat for buckwheat cakes. Hoe cakes, named because they were cooked on a flat hoe blade, and Johnnycakes were part of Colonial dining by the mid-1700s. The name "pancake" was not a commonly-used term until the 1870s.

The pancake cutter shown here is the one and only Aunt Jemima cutter that one would have acquired through a premium. There are different handle styles, but the metal of genuine Aunt Jemima cutters is always marked with the Aunt Jemima name.

8.5" diameter; no manufacturer's information, aluminum with wooden handle. This was a send-off premium through Aunt Jemima Pancake Mix. $80.

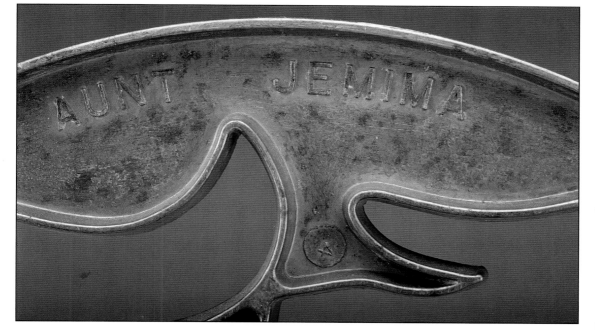

The Aunt Jemima name is shown on the underside of genuine pancake cutters.

# Perfume Bottles

Like many items used today and featured in this book, perfume bottles have their roots in ancient Egypt. Alabaster and other stone as well as sculpted clay was utilized to provide watertight containers for fragrances. It is known that perfume was used in conjunction with the ancient Egyptian elaborate preparation of the dead.

The earliest glass bottles are from 1500 BC. Large perfume bottles were found in ancient Palestinian tombs presumably to mask the odor of the decaying dead.

Both the Greek and Roman civilizations used perfume bottles. As with other aspects of Roman life, as their sphere of influence grew, so did the use of perfumes.

As man's ability to work with precious metals and gems improved so did the artistry of the perfume bottle. In the Middle Ages different containers were designed to be worn, most likely to cover the stench of unwashed people. By the 1300s porcelain was also being used to create perfume bottles.

It wasn't until the Art Nouveau period of the late 1800s that changes evolved with perfume bottles. Initially artistic efforts were made in designing lovely labels and boxes in which the bottles were placed. The next transformation was to create elaborate caps.

Sigmund Freud's (1856-1939) research and writings on psychology and psychotherapy also had an influence on perfumes and the bottles that contained them. Perfumes were given intriguing and tempting names and marketed for holidays, seasons, times of day, and so on.

In 1906 famed glass artist, Rene Lalique, was hired by Coty to create bottles for Coty fragrances.

American soldiers who fought in World War I (1914-1918) brought European perfumes back to the United States and the perfume industry flourished.

The Cristalleries de Baccarat, which had begun in 1764 in Lorraine, France, produced gorgeous crystal perfume bottles in the 1920s and 1930s.

Of course, the Great Depression which began in 1929, had a huge, negative influence on the production of perfumes and the ability of the average American to afford them. World War II had the same effect.

One can assume the bottles shown here were produced after World War II. They fail to illicit a romantic ambiance and one must consider if these were novelty items or, perhaps, pieces designed for children.

*Left:* Man in top hat. 3" tall, manufacturer's information embossed on bottom but impossible to read, frosted/satinized glass man with Bakelite hat (lid). $65. *Right:* Cylinder with man's head. 3.25" tall, no manufacturer's information, Bakelite which unscrews at waist to reveal a 1.75" vial of fragrance. Marked "Souvenir of Habana." $125.

# Photographic Images

Frenchman Joseph Nicéphore Niépce was the first person to obtain a fixed image. The year was 1827. Louis Jacques Mandé Daguerre, another French citizen, was also experimenting with what was to become photography. Niépce's process took eight hours while Daguerre's process was a mere thirty minutes. They formed a partnership in 1829 and photography became a reality. The word "photography" is derived from the Greek words photos ("light") and graphein ("to draw") (http://inventors.about.com/library/inventors/blphotography.htm).

Niépce died in 1833 and Daguerre continued his research developing the daguerreotype, an improvement on his earlier discovery. He sold the rights to the French government in 1839 and within a few years the technology had crossed the Atlantic.

In 1841 William Henry Talbot patented the process of Calotype which involves the first negative-positive printing process making it possible to make multiple copies of a picture. (http://library.thinkquest.org/04oct/01824/thehistory.htm)

Ten years later, Frederick Scott Archer developed the Collodion process which reduced the amount of sunlight needed for an exposure to a mere two to three seconds. Richard Leach Maddox invented a process that made it possible to wait to develop negatives in 1871.

The Eastman Company created paper-based photographic film in 1884 and four years later the roll film camera.

In 1900 the first camera for the common man, the Brownie, was manufactured and thirteen years later the first 35mm camera was built.

In the midst of the development of photography came the development of stereoscopic photography. Stereoscopic or binocular artwork has been traced to Giovanni Battista della Porta (1538-1615). The concept is that on average there are 2.5" between a human being's eyes, and due to this difference each eye receives an image independently and on a slightly different angle to be merged by the brain. By placing two identical pictures 2.5" apart from each other and positioning them in front of the eyes in a viewer (stereoscope) a three-dimensional image can be seen. The Jesuit Francois d'Aguillion (1567-1617), created the word "stéréoscopique" in 1613. Briton Sir Charles Wheatstone suggested the word stereoscope in 1838 but his research had been done with drawings. By 1838 photography had already been invented and stereoscopic cards with photographic images were produced from about 1850-1920. An interesting assortment of comic and realistic stereoscopic cards is presented.

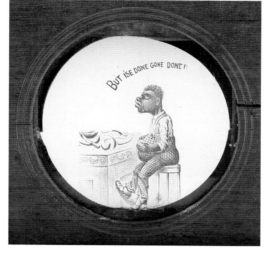

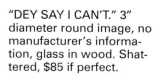

"BUT I'SE DONE GONE DONE IT." 3" diameter round image, no manufacturer's information, glass in wood. $85.

"DEY SAY I CAN'T." 3" diameter round image, no manufacturer's information, glass in wood. Shattered, $85 if perfect.

Stereoscopic card. 7" x 3.5", Keystone View Company.
**Top view:** "A ZULULAND STYLE DRESSED UP." **Bottom views:** "THE SHOES OF A CONGO FISHERMAN." $20.

Stereoscopic cards. All 7" x 3.5". ***Top left:*** "…Levee, New Orleans, Louisiana, U.S.A. Copyright 1893, by Strohmeyer & Wyman. Sold on by Underwood & Underwood New York, London, Toronto-Canada, Ottawa-Kansas. Strohmeyer & Wyman, Publishers. New York, N.Y. ***Bottom left:*** "14 Negroes at Work Near Cristobal." ***Top right:*** "On the Levee, New Orleans." REPRODUCED FROM ORIGINAL STEREOSCOPIC PHOTOGRAPHY Copyright 1905 by H.C. WHITE CO. N.Y. ***Bottom right:*** "20. Types of natives and the improvised shelters. $10 each.

Stereoscopic card. 7" x 3.5", American and Foreign Views Sold by Canvassers. "Did You Say Watermellow Was No Good? Copyright, 1898, by T.W. Ingersoll." $20 if perfect.

Stereoscopic cards. All 7" x 3.5". **Top left:** "2897. (11) Mrs. Newlywed's New Wench Cook." Geo. W, Griffith, Publisher Philadelphia, Pa. Sold only by Griffith & Griffith Philadelphia, Chicago, London, Hamburg, Ger., St. Petersburg, Russia. Copyright, 1901, by Griffith & Griffith. **Bottom left:** "535 Took a friend home to dine. El ha confided un amigo a comida. Copyright 187 , by F.G. Weller." Sold only by Underwood & Underwood New York, London, Toronto-Canada, Ottawa-Kansas. Littleton View Co., Publishers, Littleton, N.H. **Top right:** "11500. I feel obliged to remove dis temptation from de eyes ob a weaker brother." Copyright 1897, by B.W. Kilburn. JAMES M. DAVIS. New York City, and St. Louis, Mo. **Bottom right:** "423. Harts Canoe Landing-Brule River." $20 each.

Stereoscopic cards. All 7" x 3.5". **Top left:** "Cotton is King, Plantation Scene, Georgia, U.S.A. Copyright 1895 by Strohmeyer & Wyman." Sold only by Underwood & Underwood New York, London, Toronto-Canada, Ottawa-Kansas. Strohmeyer & Wyman, Publishers. New York, N.Y. **Bottom left:** "13788-General View of Cotton Field, Texas, U.S.A." Meadville, PA St. Louis, Mo. San Francisco, Cal. Toronto, Can. New York NY, London, England. Keystone View Company. Manufacturers & Publishers. Copyright 1904 by B.L. Singley. **Top right:** "Cotton is King, Plantation Scene, Georgia, U.S.A. Copyright 1895 by Strohmeyer & Wyman." Works and Studios~Orlington, N.J. Littleton, N.H. Washington, D.C. Underwood & Underwood, Publishers. New York, London, Toronto-Canada. Ottawa-Kansas." **Bottom right:** "Loading Cotton, New York." REPRODUCED FROM ORIGINAL STEREOSCOPIC PHOTOGRAPHY Copyright 1905 by H.C. WHITE CO. N.Y. $10 each.

Stereoscopic cards. All 7" x 3.5". **Top left:** "Chimney Sweeps, Savannah A.D. White, Publisher." FLORIDA VIEWS GEM SERIES. $25. **Bottom left:** "770. A Limited Train of Southern Florida. Copyright 1897, by T.W. Ingersoll." $20. **Top right:** "91(c) Oh! Golly, But Dat Ol' Gun Done Kick. Copyrighted, 1898. By T.W. Ingersoll." $20. **Bottom right:** "73 The Embryo Golfer." $20.

Stereoscopic cards. All 7" x 3.5". **Top left:** "Down in Dixie," COPYRIGHT GRIFFITH & GRIFFITH. **Bottom left:** "5019 Dars ben tree tow times, two tree times, an' one Lawd kno' how ma; times. Copyright 1901 by H.C. White Co." The "PERFECT" STEREOGRAPH. (Trade Mark) EDITION DE LUXE. Patented April 14, 1903. H.C. WHITE CO. CHICAGO, NEW YORK, LONDON. Gen'l Office and Works, North Bennington, Vt., U.S.A. **Top right:** "These are the Generations of Ham. Copyright 1895, by Strohmeyer & Wyman." Works and Studios Arlington, N.Y. Littleton, N.H. Washington, D.C. Underwood & Underwood, Publishers. New York, London, Toronto-Canada, Ottawa-Kansas. **Bottom right:** "23 A Typical Group of Refugees on Rue de Pave, Ft, de France, Martinique, W.I. copyright 1902, by William H. Rau." William De Rau Publishers Philadelphia, U.S.A. Sold by Universal View Co. Philadelphia Pa Lawrence Kan. $20 each.

Stereoscopic cards. All 7" x 3.5". **Top left:** "12114 A Tunnin' on the Old Banjo." SOLD ONLY BY GRIFFITH & GRIFFITH, PHILADELPHIA, ST. LOUIS, AND LIVERPOOL, ENG. William H. Rau, Photographer, Philad'a., Pa. **Bottom left:**

"Does you Love me Hun?" AMERICAN AND FOREIGN SCENERY RELIGIOUS COMIC AND MISCELLANEOUS SUBJECTS. **Top right:** "8053-A 'Drop in Cotton.'" Meadville, PA St. Louis, Mo. San Francisco, Cal. Toronto, Can. New York NY, London, England. Keystone View Company. Manufacturers & Publishers. Copyright 1904 by B.L. Singley. **Bottom right:** "No, Mas'r-Not 'cause I Married Young, but I is a Fas' Breeder. Copyright, 1895, by Strohmeyer & Wyman." Sold only by Underwood & Underwood New York, London, Toronto-Canada, Ottawa-Kansas. Strohmeyer & Wyman, Publishers, New York, N.Y. $20 each.

Stereoscopic cards. All 7" x 3.5". **Top left:** "6/ One Stick of Gum for Two. Copyrighted, 1898, By T.W. Ingersoll." **Bottom left:** "Tell Me Dat You Lub Me Darlin' Dina." **Top right:** "7. Did You Say Watermelon Was No Good?" **Bottom right:** "93. Deed Child's I's Didn't Know you's Was Dare. Copyrighted, 1898, By T.W. Ingersoll." $20 each.

Stereoscopic cards. All 7" x 3.5". **Top left:** "89 (a). Sam Black Gets a Shot at 'Br'er Rabbit.' Copyrighted, 1898. By T.W. Ingersoll." **Top right:** "90 (b). Lordy, Dad! Be Yous Kilt? Copyrighted, 1898. By T.W. Ingersoll." **Bottom:** "91(c). Oh! Golly, But Dat Ol' Gun Done Kick. Copyrighted, 1898. By T.W. Ingersoll." $20 each.

## Pie Birds

When baking a fruit pie with a pastry top, it is necessary to provide vents to allow the release of the steam created as the fruit cooks. This can be achieved by simply cutting a few slits into the pastry or by inserting a pie bird through the pastry top and into the pie itself. This ceramic tool operates like a miniature chimney venting the steam from inside the pie.

There are many pie bird designs, some actually being birds, hence the name. Some of the more interesting, non-African-Americana examples come from Great Britain. The examples provided here are not easily found.

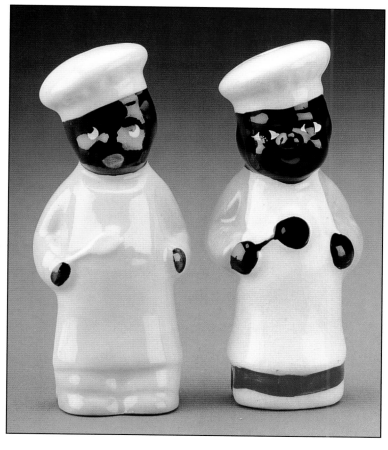

Chefs. 4.5" tall, no manufacturer's information, pottery. $125 each.

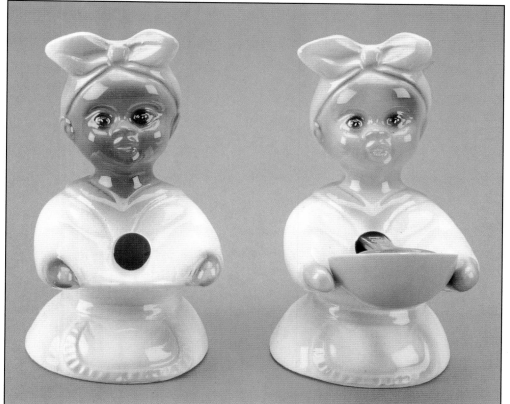

Mammies in pastel colors. 2.5" diameter of base, 5" tall, no manufacturer's information. *Right:* shown with measuring spoons in vent hole, pottery. $145 each.

## Pipes

The history of the relationship of tobacco and African-Americana is addressed in the Ashtrays section of this book. This discussion will focus specifically on the history of pipes.

Mayan ruins from 1000 BC portray priests smoking pipes in conjunction with religious rituals, and stone and clay pipes have been recovered from Mayan pyramids. Smoking herbs in pipes was also used for medicinal purposes by this civilization.

Man's head. 7.5" long, no manufacturer's information, pottery. $150.

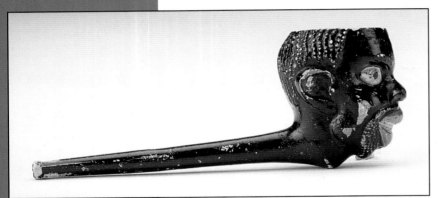

After the demise of the Mayan empire the use of pipes continued with other civilizations and these smoking instruments reflected the available natural resources. Natives in North America used a soft red stone, kaolinite, to create pipes while natives in South America utilized wood from tropical plants. As with the Mayans, these pipes often took the form of various animals.

Columbus's experiences in the New World brought tobacco to Europe. Smoking was associated with the Devil and smokers were persecuted and jailed. For this reason, early European pipes were often shaped as a devil's head.

Sir Walter Raleigh is credited or blamed for bringing tobacco to England. In 1603 King James was so passionately in opposition to smoking, he ordered the execution of Sir Raleigh whose final act was to smoke a pipe in defiance of his pending death. The king's efforts to eliminate smoking included levying taxes on pipe makers hoping the additional fees would cause them to go out of business, but the effect was to establish pipe making as a legitimate profession.

Many American colonists grew tobacco as a crop and by the early 1700s tobacco use was pervasive throughout Europe, particularly in England and Holland. Gouda, Holland became a center for pipe production with about 500 workshops whose materials actually came from Germany. Although the number of shops has diminished through the centuries Gouda is still known for pipes.

As the use of tobacco widened beyond Europe to the north, south, and east, pipes evolved into two forms: "nargila," which are water pipes, and pipes with a clay head.

Victorian Europeans began to move from pipes to snuff while pipe smoking flourished in America. It was during this time that pipe smoking began to be associated with higher class individuals as well as those who were contemplative, philosophical, and educated as cigars and cigarettes began to evolve into the common person's tobacco.

Chinese and Mongolians were already accustomed to smoking opium so by the 1800s the use of tobacco was easily adopted; it was smoked in opium pipes already on hand. Smoking tobacco was such a mundane part of the Chinese culture that pubs stocked pipes as they stocked glassware.

The Czechs also became noted for wooden pipes in a variety of fruit wood like cherry, pear, and plum as well as alder and red ash. As with Gouda, Holland, the Czech Republic is still known for pipe manufacturing.

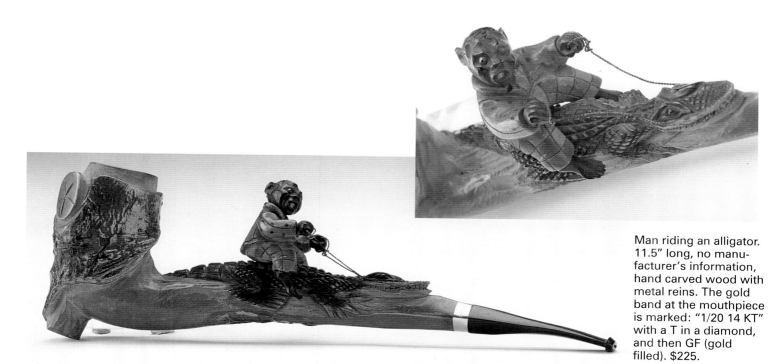

Man riding an alligator. 11.5" long, no manufacturer's information, hand carved wood with metal reins. The gold band at the mouthpiece is marked: "1/20 14 KT" with a T in a diamond, and then GF (gold filled). $225.

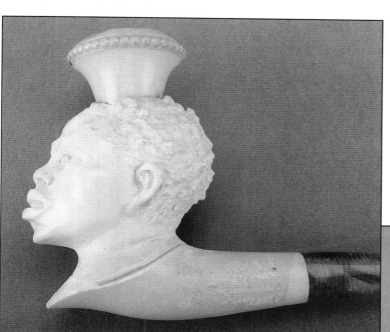

Man's head. 3.25" long with leather case, no manufacturer's information, ivory with Bakelite mouthpiece. $300.

## Pin Trays

A proper Victorian lady would never be without a pin tray. These small dish-like accessories were usually made of china or porcelain and were for holding one's hair pins. Often they were part of a dresser set that would include a comb, brush, hand mirror, hair receiver, and large tray on which all would rest in a decorative display.

It is unlikely that the pin trays shown here had any matching accessories. They were produced many years after the Victorian age, probably post WWII and may have been souvenirs or dime store purchases.

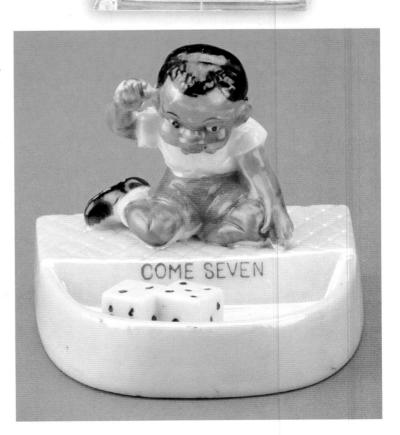

*Above:*
Turban-clad head. 3.75" x 4.5", base stamped in red "TA MADE IN JAPAN," china with cold painted details. $15.

*Below:*
Boy with dice. 2.75" wide, 2.75" tall, base stamped in red "Japan," china with luster glaze and cold painted details including "COME SEVEN." $25.

# Planters and Wall Pockets

Ruins from ancient Egypt reveal that houseplants were a part of that civilization, and residences in ancient Greece and Rome were constructed with atria. Bringing the outdoors inside has been a part of man's connection with nature for thousands of years.

During the Age of Exploration, the sixteenth century, plants from new lands were brought back as gifts for the kings and queens who sponsored the journeys. Many of these plants came from tropical or semitropical climates and needed special care to survive.

Houseplants in American homes only became popular after WWII as consistent indoor temperature controls became dependable. In the 1950s, Ivy and Philodendron were favorites. As these are vines planters and wall pockets were created to accommodate these plants which became commonplace in kitchens and living rooms.

The use of pockets actually predates planters in America. Early automobiles featured glass pocket vases to hold flowers, a detail revisited by Volkswagen when the "Bug" was reintroduced in 1998. From cars to homes, wall pockets have found a permanent place.

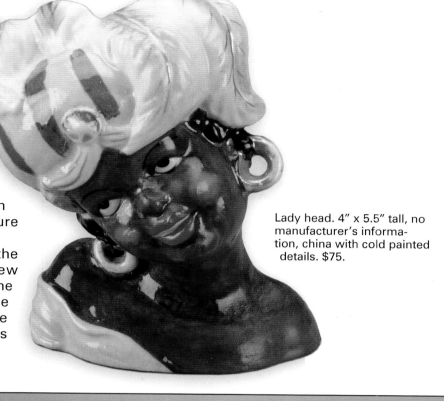

Lady head. 4" x 5.5" tall, no manufacturer's information, china with cold painted details. $75.

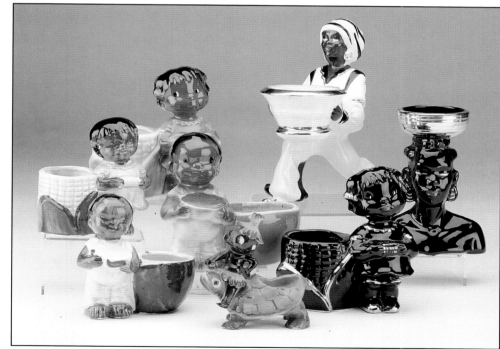

Eight figural planters.
**Back row, left:** Girl standing next to corn. 5" wide, 5.5" tall, no manufacturer's information, pottery. $45. **Back row, right:** Turbaned boy with pot. 7" from front foot to back foot, 8" tall, no manufacturer's information, pottery. $35. **Middle row, left:** Girl standing next to corn. 4" wide, 5" tall, base stamped in black "MADE IN OCCUPIED JAPAN," pottery. $50. **Middle row, middle position:** Boy standing next to watermelon. 5.5" wide, 5.5" tall, no manufacturer's information, pottery. $45. **Middle row, right:** Black native bust with pot on head. 4.5" wide, 5.75" tall, pottery. $25. **Front row, left:** Boy standing next to watermelon. 4" wide, 4.5" tall, base stamped in black "MADE IN OCCUPIED JAPAN," pottery. $50 if perfect, this planter is missing some paint. **Front row, right:** Black girl standing next to corn. 5" wide, 5.75" tall, no manufacturer's information, pottery. $25. **Front and center:** Native riding a tortoise. 4" long, 4.25" tall, base stamped in black "MADE IN JAPAN," bisque china. $45.

Boy's head. 4" x 4" with 1.5" diameter pocket, no manufacturer's information but could be American-made, chalkware with exceptionally detailed paint. $175.

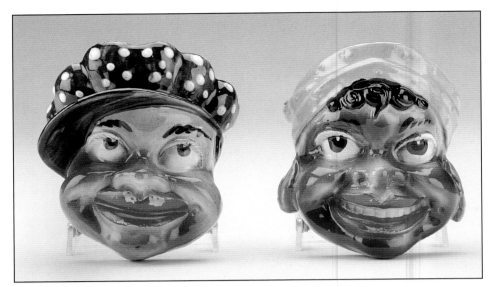

Pair of smiling faces. *Left:* 5" wide, 5" tall, impressed logo of diamond with "SK" inside on back, and stamped "E" with a crown, china with cold painted details. *Right:* 4.75" wide, 4.75" tall, impressed logo of diamond with "SK" inside on back, back stamped in green "MADE IN JAPAN," china with cold painted details. $150 each.

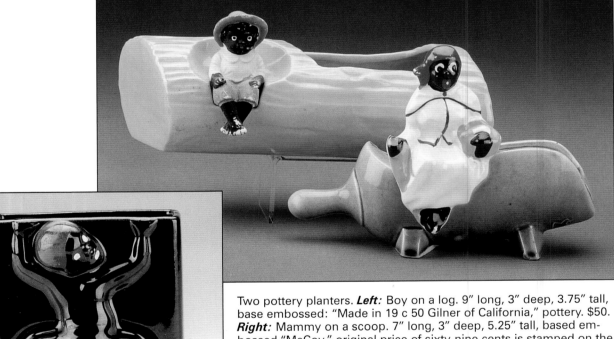

Two pottery planters. *Left:* Boy on a log. 9" long, 3" deep, 3.75" tall, base embossed: "Made in 19 c 50 Gilner of California," pottery. $50. *Right:* Mammy on a scoop. 7" long, 3" deep, 5.25" tall, based embossed "McCoy," original price of sixty-nine cents is stamped on the bottom, and then it was reduced to thirty-five cents, pottery. $50.

Boy climbing toilet. 2.75" wide, 4.5" tall, with original paper tag/label "JAPAN," redware with cold painted details on top of glazed base. This item is quite unique: the tank of the toilet is designed to hold cigarettes; the toilet seat has an indentation to support a cigarette, but this was made with an opening in the back to allow one to hang this on a wall for use as either a planter or an ashtray. Redware is not as popular as china and therefore of lower value. $100.

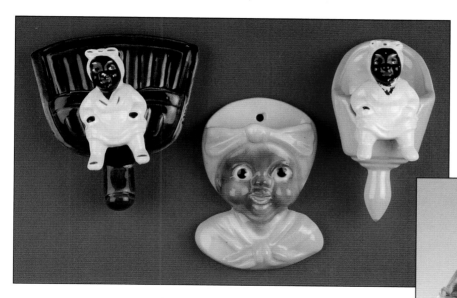

Left: Mammy on dust pan: 4.75" x 5", "Hollywood Ceramics Pat Pend C," a dustpan creates the "pocket," pottery. $75. **Middle:** Lady Head: 3.25" x 5", stamped on back in black: "560/A COVENTRY Made in U.S.A.," pottery. $85. **Right:** Mammy on Flour Scoop: 3" x 5.5", "Hollywood Ceramics," a flour scoop creates the "pocket," pottery. $75.

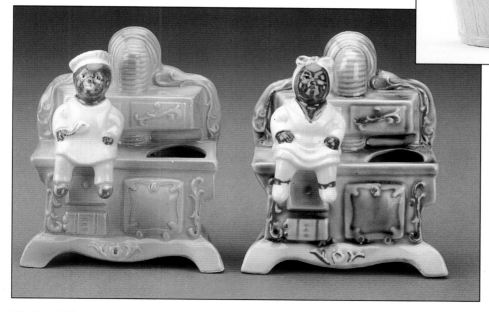

Chef and Mammy on the stoves. 4.25" x 5", bottoms stamped in black "HAND PAINTED JAPAN." Note: There is a hole in the back of each for use as a wall pocket, pottery. $75 each.

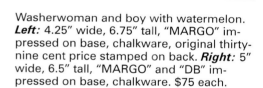

Washerwoman and boy with watermelon. **Left:** 4.25" wide, 6.75" tall, "MARGO" impressed on base, chalkware, original thirty-nine cent price stamped on back. **Right:** 5" wide, 6.5" tall, "MARGO" and "DB" impressed on base, chalkware. $75 each.

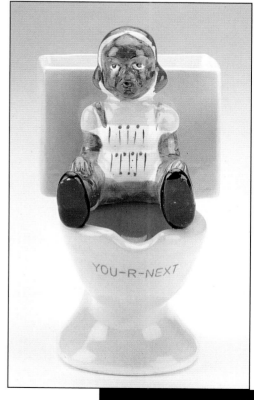

Girl on toilet. 2.75" wide, 4.5" tall, no manufacturer's information, known to be made in Japan, china with cold painted details. "YOU-R-NEXT" is written across the front of the toilet. This item is quite unique: the tank of the toilet is designed to hold cigarettes; the toilet seat has an indentation to support a cigarette, but this was made with an opening in the back to allow one to hang this on a wall for use as either a planter or an ashtray. $150.

## Plates and More

When archeologists seek understanding of ancient civilizations clues to the past often begin with the discovery of shards of vessels and plates. Throughout the ages man has needed to store, cook, and eat food and even the earliest humans utilized dinnerware of some form be it a broad leaf or a hollowed piece of wood.

Today we have a preconceived notion of dinnerware: plates, bowls, cups, saucers, and we can thank the Chinese for their influence regarding this aspect of our traditions. As discussed in the Figurines section, the Chinese invented hard paste porcelain from kaolin, a pure white clay, and petuntse, a type of feldspar in 618 AD. When mixed and baked at temperatures higher than 2200 degrees Fahrenheit the result is porcelain.

Through trade with the West, Chinese porcelain was introduced to other cultures and European tradesmen began producing wares with a variety of glazes and techniques. The mid-1700s to the mid-1800s saw a huge leap in European skill and artistry which set the benchmark for contemporary dinnerware.

Pottery dinnerware comes from ceramic or clay materials and tends to be heavier than porcelain or china. We know that pottery dinnerware has been around for centuries. Stoneware is similar to pottery but is more water resistant than pottery and also more durable. There are no stoneware objects in this book.

The pieces presented in this section are not from a line of dinnerware; rather they are largely meant to be decorative or functional for a specific task. For instance, the cake plate and server: the cake plate can be used as a serving piece for a variety of things, but it is still for serving. The Norman Rockwell plate is strictly a decorative object and is not meant to be used with food.

Perhaps someday archeologists will uncover shards from one of these items, say the plate with the alligator eating the boy, and attempt to piece together our culture. What would future man conclude from that plate?

"Listening." 8" diameter, c. 1980 Dave Grossman Design Japan, Norman Rockwell limited edition plate from "The Adventures of Huck Finn," Fine china, one of 10,000 made. $20.

Fisher boy. 4", no manufacturer's information, "Brownie Downing," china. $30.

Musically-theme plates. **Left:** "In the evening by the moonlight." **Right:** "I'll be down to get you in a taxi honey." Both 6.25" diameter, but plate on right is rimmed, Songs Fondeville New York. Artwork signed by C.A. Lewis, china. $20 each.

"Spirit of St. Louis" bowl. 6" diameter, almost 1.5" deep, back stamped in gold: "TRADE MARK REG. U.S. & CAN. PATENT OFFICE MADE IN U.S.A." This was a Cream of Wheat premium, china. $50.

Cake plate and server. Plate: 12.5" x 11", back marked: "ITALY 1/149," pottery. $25. Server: 9.5" long, pottery. $25.

Alligator eating a boy. 4", no manufacturer's information, bisque china. $50.

Watermelon Eaters: "Dixie Land." 5", back stamped in orange "HAND PAINTED JAPAN," china. $30.

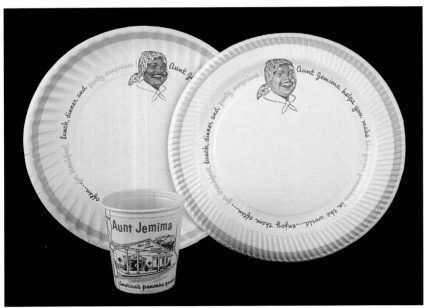

Aunt Jemima paper products. *Left:* Plate: just over 9" diameter. *Middle:* Cup with fold-out handles: 2.75" diameter, 3.25" tall, marked: "41.613 6PH CONTINENTAL CAN COMPANY, INC. PRACT. CAP. 6 FL. OZ. MADE IN U.S.A." *Right:* Plate: just over 9" diameter. These were used at Aunt Jemima breakfasts, promotions throughout the U.S.A., largely in the 1950s. $20 each.

Aunt Jemima PANCAKE WARMER. 6" diameter, 1.75" tall, WINSTON GRAY INC., plastic. This was a premium through Aunt Jemima products. $20.

The Aunt Jemima name is found by the vent hole.

## Pot Holder Hangers

Most of the hangers presented here are chalkware making this is an appropriate place to discuss this material.

The earliest chalkware was actually plaster of Paris, but this predates anything shown here by two centuries. These truly antique works were figurines often of animals.

American chalkware is largely associated with carnival prizes from the 1920s through the 1950s. Most of the wall hangers pictured here are from 1949 or later, and this is easy to understand. As the demand for chalkware carnival prizes diminished the businesses that made these prizes were compelled to maintain sales so they began to market household pieces directly to the consumer. Beyond the African-Americana shown here chalkware products included fish, scenery, fruit, vegetables, and more, and their popularity extended into the 1970s. As vintage collectibles a generation or so old this chalkware is again popular.

*Left:* 6.5" x 8.75", handmade, wood with four hooks. $20. ***Middle/back:*** 5" x 11.25", back stamped in white: "TEL-EMM NOVELTY CO. NEW YORK 57, N.Y. D. PAT. 166401," wood, fabric, and wire with two hooks. $25. *Right:* 5.75" x 7", no manufacturer's information, wood with three hooks. $20.

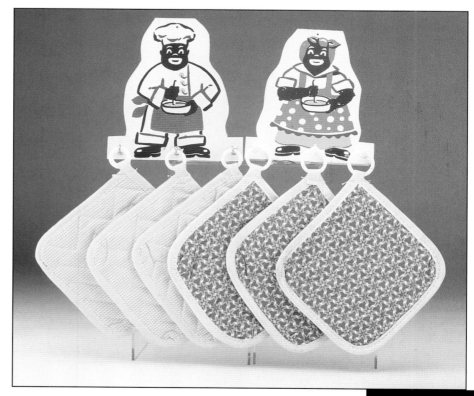

Mammy and Chef. Mammy, 5.25" x 6"; Chef, 5.5" x 6", no manufacturer's information, wood with metal hooks. Pot holders, 5.75" quilted fabric squares with plastic rings. Holders, $50 each; pot holders, $1 each.

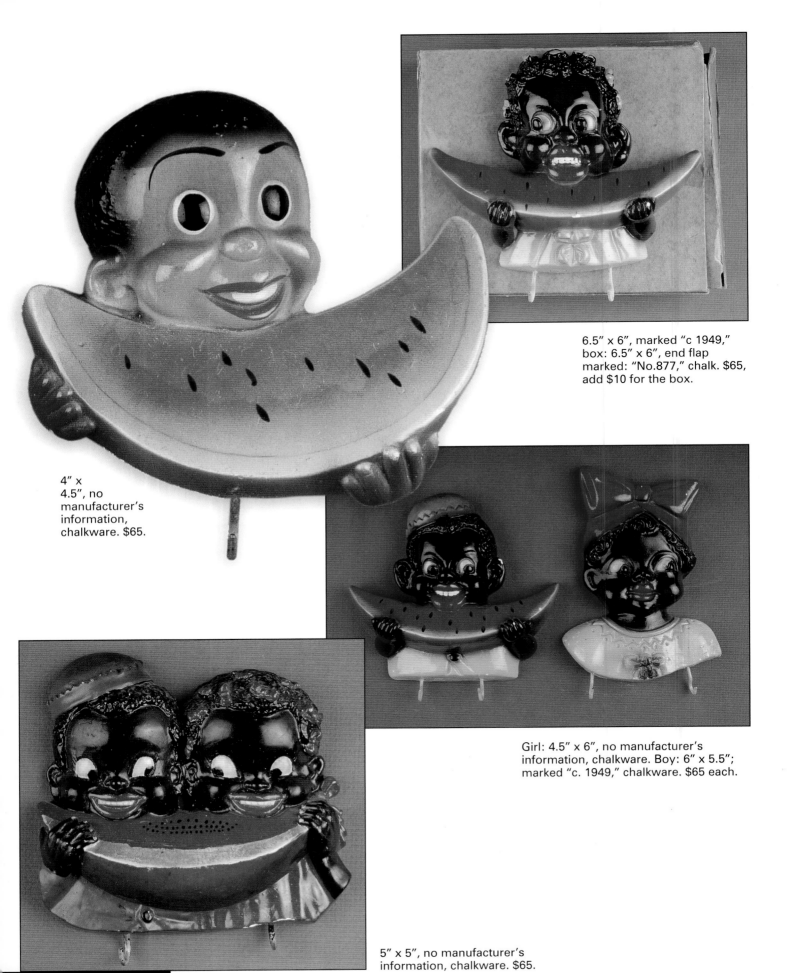

6.5" x 6", marked "c 1949,"
box: 6.5" x 6", end flap
marked: "No.877," chalk. $65,
add $10 for the box.

4" x
4.5", no
manufacturer's
information,
chalkware. $65.

Girl: 4.5" x 6", no manufacturer's
information, chalkware. Boy: 6" x 5.5";
marked "c. 1949," chalkware. $65 each.

5" x 5", no manufacturer's
information, chalkware. $65.

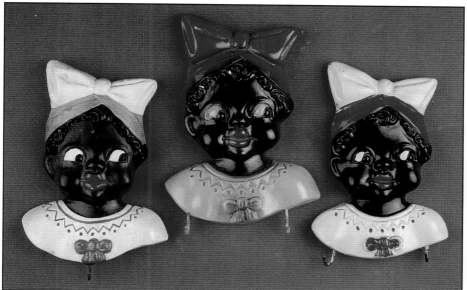

*Left:* 4" x 6", no manufacturer's information, chalkware. $50. *Middle:* 4.25" x 6", back stamped in black: "C CIG 101," price of 10c penciled on back, chalkware. $65. *Right:* 4" x 5.75", no manufacturer's information, chalkware. $50.

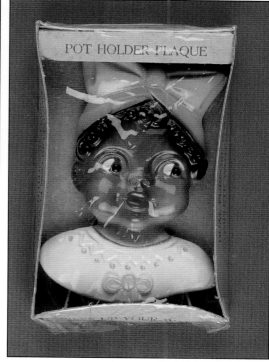

4" x 6.25", "CAMPANA'S ART NOVELTIES, Camden, New Jersey," the back of the package states: "PUT YOUR WALLS TO WORK. This dual Purpose Plaque Serves You in Two Ways: Adds beauty to your kitchen Keeps pot holders within easy reach," chalkware. $65, add $15 for original packaging.

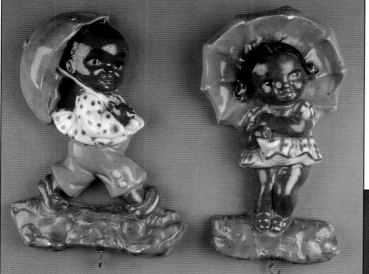

*Left:* 6.75" x 8.75", no manufacturer's information, chalkware. *Right:* 5.25" x 9.5", no manufacturer's information, chalkware. $65 each.

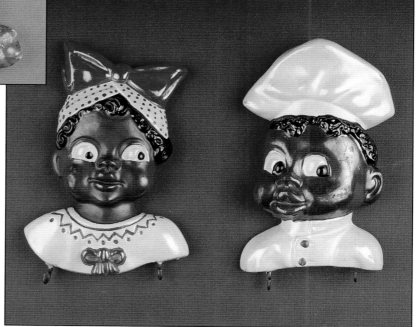

3.5" x 6", no manufacturer's information, chalkware. $50 each.

## Recipe Boxes

A recipe card can be more than words giving ingredients and directions to prepare some kind of food. When saved for future use it becomes a representational piece of one's heritage. We are a nation that socializes amid food, whether with friends or family. When a particular food is prepared and enjoyed the preparation is preserved via a small piece of paper. When the food is enjoyed another time, warm feelings abound. We humans have such a food mentality; consider how we react just to the smell of coffee, chocolate, or popcorn.

Recipes are retained and favorite foods and how to create them are passed through the generations. Before the days of saving recipes on a PC or notebook they were written by hand on a 3" x 5" or 4" x 6" card and placed in a box, a recipe box. Vintage kitchenware sets - canisters, trash cans, sifters - usually had a recipe box as one of the options.

A couple's life together can be documented by the recipes that have been saved: first their personal favorites, then their children's, and finally their grandchildren's. These recipes are protected in a recipe box and become a treasure to pass forward through the family so grandma's casserole or pie is savored long after grandma has passed. And with each meal created from grandma's recipes she is honored and her memory is kept alive.

The following blog expresses the joy of acquiring family recipes:

"...mom decided that if she was going to come up and visit for Thanksgiving, that she was going to bequeath to me a little bit of culinary history. She went into the attic and after much treasure hunting recovered the object she wished to find.

"My grandmother's recipe files. Yellowed with age, stained, marked and retooled with a pen after use, a bountiful plethora of homey, American recipes from the California Central Valley and the little hidden nest of Ojai (grandmother). Each little note card contains one recipe, hand written or typed via an old Remington Rand, or displays some various magazine or newspaper clipping perfectly adhered to the card.

"And not just a few recipes... cookies, veal, crab meat, salads, cakes, BBQ, and every other little sub-category that any grandmother had in her veritable secret stockhouse of recipes was here...

"So now I have to discover them myself, and it'll only be some distorted mirror image of them, like the squatty self you see in a carnival house of mirrors, real, but not authentic. They'll never be as grandma made them, but they'll be as close as I can get. Still, cooking and recipes evolve and pay homage to our history. (Who sees a sociology paper topic here?)."

—http://vanillagarlic.blogspot.com/2007/11/inheriting-my-familys-culinary-history.html

Aunt Jemima recipe boxes. 5.25" across, 3" deep, 3.75" tall, no manufacturer's information, presumed to be made in America, shown are the only colors in which these were manufactured, plastic. They would have been acquired through an Aunt Jemima promotion. Yellow: $150; red: $200; green, $450.

## Sewing Items

Today straight pins are quite disposable; if one happens to get bent it is discarded without another thought. But those little pins were quite extravagant in the 1400s as they were bone, silver, gold, brass, or ivory and to protect them from loss the pincushion was developed.

The first pin cushions were simple shapes with opulent fabrics like silk and linen that were embellished with lace and tassels.

During the 1700s pin cushions (known as pynpyllowes) became a venue for expressing one's creativity. Ivory, silver, and wood were shaped and covered with all sorts of handiwork: tatting, lace, patchwork, and so on. The shapes became as varied as the work that decorated them.

The first commercially manufactured pincushions were offered in the 1800s. They became a way to commemorate important events such as a coronation of royalty.

Other changes occurred during the 1800s. Some pincushions were executed in pins that were pushed into the cushion to create the decoration. Pulling the pins out to use them destroyed the decoration, so this design was abandoned. Pincushions were also embellished with beads, and eventually so many beads were attached they were simply in the way and the pincushion could not be used. These pincushions became decorations rather than useful tools for the seamstress. This art form progressed to the point that they were prominently displayed as important household pieces that were hung on walls, placed on tables, and so on.

The red tomato evolved into the most common pincushion one will find in today's retail outlets. The pincushions pictured here predate tomatoes.

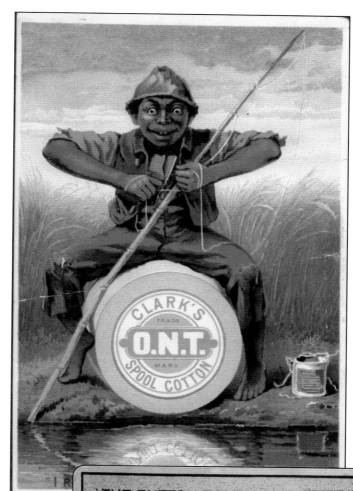

Trade card for Clark's O.N.T. Spool Cotton, George A. Clark sole agent.

Postcard for Buttons Buttons, copyrighted 1906.
"I's de Buttons Picanniny
And don't make no mistook
Dem folks what got no use fo me,
Just got to use de Hook."

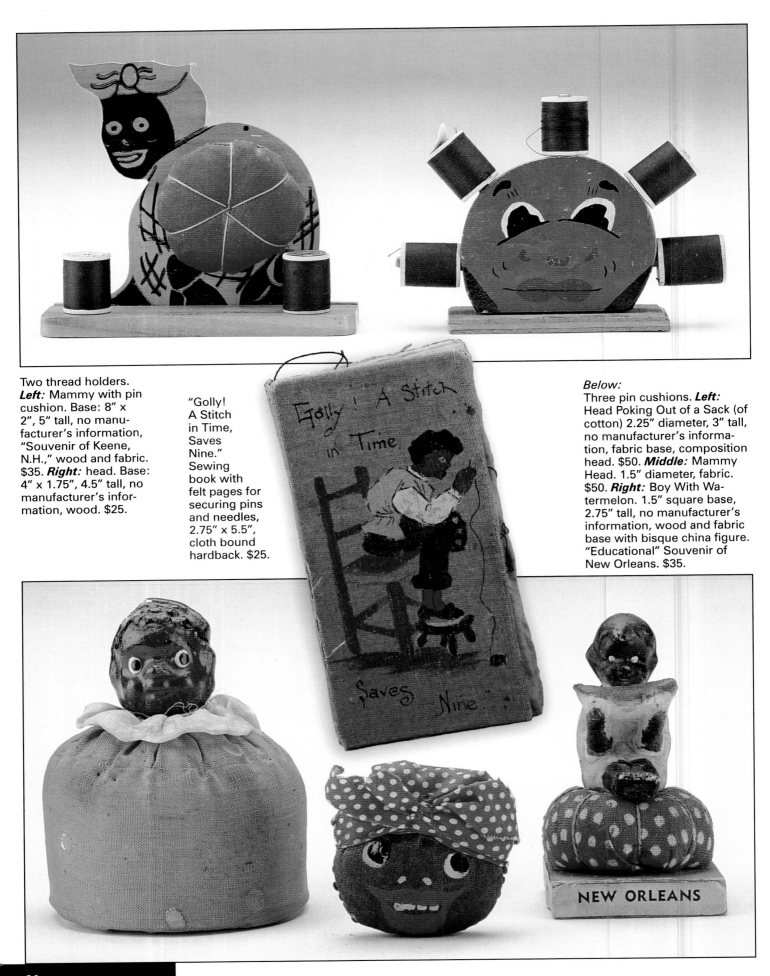

Two thread holders. *Left:* Mammy with pin cushion. Base: 8" x 2", 5" tall, no manufacturer's information, "Souvenir of Keene, N.H.," wood and fabric. $35. *Right:* head. Base: 4" x 1.75", 4.5" tall, no manufacturer's information, wood. $25.

"Golly! A Stitch in Time, Saves Nine." Sewing book with felt pages for securing pins and needles, 2.75" x 5.5", cloth bound hardback. $25.

*Below:*
Three pin cushions. *Left:* Head Poking Out of a Sack (of cotton) 2.25" diameter, 3" tall, no manufacturer's information, fabric base, composition head. $50. *Middle:* Mammy Head. 1.5" diameter, fabric. $50. *Right:* Boy With Watermelon. 1.5" square base, 2.75" tall, no manufacturer's information, wood and fabric base with bisque china figure. "Educational" Souvenir of New Orleans. $35.

# Shakers — Salt and Pepper

The use of pepper originated in India 2000 BC and spread to Southeast Asia. It is documented that pepper was enjoyed by ancient Romans, and peppercorns were in such demand that they were even utilized as a form of currency and traded in barter.

After the fall of the Roman Empire the use of pepper diminished, if not disappeared. During the Renaissance, Venetian traders became the source of pepper for Europeans. Pepper was a real extravagance and was used to show wealth and the appreciation of a guest at one's table. Pepper was also used to hide the stench of rancid foods in an era that had no refrigeration.

The price of pepper continued to escalate until the Portuguese explorer Vasco da Gama discovered a new trade route to India in 1498. The Portuguese were able to compete with the Venetian importers, and in time pepper became readily available. As the supply increased the value decreased and pepper became easily affordable to commoners.

Salt has been a part of food consumption ever since its preservation qualities were discovered by ancient Egyptians.

It continued to be an integral part of eating for centuries, eventually earning a place on the table in the 1800s. During the Victorian Age salt was purchased in chunks, and these pieces were placed in a decorative bowl-like container called a salt cellar. Pieces were chipped off and added to one's plate of food.

The first salt shakers were actually salt mills that ground larger pieces of salt into smaller ones that were more suitable to one's dining needs. In the mid-1800s free-flowing salt crystals were available for the first time and consumers needed some sort of delivery system to use this seasoning, and salt shakers were born.

The reconstruction of Japan after World War II (see the Introduction for more information regarding this event) led to the inexpensive production of salt and pepper shakers. This was the real beginning of figural salt and pepper shakers like the ones pictured here, and the start of an extremely popular collectible.

Elephant and rider. Elephant: 5" tall, bottom stamped in black: "CERAMIC ARTS STUDIO TRADEMARK"; Rider: 2.75" tall, stamped in black: "CERAMIC ARTS," pottery. $125 pair.

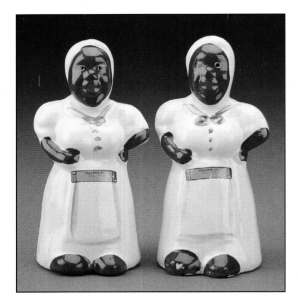

"Souvenir of Ely, Nev."
7" tall, no manufacturer's
information, pottery. $60.

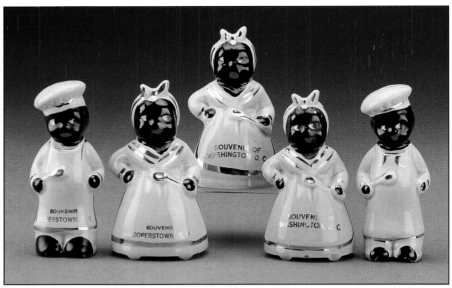

Souvenir Mammy and Chef shakers in rarely-seen color.
**Back:** Souvenir of Washington, D.C., 4.75" tall. **Front left:**
Souvenir of Cooperstown, N.Y., just over 5" tall. **Front
right:** Souvenir of Washington, D.C. and plain mate, 4.75"
tall, pottery with cold painted details. Souvenir shakers,
$60 each; plain shaker, $45.

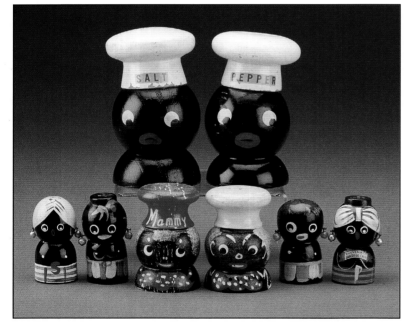

Four pairs of wooden shakers. **Back:** Chef heads: 4.5" tall,
no manufacturer's information. **Front left:** Couple with faux
pearl earrings: 2.5" tall, corks stamped "JAPAN," pepper
has "SOUVENIR OF SAN DIEGO CALIF" sticker/label. **Front
middle:** Chef Heads: 3" tall, bases marked "JAPAN." **Front
right:** Couple with Faux Pearl Earrings: 2.5" tall, no manufac-
turer's information. $15 per set.

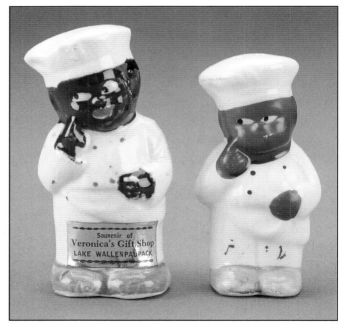

Two similar chefs. **Left:** 3.25" tall, base
stamped in green "JAPAN," original sticker/
label: "Souvenir of Veronica's Gift Shop LAKE
WALLENPAUPACK" (which is a location in
Pennsylvania), china with cold painted details.
$25. **Right:** 2.75" tall, base stamped in red "JA-
PAN," china with cold painted details. $12.

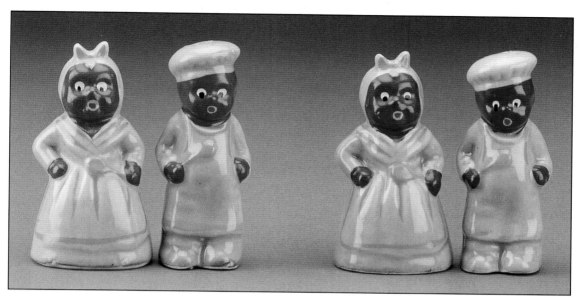

Mammy and Chef shakers in rarely-seen color. 4" tall, bottom of one stamped in black: "JAPAN," pottery with cold painted details. $90 pair.

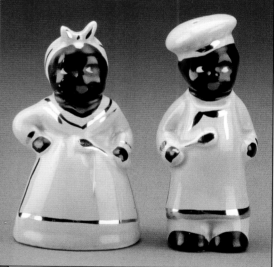

Mammy and Chef shakers in rarely-seen color. 4.75" tall, no manufacturer's information, pottery with cold painted details. $90 pair.

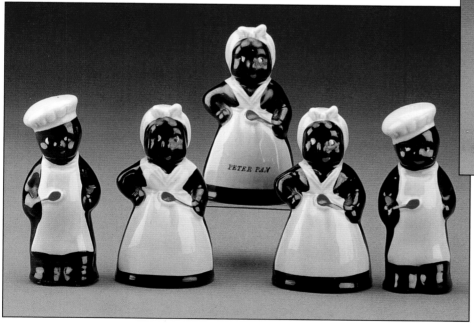

Mammy and Chef in black and blue with red spoons. **Back:** "PETER PAN," assumed to be a premium from this brand of peanut butter. **Front:** Matched pairs. All 4.5" tall, no manufacturer's information, pottery with cold painted details. Peter Pan shaker, $65; plain shakers, $45 each.

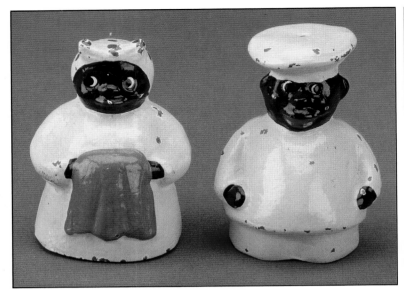

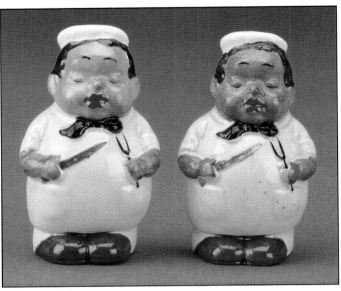

Mammy and Chef. About 2.25" tall, no manufacturer's information, metal. $65 pair.

Chefs. Almost 3.5" tall, bottoms stamped in red: "JAPAN," china with cold painted details. $95 pair.

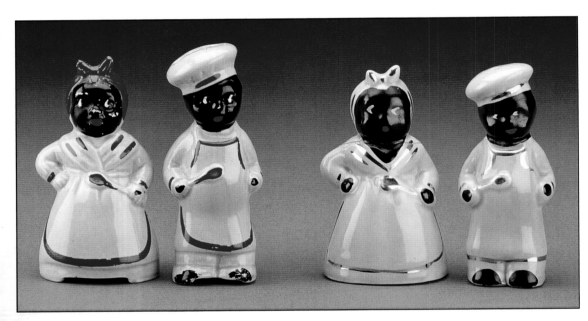

Mammies and Chefs in rarely-seen color. *Left:* 5" tall, no manufacturer's information. $100 pair (red details add to the value). *Right:* 4.75" tall, no manufacturer's information, pottery with cold painted details. $90 pair.

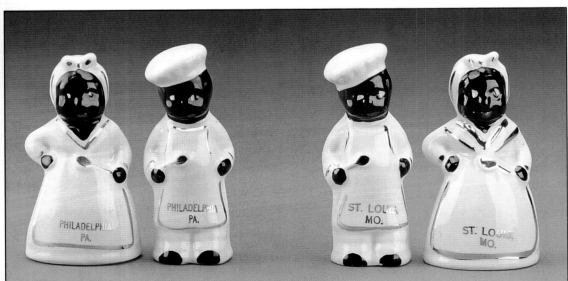

Souvenir Mammy and Chef shakers. *Left:* PHILA-DELPHIA PA.: 4.25" tall, no manufacturer's information. *Right:* ST. LOUIS MO.: 4.5" tall, no manufacturer's information. Pottery with cold painted details. $90 per pair (white shakers are more common than colorful ones).

PHILADELPHIA PA.

PHILADELPHIA PA.

ST. LOUIS MO.

ST. LOUIS MO.

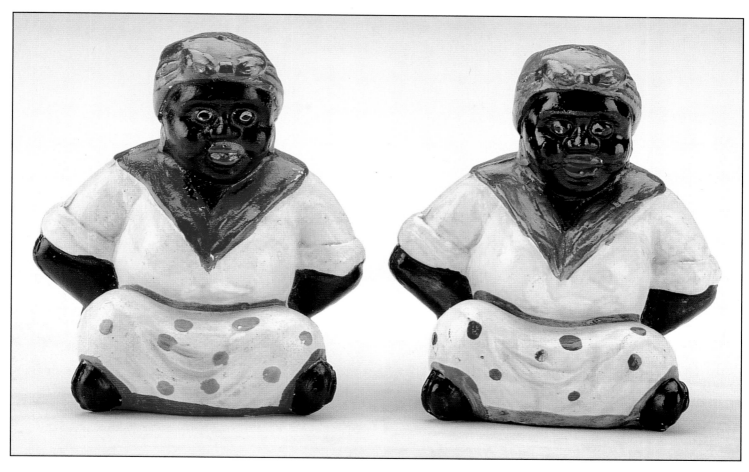

Seated Mammies. 4" tall, no manufacturer's information, chalk with cold painted details. $65 pair.

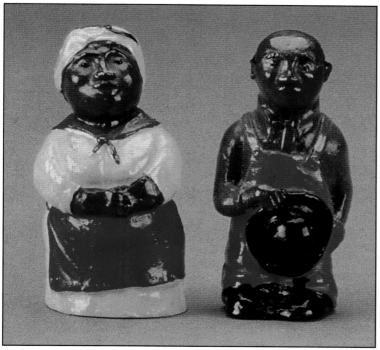

Mammy and Husband. 3.75" tall, no manufacturer's information, composition. $45 pair.

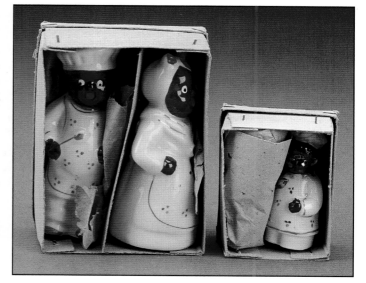

Mammy and Chef shakers in original boxes. *Left:* Box: almost 2.25" x 3.75" x 4.75", marked: "NO. 6584 1 SET. MADE IN JAPAN."; shakers: 4.5" tall, both stamped on bottom in light brown: "HANDPAINTED JAPAN." *Right:* Box: almost 1.5" x 2.25" x 3", marked: "MADE IN OCCUPIED JAPAN"; shakers: 3" tall, both stamped on bottom in red: "JAPAN." Shakers: $50 pair; boxes: $10 each.

Chef's heads. **Left:** 5" tall, no manufacturer's information, redware with cold painted details. $40 pair. **Right:** 4.5" tall, no manufacturer's information, pottery. $45 pair.

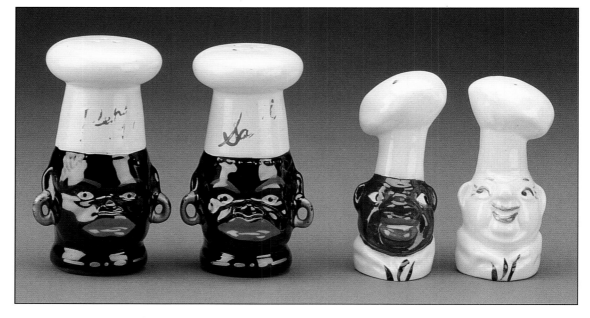

*Right:*
Salty and Peppy. **Back:** SALTY: 7.75" tall; PEPPY: 7.25" tall. **Front:** SALTY: 4.5" tall; PEPPY: just over 4" tall. All shakers are unmarked but known to be Pearl China, made in America, pottery. Tall shakers: $200 pair; short shakers, $150 pair.

*Far right:*
Mammy and Chef shakers, rarely seen with orange details. Mammies just under 4" tall, Chefs just over 4" tall. **Back/left:** Plain aprons, bottoms stamped in black: "MADE IN OCCUPIED JAPAN." **Front/right:** "MONTREAL CANADA" decals on aprons, pottery with cold painted details. $75 pair.

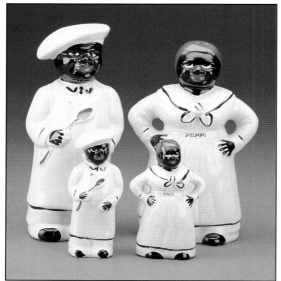

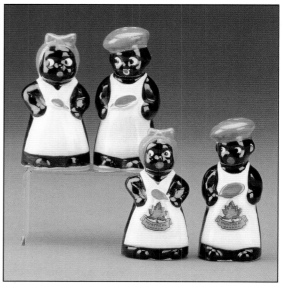

Mammy and Chef shakers with red details. Mammies in two sizes: 4.25" tall and 4.5" tall. Chefs in two sizes: 4.5" tall and 4.75" tall. **Front row:** "FRIENDSHIP INTERNATIONAL AIRPORT, MD" and "DETROIT, MICH." No shakers are marked, all are pottery with cold painted details. Plain shakers, $75 pair; souvenir shakers, $100 pair.

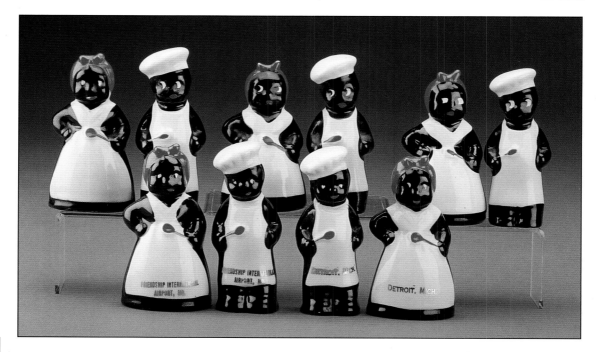

104

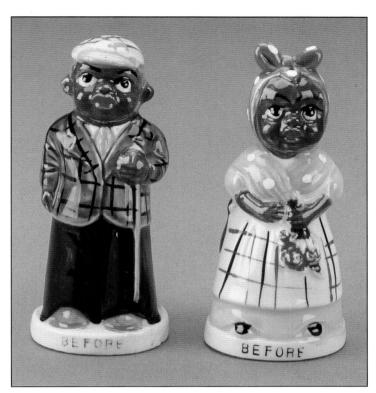
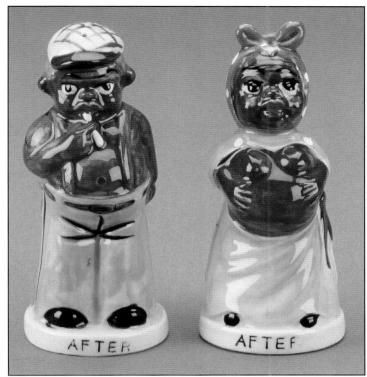

Married couple. Two-sided shakers depicting "before" and "after," about 5" tall, original sticker/label on bottom of each: "JAPAN," original price of $.98 remains on bottom, pottery. $125 pair.

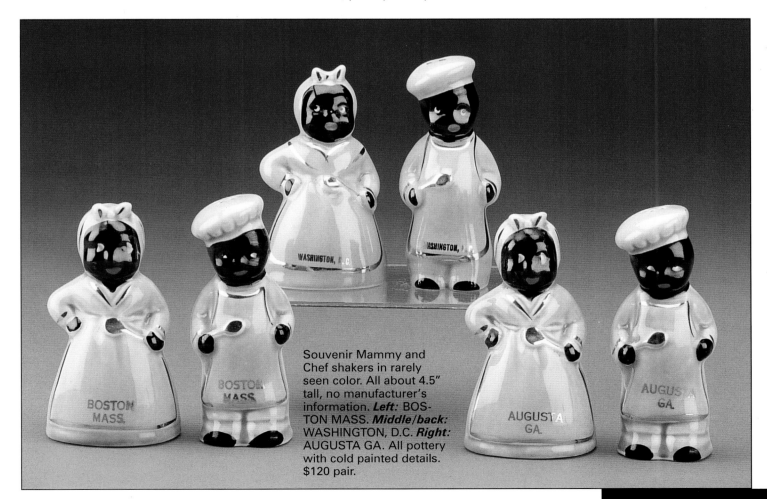

Souvenir Mammy and Chef shakers in rarely seen color. All about 4.5" tall, no manufacturer's information. *Left:* BOSTON MASS. *Middle/back:* WASHINGTON, D.C. *Right:* AUGUSTA GA. All pottery with cold painted details. $120 pair.

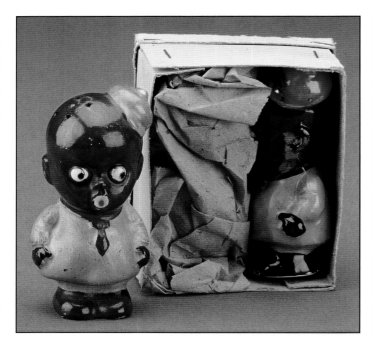

Men with orange hats in box. Just over 3" tall, bottoms stamped in brown: "JAPAN." Original 2.75" x 1.5" x 3.25" box remains, pottery with cold painted details. $50 pair, add $10 for box.

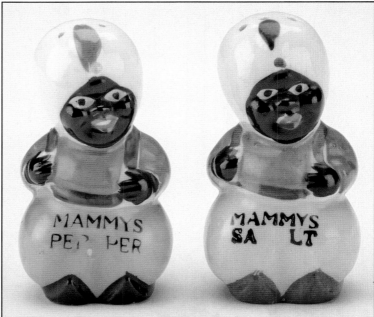

MAMMY'S SALT and MAMMY'S PEPPER. 3.25" tall, bottoms stamped in brown: "MADE IN JAPAN," china with cold painted details. $40 pair.

Mammy and Chef. 2.5" tall, bottoms stamped in red: "JAPAN," personalized for the recipients, china with cold painted details. $45 pair.

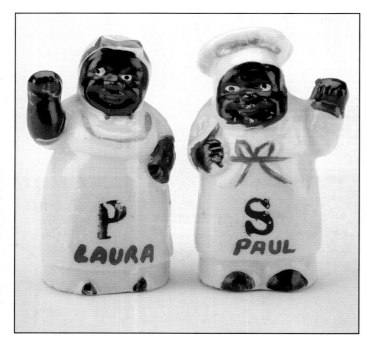

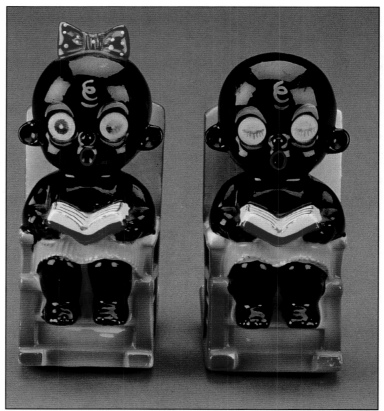

Rocking chair children with motion eyes. Girl: 5.25" tall, no manufacturer's information. Boy: 5" tall, no manufacturer's information. These shakers rock causing the motion eyes to wink, china with cold painted details. $65 pair.

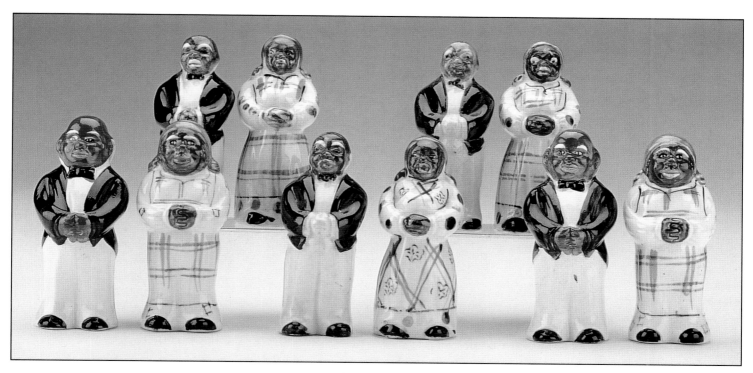

Five Pairs of Mammies and Butlers. Careful scrutiny will reveal that all five pairs of shakers are distinctly different. There are two head sizes, both small and large. The size differential is found with the butlers, but it is more evident when scrutinizing the mammies. As these are hand painted there are variations in the clothing that are less obvious but will be detailed here. All about 5" tall; all marked "JAPAN" or "MADE IN JAPAN," china with cold painted details. **Back left:** Butler: maroon vest below his hands, white lips; Mammy: four gold horizontal lines on her chest, dots on right arm touch. **Back right:** Butler: white hands (gloved?); Mammy: six gold horizontal lines on her chest, darker skin. **Front left:** (larger version) Butler: blue-gray hair, eyes clearly defined, large bowtie; Mammy: white eyebrows, diamonds on sleeves and on hem of dress. **Front middle:** Butler: white hands (gloved?), darkest skin tone of all the men; Mammy: flowers mingled among diagonal plaid. **Front right:** (larger version) similar to front left set with darker skin; Butler: lapel is gray, not black; Mammy: diamonds on sleeves and on hem of dress dark blue, almost navy. $125 pair.

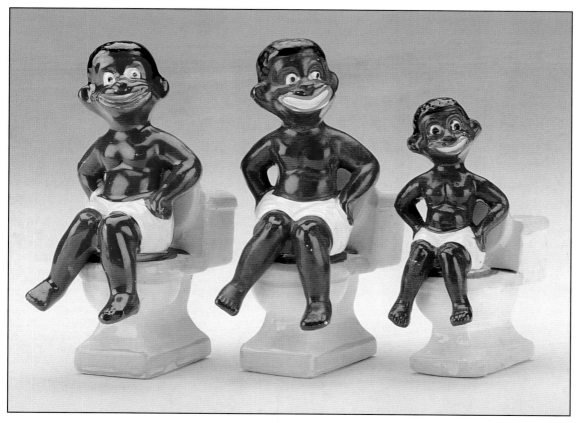

Two-part shakers: boys on toilets. **Left:** Toilet: 3.75" tall, three pouring holes in triangle on tank; boy: lips together, 4.25" from toes to head. **Middle:** Toilet: 3.75" tall, three pouring holes in straight line on tank; boy: teeth showing, 4.25" from toes to head. **Right:** Toilet: 3" tall; boy: 3.5" from toes to head. Boys have no manufacturer's information; toilets are stamped on the bottom in brown: "JAPAN," china with cold painted details. $80 each set.

Three-part shaker (XXX): woman's breasts. Each 1.5" tall breast is a shaker, original stickers/labels: "JAPAN," redware with cold painted details. $50 set.

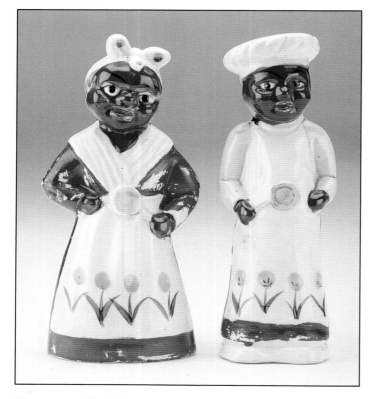

Mammy and Chef. Rare size - 8.25" tall, original sticker/label: "JAPAN," china with cold painted details, the flowers on the aprons are quite unusual. $125 pair.

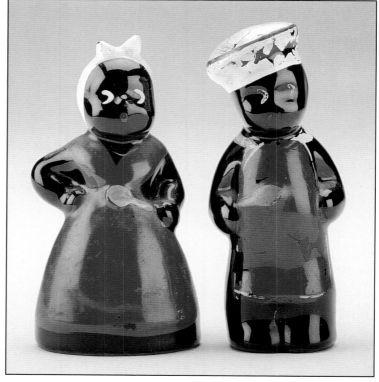

Mammy and Chef. 4.75" tall, original sticker/label: "MADE IN JAPAN," redware with cold painted details. Although the colors on these shakers are uncommon they are in low value due to the poorly applied paint that is peeling. $40 pair.

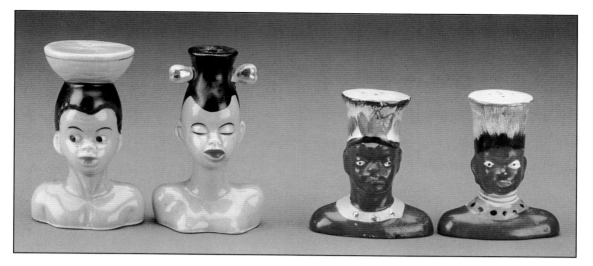

Native heads. **Left:** 3.75" tall, bottoms stamped in brown: "JAPAN." **Right:** 3" tall, bottoms stamped in black: "MADE IN JAPAN." China with cold painted details. $35 pair.

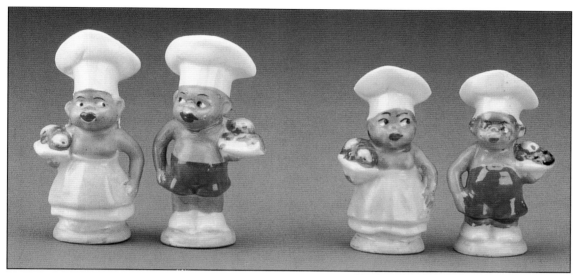

Natives with chef's hats. **Left:** 3.5" tall. **Right:** 3" tall. All bottoms stamped in brown: "JAPAN," china with cold painted details. **Note:** a figurine of a native with a chef's hat is pictured with the figurines. $45 pair.

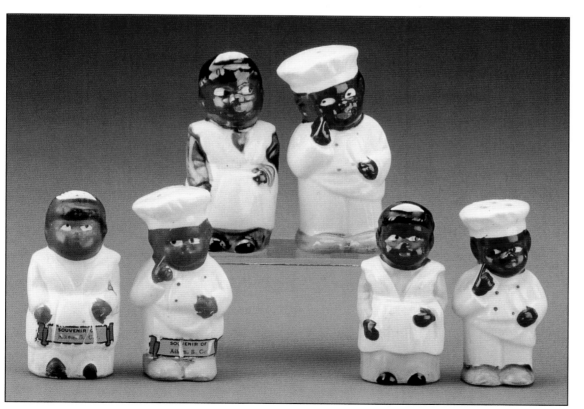

Three pairs of Mammies and Chefs. **Left:** 3" tall, bottoms stamped in brown: "JAPAN," original sticker/label: "SOUVENIR OF Aiken, S.C." **Middle/ back:** 3.25" tall, Mammy: bottom stamped in black: "JAPAN"; chef: bottom stamped in black: "OCCUPIED JAPAN." **Right:** 2.75" tall, bottoms stamped in brown: "JAPAN." China with cold painted details. $45 pair.

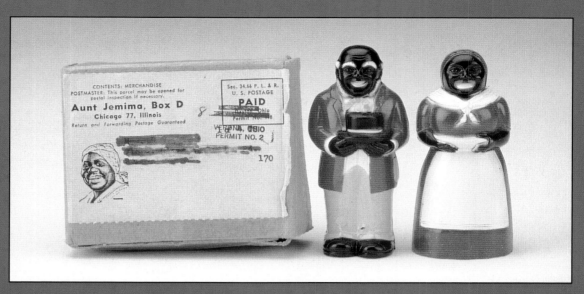

Aunt Jemima and Uncle Mose. Almost 3.75" tall, "F & F MOLD & DIE WORKS DAYTON, OHIO MADE IN U.S.A." These were a premium one acquired through Aunt Jemima products, plastic. Shakers, $50 pair; original mailer box, $25.

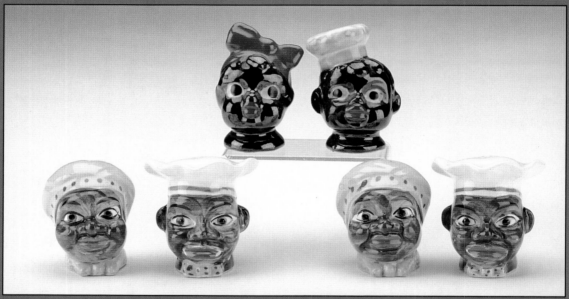

Mammy and Chef heads. *Back:* 3" tall, no manufacturer's information, redware with cold painted details. $45 Pair.

Natives. 3.25" tall, one shaker is unmarked while the other has a bottom stamped in brown: "JAPAN," china with cold painted details. $35 pair.

Rastus and Liza. Just over 2.5" tall, no manufacturer's information, back of one marked: "Orono ME.," back of other marked with original price of $.29, wood. $15 pair.

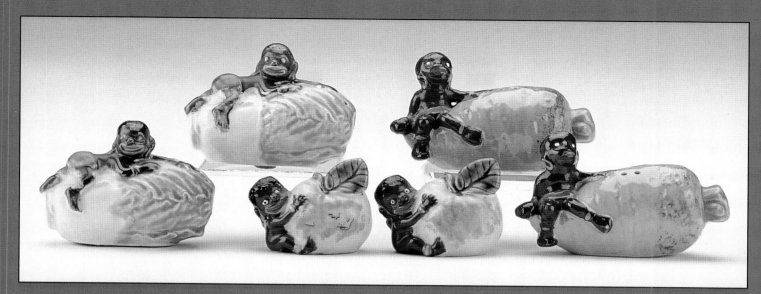

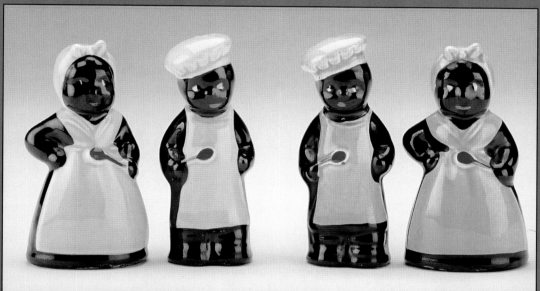

Natives with produce. **Left:** 3" long, bottoms stamped in black: "JAPAN." **Middle:** 2.25" long, no manufacturer's information. **Right:** 3.5" long, bottoms stamped in black: "JAPAN." China with cold painted details. $40 pair.

Mammies and Chefs. 4.5" tall, no manufacturer's information, uncommon color combinations, pottery. $80 pair.

Jazz players. Saxophone player, 2.75" tall; Trumpet player, 3.75" tall, Clay Art, circa 1995, pottery. Shakers, $25 pair; box, $5.

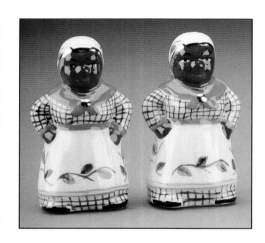

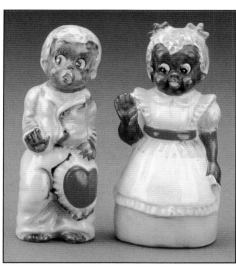

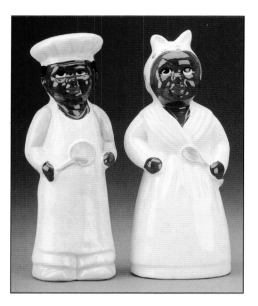

Mammies. 3.75" tall, no manufacturer's information but known to be Erwin Pottery Hand Painted Erwin, Tenn., Hand-painted Pottery By Negatha R. The matching cookie jar is pictured in this book, pottery. $85 pair.

Sweethearts. 5" tall, bottoms stamped in red: "MADE IN JAPAN," china with cold painted details. $125 pair.

Mammy and Chef. Rare size – 8.25" tall, bottoms stamped in black: " MADE IN JAPAN" with a laurel wreath. This pair is unique because there are few colorful details. Were these originally sold as found or have some of the cold paint details been washed away? This set would have little interest to most collectors. Pottery with cold painted details. $40 pair.

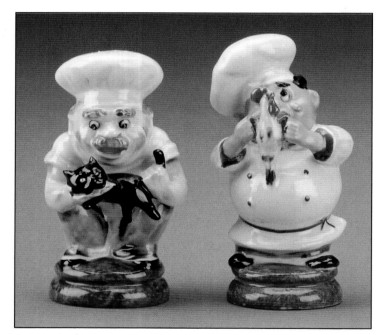

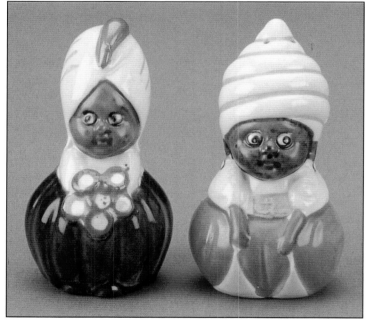

Chefs. 4.25" tall, bottoms stamped in red: "HAND PAINTED Shafford China JAPAN," china with cold painted details. $85 pair.

Men in turbans. 3.5" tall, bottoms stamped in brown: "JAPAN," china with cold painted details. $35 pair.

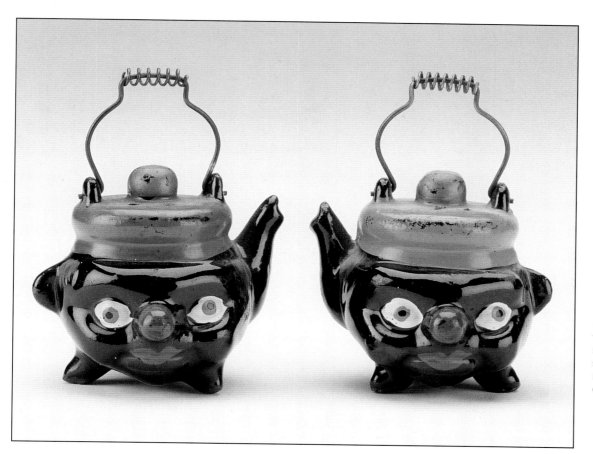

Clown teapots. 4.5" tall to top of wire handles, one shaker has the original sticker/label: "JAPAN," redware with cold painted details. $30 pair.

Close-up of "JONA AND THE WHALE" sticker/label.

Jona and the Whale. Jona: 2.25" tall; whale: 4" long, both have the original sticker/label: "JAPAN" and the whale has a "JONA AND THE WHALE" sticker/label. China with cold painted details. $125 pair.

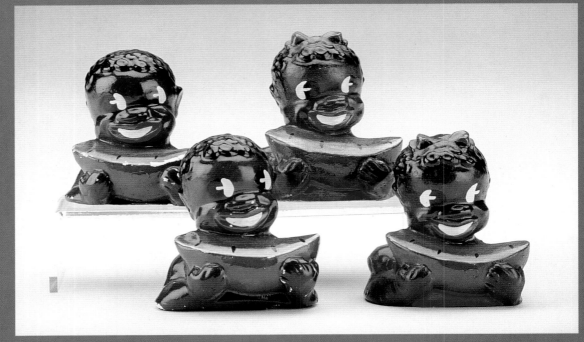

Children with watermelons. 2.5" tall, no manufacturer's information. The holes to pour salt and pepper are located at the back of the necks, not at the tops of the heads as one would expect, composition. $45 per pair.

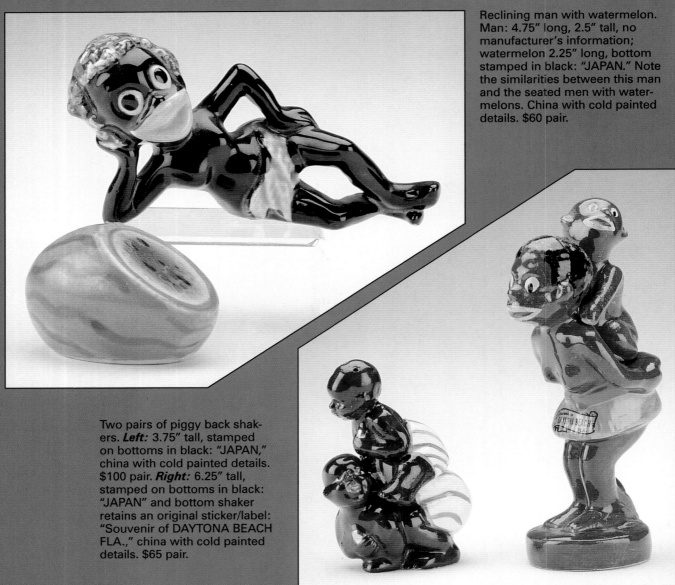

Reclining man with watermelon. Man: 4.75" long, 2.5" tall, no manufacturer's information; watermelon 2.25" long, bottom stamped in black: "JAPAN." Note the similarities between this man and the seated men with watermelons. China with cold painted details. $60 pair.

Two pairs of piggy back shakers. *Left:* 3.75" tall, stamped on bottoms in black: "JAPAN," china with cold painted details. $100 pair. *Right:* 6.25" tall, stamped on bottoms in black: "JAPAN" and bottom shaker retains an original sticker/label: "Souvenir of DAYTONA BEACH FLA.," china with cold painted details. $65 pair.

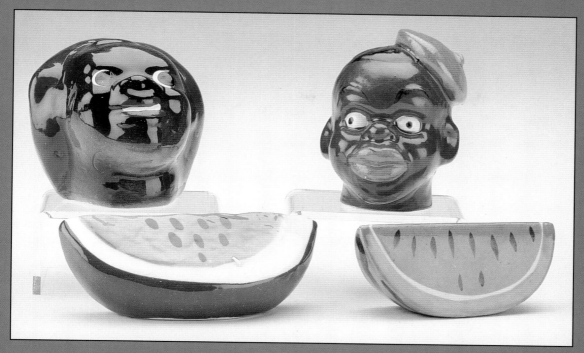

Watermelons and heads. *Left:* Watermelon: 3.75" long; head: 2.25" tall, no manufacturer's information. *Right:* Watermelon: 3" long; head: 2.5" tall, bottoms stamped in brown: "JAPAN." Both sets are china with cold painted details. $60 pair.

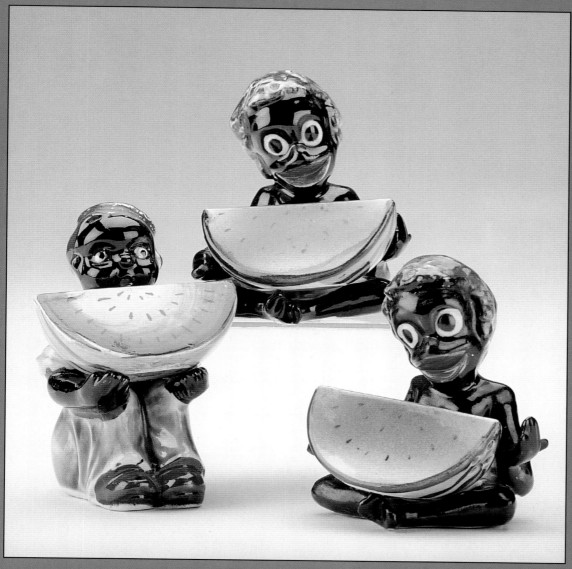

Seated men with watermelons. *Left:* Man: 4" tall; watermelon: 2.75" long, no manufacturer's information. *Middle/ back and right:* Men: 3.25" tall, bottoms stamped in black: "JAPAN," watermelons: 2.5" long, bottoms stamped in black: "JAPAN," china with cold painted details. $85 pair.

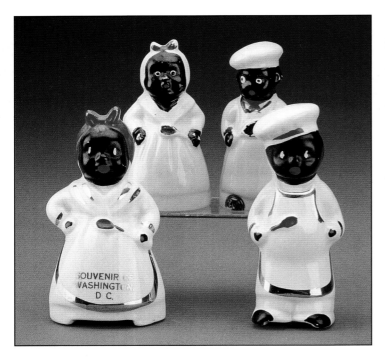

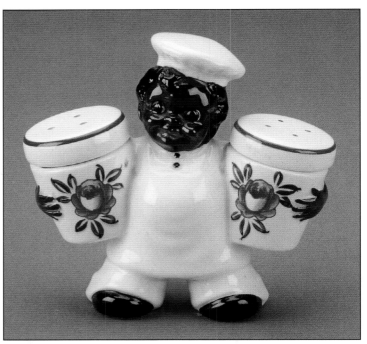

Two pairs of Mammies and Chefs. **Back:** 4" tall, both stamped on bottom in black: "JAPAN," wooden spoons are blue. $35. **Front:** Mammy: 5" tall, "SOUVENIR OF WASHINGTON, D.C."; Chef: 5" tall, no manufacturer's information, wooden spoons are red and the gold trim is exceptionally broad, pottery. $65.

Chef with flower pots. 5" tall, no manufacturer's information. The salt and pepper shakers are the removable pots in the Chef's arms, pottery. $75.

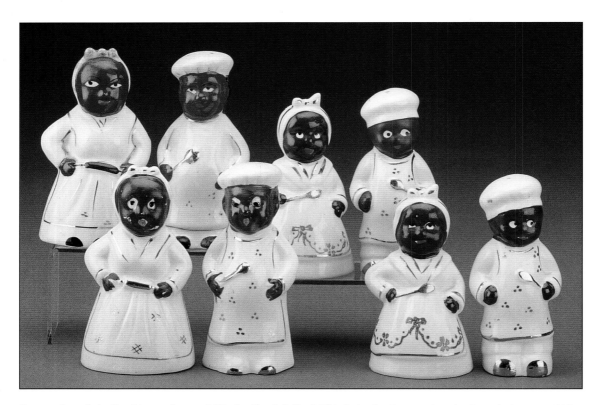

Four pairs of similar Mammies and Chefs. **Back left:** 4.5" tall, both stamped on bottom in brown: "JAPAN." This pair has some unusual details: Mammy had a blue rolling pin and apron tie, and her bow is rose-colored. Chef has turquoise blue stripes on his pants and matching trim around the back of his collar. **Back right:** Mammy: 4.25" tall, chef: 4.5" tall, bottom stamped in brown: "JAPAN." **Front left:** 4.5" tall, both stamped on bottom in brown: "HAND PAINTED JAPAN." Mammy has an orange garland on her apron. **Front right:** 4.5" tall, both stamped on bottom in brown: "HAND PAINTED JAPAN." Mammy has an orange garland on her apron. China with cold painted details. $50 pair.

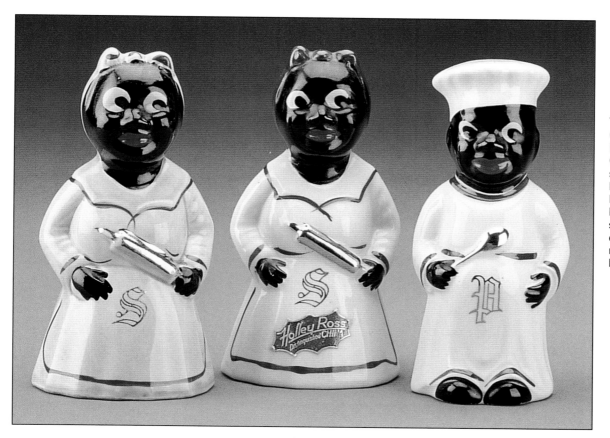

Two Mammies and a Chef. 5.75" tall; "Holley Ross Distinguished CHINA"; both Mammies stamped on bottom in black, "Hand Painted." Note the original sticker/label on the middle shaker, pottery. $40 each; add $10 for a manufacturer's sticker/label.

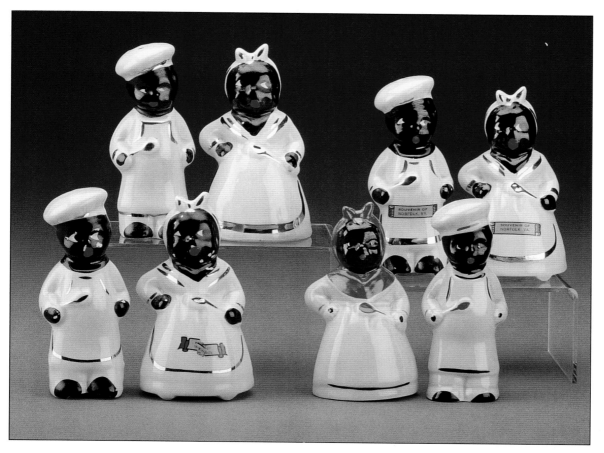

Four pairs of Mammies and Chefs. All 5" tall, no manufacturer's information. *Back left:* plain. *Back right:* original sticker/label: "SOUVENIR OF NORFOLK VA." *Front left:* original sticker/label: "SOUVENIR OF WEST VIRGINIA." *Front right:* reddish-orange trim, pottery. Plain, $75 pair; others, $85 pair.

Alligators and men. **Left:** Alligator: 5.5" long with original sticker/label: "Souvenir OLD ORCHARD BEACH, ME."; man: 3" long, no manufacturer's information. **Right:** Alligator: 4" long, no manufacturer's information; man: 2.5" tall, original sticker/label: "MADE IN JAPAN." China with cold painted details. $100 each pair.

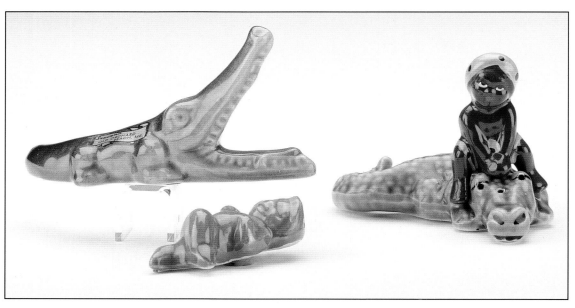

**Left:** Camel: 4" long, 3.5" tall; Rider: 3.5" tall, stamped on bottoms in brown: "JAPAN." **Middle/back:** Peanut base: 4.75" x 2.75"; figures about 2.5" tall, all pieces stamped on bottoms in brown: "JAPAN." **Right:** Basket: 4.5" long, 4" tall; figures: 3" tall, all pieces retain an original sticker/label: "MADE IN JAPAN." $125 each set.

Three pairs of natives. **Left:** Couple with colorful shields in front: 2.75" tall, stamped on bottoms in green: "PY JAPAN." **Middle/back:** Graduates: 3.25" tall, stamped on bottoms in black: "JAPAN." **Right:** Spear holders in grass skirts: 3.5" tall, stamped on bottoms in green: "JAPAN." $35 each pair.

Two pairs of Mammies and Chefs. Mammies: 4.5" tall; chefs: 4.75" tall; stamped on bottoms in black: "ABRAYTON CALIFORNIA U.S.A.," pottery. $75 pair.

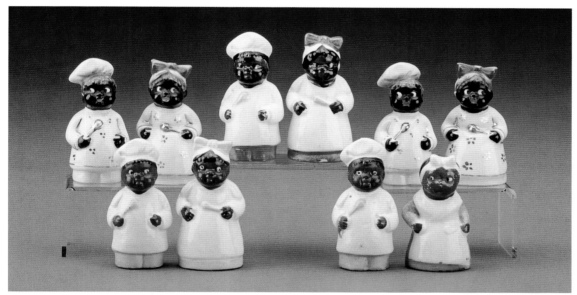

Five pairs of Mammies and Chefs. 3" tall, stamped on bottoms in black or brown: "JAPAN," note the slight variations, china with cold painted details. $45 pair.

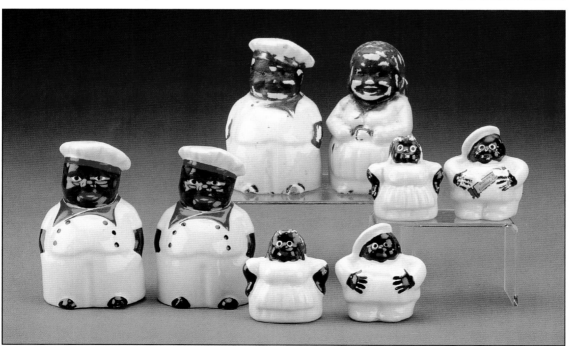

Mammies and Chefs. **Back/middle:** 4.5" tall, no manufacturer's information, note the poor condition. **Far left:** 4.5" tall, no manufacturer's information, note that these are two salt shakers as Mammy is the pepper. **Front middle:** 2.75" tall, no manufacturer's information. **Far right:** 2.75" tall, no manufacturer's information, note the original sticker/label: "SOUVENIR OF Guilford, Conn." Pottery. Tall shakers in good condition, $75 pair; short shakers, $45 pair.

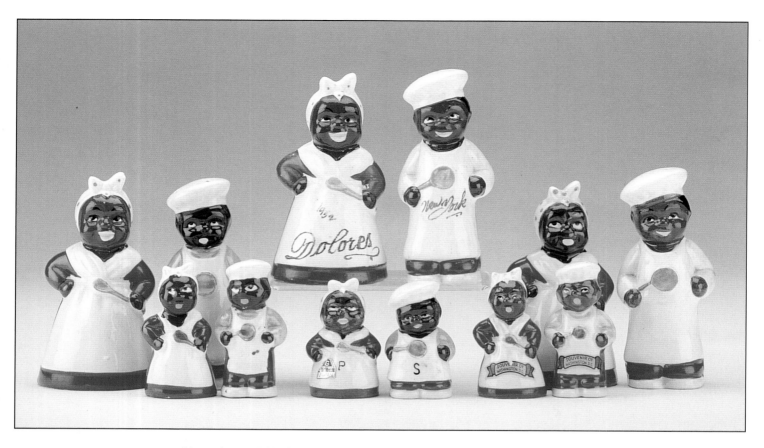

Mammies and Chefs. The color scheme presented here is the one that is most commonly-seen with these mammies and chefs. This grouping presents two sizes as well as personalization of the pair of shakers in the back/middle and souvenir stickers/labels on the pair in the front, far right. As these shakers are relatively common one can be discriminating when selecting shakers for purchase. Tall shakers: 5.25" tall; short shakers: 2.75" tall. Original sticker/label reveals the manufacturer as "G NOV. CO. JAPAN," "Nov" probably is an abbreviation for "Novelty." Tall shakers, $50 pair; add $20 for personalization; short shakers: $35 pair; add $15 for stickers/labels.

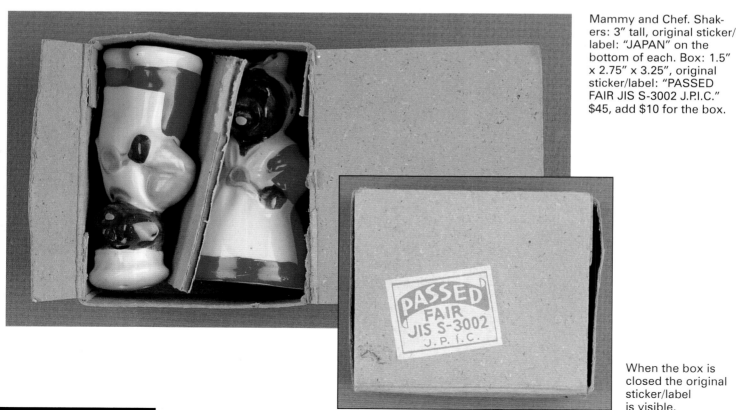

Mammy and Chef. Shakers: 3" tall, original sticker/label: "JAPAN" on the bottom of each. Box: 1.5" x 2.75" x 3.25", original sticker/label: "PASSED FAIR JIS S-3002 J.P.I.C." $45, add $10 for the box.

When the box is closed the original sticker/label is visible.

## Shakers – Spices and Spice Racks

The use of spices and herbs begins with the earliest people. Foods wrapped in leaves and the use of various plant parts enhanced the flavor of food, over-powered the scent and taste of rotten food, and helped to preserve food.

The history of spices can be traced to 3000 BC when Arab traders brought spices to their people. In the 1300s BC the Phoenicians acquired spices and marketed them in more distant Mediterranean regions. It is documented that around 1000 BC Queen Sheba called upon King Solomon and offered him gifts which included spices.

Europeans learned of spices from Arab traders, and the history of the Roman Empire includes many accounts of using spices. Spices, particularly pepper, were seen as a wealthy man's pleasure. Even the three wise men that came to baby Jesus carried spices as gifts.

In the 400s AD prophet Mohammed was a spice seller and used his occupation to provide an opportunity to proselytize.

The word "spice" wasn't used until the 1100s. The root of this word is the Latin word "species" as there were so many spices and spice products from many species of plants.

The explorers of the 1200s were motivated to find new routes to acquire gold and spices, and the trade routes they established over the next few centuries were followed until World War II.

At the end of the 1700s ships from New England joined the spice trade and pepper became so available that the price tumbled in the early to mid-1800s. The westward expansion of our country led to the discovery of Mexican spices and new flavors were added to the American palate.

The spice shakers presented here are post WWII. Ceramic, pottery, and china shakers were most often made in Japan; plastic shakers are from the 1950s and were made in America.

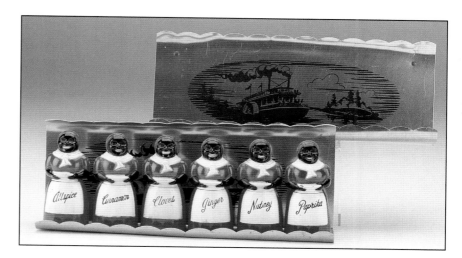

Spices and steamboat rack. Spices: 4" tall, bottoms marked: AUNT JEMIMA F & F TOOL & DIE WORKS DAYTON, OHIO MADE IN U.S.A. Look for a plastic "lid" which creates a shaker top when separated at her waist. These plastic shakers were acquired by mailing in box tops of Aunt Jemima Pancake Mix with seventy-five cents. Cinnamon, Cloves, and Nutmeg were received. To complete the set one would have to send in additional box tops with money and fewer people did this, resulting in considerably more shakers from the initial offering. Greater supply causes a lower value. Cinnamon, Paprika, Nutmeg, $50 each. Ginger, Allspice, Cloves, $150 each. Spice rack: 11.75" across, 4.5" tall, no manufacturer's information. The rack was also acquired as a mail-in offer and few people took advantage of this making the rack difficult to find. Note the steamboat and "THE MISSISSIPPI" on the back, decorations that are totally hidden when the spices are inserted. Copper plated aluminum. $500.

"Spices" rack. 13.5" long across the back, 2.25" tall, no manufacturer's information, made in red and yellow, often incorrectly paired with F & F Mammy shakers. Thought to be Lustro-ware. Plastic. $45.

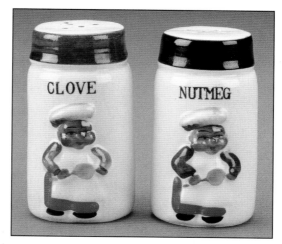

CLOVE and NUTMEG. 3" tall, no manufacturer's information, pottery. $35 each.

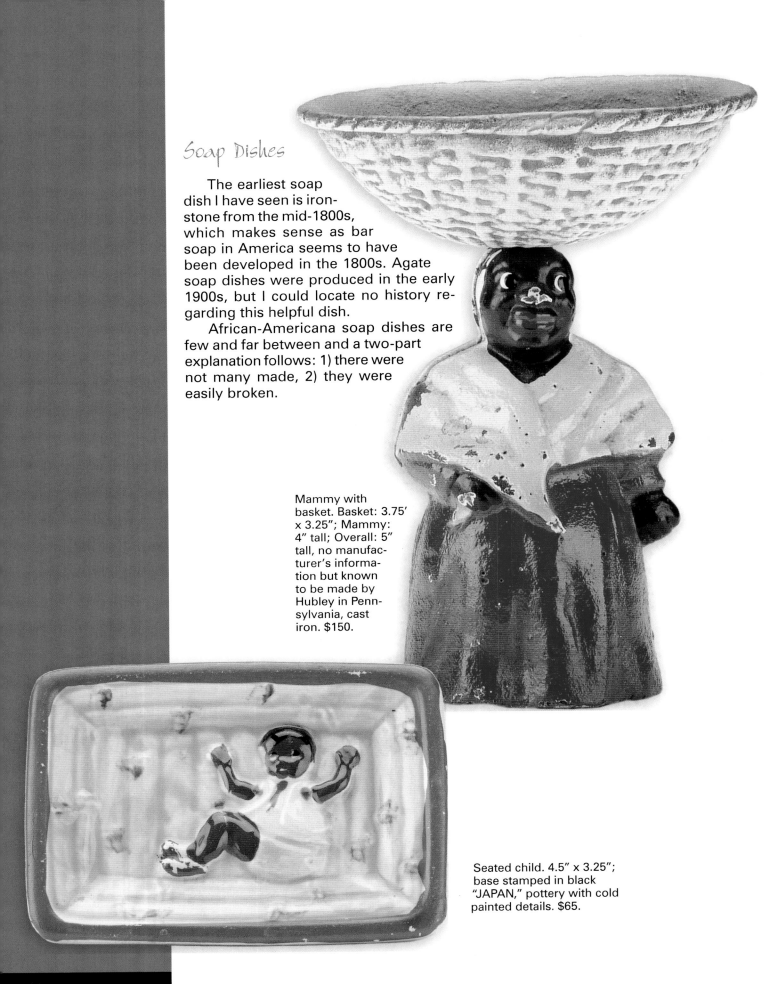

## Soap Dishes

The earliest soap dish I have seen is ironstone from the mid-1800s, which makes sense as bar soap in America seems to have been developed in the 1800s. Agate soap dishes were produced in the early 1900s, but I could locate no history regarding this helpful dish.

African-Americana soap dishes are few and far between and a two-part explanation follows: 1) there were not many made, 2) they were easily broken.

Mammy with basket. Basket: 3.75' x 3.25"; Mammy: 4" tall; Overall: 5" tall, no manufacturer's information but known to be made by Hubley in Pennsylvania, cast iron. $150.

Seated child. 4.5" x 3.25"; base stamped in black "JAPAN," pottery with cold painted details. $65.

## Spoon Rests

There seems to be no history for spoon rests, but one can assume that, although there always would have been a need to have a location to place a cooking spoon while preparing a meal, the concept of purchasing a specific item for this limited task is a modern one. The examples shown here would have been produced after WWII during a healthy economic period.

Today it is common to find a spoon rest positioned on the cooking surface of most American homes.

Chef's head and tie. 3" x 8.5", no manufacturer's information but presumed to be made in Japan, china with cold painted details. $125.

Chef's head. 7" x 4", no manufacturer's information but presumed to be made in Japan, china with cold painted details, end marked "SPOON REST." $125.

## String Holders

As early as 4000 BC tree sap was utilized as glue and both the ancient Greeks and Romans developed recipes for adhesives. It wasn't until 1750 that the first patent for glue was granted in England for a substance made from fish.

The successful use of adhesives didn't really occur until the mid-1900s with the growth of the chemical industry. Meanwhile, people needed a way to secure packages and the method of choice was using string.

String holders were created as a way to keep a ball of string accessible and tangle-free. Heavy, cast iron string holders would be suitable for a store countertop as they would be difficult to pull off or drop onto the floor. Domestic string holders were lighter versions of commercial ones and in the 1930s they evolved from something strictly utilitarian to something decorative as the examples presented here.

*Below:*
Three string holders. *Left:* Mammy. 3.75" x 6.5", inside bottom stamped in green: "MADE IN JAPAN," china with cold painted details. $175. *Middle/front:* Mammy. 4.25" x 6.5", inside stamped in green: "PATENT Kinode JAPAN," china with cold painted details. $175. *Right:* Butler. 3.75" x 6.5", inside bottom stamped in black: "JAPAN," china. $175.

Mammy. No manufacturer's information, pottery. $175.

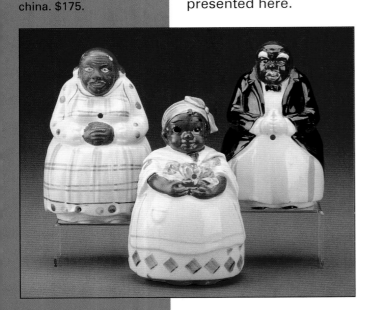

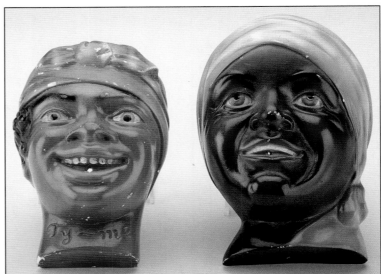

*Left:* Boy with polka dot bandana. 7.5" x 4.5", no manufacturer's information, neck marked: "Ty~me," chalkware. $175. *Right:* Man with yellow bandana. 9.25" x 5.25", no manufacturer's information, chalkware. $175.

# Teapots

It is unclear exactly when the beverage tea evolved, but, no matter which of the many legends is embraced, by the 800s AD the Chinese were adding leaves to hot water to create a flavorful drink.

Initially the Chinese used tea leaves that were rolled by hand, dried, and made into cakes that were dropped into hot water. In the 1200s the Japanese added loose leaves to boiling water which was whipped into a frothy texture. The medicinal use of tea that one would drink from a bowl continued for another 500 years in China and Japan.

Teapots were developed to create a tea delivery system, and they first appeared sometime during the Ming Dynasty, 1368-1644. Tea was steeped in a single-serving spouted vessel that one would drink from the spout. The earliest models were made from an unglazed purple clay call zisha. These YiXing teapots absorbed the flavor of the tea and became more cherished the more seasoned they became. The YiXing teapot style is still being manufactured. Islamic coffee pots and Chinese wine vessels were also thought to contribute to the design of these early teapots as their shapes were very similar to that of a teapot.

By the 1800s Asian use of tea extended to ceremonial consumption and the teapot was redesigned by the Chinese who traveled to Japan to teach their pottery methods to the Japanese.

Meanwhile, tea had become an important beverage through much of Europe and America so the teapot became an accessory needed by many.

The prosperity of the 1920 brought an interest in design to many household items that had previously been utilitarian. The teapot was one of many things that were a magnet for creative inspiration and radical designs continued until World War II when the manufacturing of household goods was ceased.

The teapots shown here were made in Japan after WWII. The basic shape of the vessel doesn't change, the artistic execution does.

Clown. **Teapot base:** 7.25" long, 3" tall, original sticker/label: "THAMES Hand Painted MADE IN JAPAN," bottom stamped in gold: " DES. PAT. PEND." **Creamer:** 5" long, 1.75" tall, original sticker/label: "THAMES Hand Painted MADE IN JAPAN." **Sugar bowl:** 5" long, 2" tall, original sticker/label: "THAMES Hand Painted MADE IN JAPAN," lid: 2.75" x 2.25." Redware with cold painted details, this was found in the original box packed in excelsior. The box is stamped: "52/527 1 SET." $65 for the complete set

The sticker/label found on three pieces.

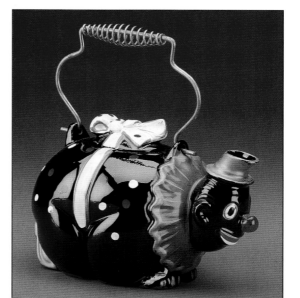

Clown. 8" long, 5" tall, original sticker/label: "JAPAN," redware with cold painted details. $50.

## Thermometers

It is known that the Italian mathematician Galileo Galilei (1564-1642) invented the thermometer, but the year is unknown. Typically modern thermometers have alcohol or mercury that expands when hot and contracts when cold. The level of this liquid in a small tube that is calibrated changes size enabling one to determine the temperature. Americans use the Fahrenheit scale for temperatures that was invented by Gabriel Fahrenheit in 1714.

Diaper Dan's diaper originally changed color – blue for high atmospheric pressure and pink for low atmospheric pressure – as he posed with the thermometer. The composition Dan is fairly common but the plastic version is relatively rare. One can assume composition Diaper Dans are earlier, some have a 1949 copyright on them, while the plastic versions are from the 1950s. Apparently more composition models were produced.

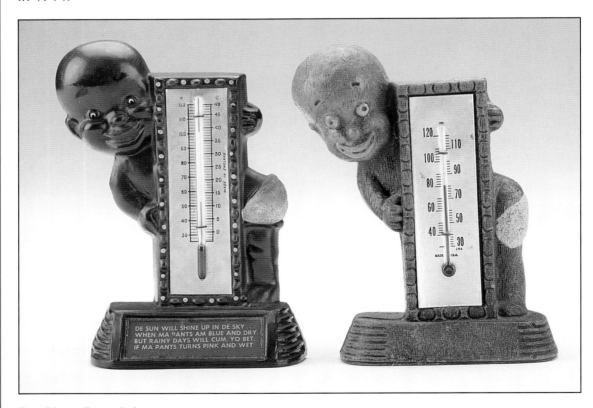

Two Diaper Dans. **Left:** 5.75"tall, Made in England, Plastic. "DE SUN WILL SHINE UP IN DE SKY WHEN MA PANTS AM BLUE AND DRY BUT RAINTY DAYS WILL CUM YO BET IF MA PANTS TURNS PINK AND WET." $60. **Right:** Multi Products Inc., Chicago, composition, 5.75" tall. $25.

After early humans learned to use the position of the sun to tell the time of day, the sun dial was developed. About 1400 BC Egyptians invented the water clock. The ancient Greeks improved the water clock and went on to devise the calendar with twelve months of thirty days each.

Egyptians and Babylonians divided the days and nights into unequal segments of time. The days eventually got divided into twenty-four hours with each hour havING a value of sixty minutes and each minute having sixty seconds based on the Sumerian sexagesimal system from 4000-3000 BC, a conversion system that still influences our measurement.

Records indicate the use of sand timers by 1400 AD. These glass containers housed sand that flowed from one container to another and offered a concrete representation of the abstract understanding of time as something that was free flowing. Although these became known as hour glasses, the sand timer was made in many different sizes and WAS used prolifically through the end of the 1800s.

The German inventor, Peter Henlein, (c. 1480-1542) developed the spring-powered clock around 1510. Jost Burji added a minute hand in 1577 and Christian Huygens (1629-1695) developed the pendulum in 1656. He went on to build the first balance wheel and spring assembly, the foundation of modern wrist watches. All of these benchmarks still left mankind with inaccurate timepieces.

External batteries were added to pendulum clocks in 1840 and moved inside the clock around 1906. Harnessing the energy of quartz crystals in 1920 resulted in truly accurate clocks and watches.

The kitchen timers featured here use sand to mark the passage of time. Normally they measured three minutes, the time needed to cook soft boiled eggs. It is worth noting that in the days of party telephone lines these timers were also used to monitor one's use or overuse of the telephone.

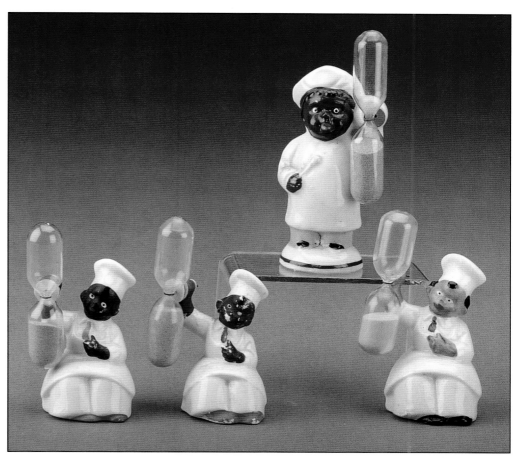

Four Chefs. *Far left:* 1.5" wide, 3.5" tall overall, bottom stamped in black: "Germany." *Second from left:* 1.25" wide, 3.5" tall overall, no manufacturer's information. *Second from right/back:* 4.5" tall overall, bottom stamped in black: "JAPAN," *Far right:* 1.5" wide, 3.75" tall overall, no manufacturer's information. All are china with cold painted details including noticeable differences in skin tone. $125 each.

## Toaster Covers

The earliest people made bread-like cakes using barley and wheat, and a millstone created for this purpose about 7,500 years ago has been found. Loaves of bread 5,000 years old have survived in Egyptian tombs, so clearly the job of a baker is one of the earliest trades.

The word "toast" evolved from the Latin words "torrere" and "tostum" which translate to "scorch" or "burn," and the Romans toasted bread to preserve it. As the Roman Empire grew and their sphere of influence extended Roman customs were introduced and adopted over a vast region and toasting bread was one routine that reached the Britons.

Before electricity man depended on fire to toast bread and through the centuries an interesting assortment of forks were created to assist in the toasting endeavor. Eventually hinged wire holders were developed.

The 1893 World's Columbia Exposition in Chicago featured an "all electric" kitchen but missing from the assortment of appliances and applications was the toaster which had been invented that same year. The first electric toaster was developed in England by Crompton and Company in 1893, and the first American toaster was patented in 1909. Probably the single most influential inventor related to the development

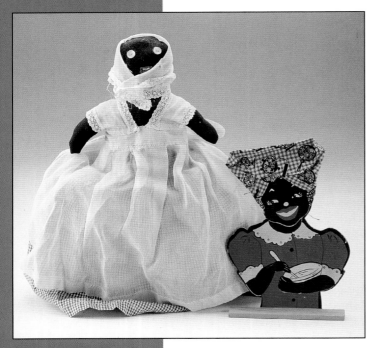

**Left:** Complete cover (the dress billows over the appliance) 17" long, hand crafted, fabric. $12. **Right:** Commercially made Mammy that will be "dressed" by Mother in fabrics that would match her kitchen. Cardboard, wood, and fabric. $20.

of the toaster is Charles Strite. He was able to build a toaster with heating elements on two sides, a timer to turn off the electricity/heat, and an ejection component to pop up the toast when ready. His patent, number 1,394,450 issued on October 18, 1921, became known as "the Toastmaster" which was initially offered to restaurants. Domestic versions of the Toastmaster were introduced in 1926 and included a lever to adjust the darkness of the toast. The Toastmaster was an expensive luxury item that few people could afford, even during this era of financial health. This toaster in its basic form was so well designed that its manufacture continued into the 1950s.

Another invention contributed to the growth of the toaster, the invention of the bread slicer. Otto Frederick Rohwedder (1880-1960) spent sixteen years developing this technology. In 1928 he succeeded in producing a machine that would slice and wrap a loaf of bread. Wonder Bread became the first major commercial brand of pre-sliced bread. It is interesting to note that during World War II pre-sliced bread was eliminated as the metal for the slicing blades was unavailable; metal was used for the war effort and domestic applications were extremely limited.

Small appliance covers were introduced in the 1930s, predominately for toasters and mixers as a way to maintain cleanliness in the kitchen. Figural covers as the ones shown here utilized a doll-like top with a billowing skirt to envelope the toaster while adding a decorative element to the kitchen.

Toaster covers were commercially made and of course hand crafted. The example on the right shows the top half of a cover commercially produced in wood, cardboard, and fabric while the full toaster cover on the left is entirely fabric and hand crafted. Mammy toaster covers represent one of many styles that became available and were used predominately until the 1960s.

## Tumblers and Coasters

Glass companies began decorating tumblers in the late 1920s and early 1930s utilizing several basic techniques. The earliest process was painting decorations by hand, and at one point Bartlett-Collins Company in Oklahoma employed one hundred women to produce hand painted glassware, most of this was tumblers with matching pitchers. Even early striped designs were done by hand, although various configurations to provide the rotation of the tumbler to be painted were created; sometimes the table turned, sometimes the glass turned. Real mechanization occurred in the mid-1930s when Kraft cheese products were packaged in small "Swankyswigs." This extremely successful marketing campaign that was introduced in 1933 was hugely influential on the growth of decorated tumblers. To produce some of the Swankyswig designs a stencil was cut with the design to be applied to the glass and a squeegee applied the color. Silk-screening was introduced in the early 1930s and became widely used by the mid- to late-1930s, and this opened the designs to multiple colors that could be applied mechanically.

The decorated tumbler was now an integral part of the American Kitchen. Naturally designs reflected themes and colors that manufacturers presumed would be popular with contemporary tastes. This section features a colorful array of African-Americana tumblers that fall in basically two themes: pre-Civil War Dixie and natives in Africa.

As with most housewares, decorated tumblers were not produced during World War II as industrial efforts were focused on winning the war. The tumblers shown here were produced before or shortly after the war. By the late 1950s these were already becoming politically incorrect.

I was unable to locate specific information regarding coasters and their history. It is known that several Depression Glass patterns of the late 1920s and early 1930s offered coasters. One can date some coasters based upon the material used: aluminum, 1940s; plastic, 1950s. The metal coaster most likely predates World War II and the cork set made by The Kemper-Thomas Co., Cincinnati is probably from the 1950s or 1960s.

"Plantation Scenes" tumbler. 6.5" tall, 2.5" diameter. $12.

Coaster. Just over 4" diameter, marked "MADE IN U.S.A.," tin with lithography. $18.

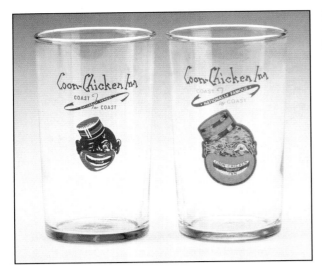

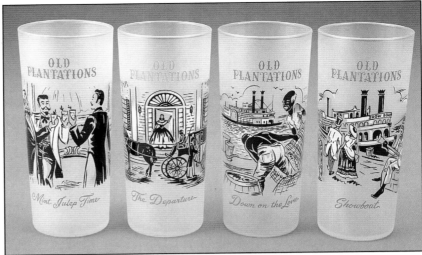

Coon Chicken Inn, REPRODUCTIONS by Libbey Glass. *Left:* Small head, 4.25" tall, 2.5" diameter. *Right:* Large head, 4.25" tall, 2.5" diameter. $10 each.

Set of "Old Plantations" tumblers. 6.5" tall, 2.5" diameter, Libbey Glass Company logo on bottom, frosted/satinized glass with clear bottoms. *Left to right:* Mint Julep Time, The Departure, Down on the Levee, Showboat. $12 each.

Set of musicians tumblers. 3.25" tall, 2" diameter, no manufacturer's information. *Left to right:* trombone, saxophone, trumpet, guitar, accordion. $15 each.

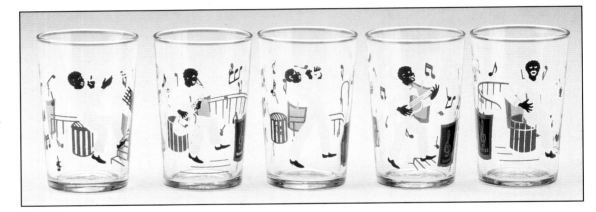

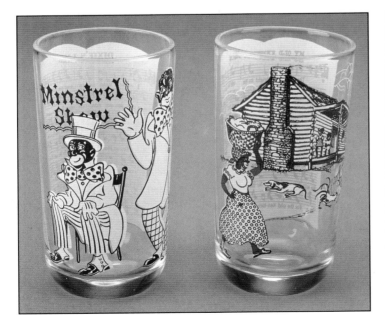

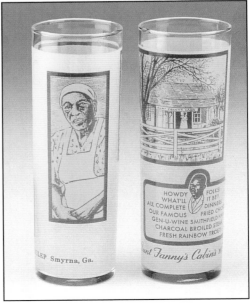

Both of these tumblers have the same mold/shape. *Left:* Minstrel Show. 5.25" tall, 2.75" diameter, no manufacturer's information, on side not shown: Music and words for "Dixie's Land." $20. *Right:* Scene outside a cabin with mother, children, and animals. 5.25" tall, 2.75" diameter, no manufacturer's information, on side not shown: Music and words for "My Old Kentucky Home." $20.

"Aunt Fanny's Cabin's MINT JULEP, Smyrna, Ga." 7" tall, 2.5" diameter, no manufacturer's information, frosted/satinized glass with clear bottoms, shown are two views of the same tumbler. $12 each.

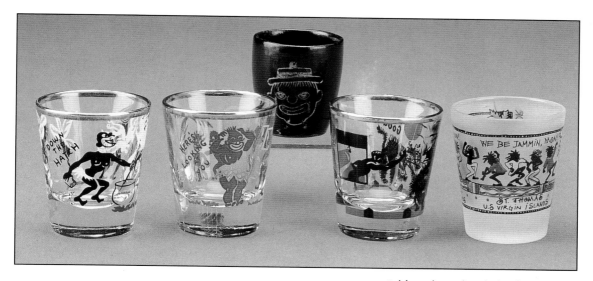

Five whiskey tumblers (shot glasses). *Far left*: "DOWN THE HATCH" natives preparing to boil a white woman. 2.25" tall, 2" diameter, no manufacturer's information but could be American-made, glass. $7. *Second from left*: "HERE'S LOOKING AT YOU" natives with a mirror. 2.25" tall, 2" diameter, no manufacturer's information but could be American-made, glass. $7. *Middle (back)*: Black clown face. 1.75" tall, 1.5" diameter, Thames made in Japan, redware. Note: the matching clown bottle is pictured earlier in this book. $5. *Second from right*: Good Luck man and black cats. 2.25" tall, 2" diameter, no manufacturer's information but could be American-made, glass. $5. *Far right*: "WE BE JAMMIN, MON!" 2.25" tall, 2" diameter, no manufacturer's information but could be American-made, assumed to be modern, frosted/satinized glass. $3.

12 "GENUINE KEMPtone CORK COASTERS." 3.5" square. The Kemper-Thomas Co., Cincinnati, Ohio. Stylized "SCREEN PRINTED by hand" artwork with the suits from a deck of cards for use at a card party. $25.

*Back left:* female natives clubbing and chasing male natives. 6.75" tall, 2.5" diameter, Federal Glass Company, frosted/satinized glass with clear bottom. *Back middle:* topless natives dancing around a fire. 6" tall, 2.5" diameter, Federal Glass Company. *Back right:* topless natives dancing around a fire. 6.75" tall, 2.5" diameter, Federal Glass Company. *Front left:* natives dancing around a fire. 6.75" tall, 2.5" diameter, Federal Glass Company no. 81138-13oz. tumbler with decoration no. 1105, "Bongo" Slim Jim/Zombie blown tumbler. *Front middle:* native cooking a camel. 5" tall, 2.75" diameter, no manufacturer's information. *Front right:* "HOT DOGS." 6.25" tall, almost 3" diameter, no manufacturer's information. $12 each regardless of the style.

## Wall Plaques

The earliest civilizations created images to tell the story of their lives and their history. Dimensional depictions from Ancient Egypt dating from circa 3300-3000 BC disclose the mysteries of the earliest kings and pharaohs in stone carvings.

The items in this section reveal a bit of our contemporary civilization. Although these plaques are purely decorative, they expose what images are pleasant or desirable enough to purchase and display in one's home. These pieces are most commonly executed in chalkware which is a material discussed in Pot Holder Hangers.

Goosed boy. 5" x 8", back stamped in black "A DUROTEX PRODUCT," chalkware. $40.

Buccaneer. 4" x 6.25", no manufacturer's information, chalkware. $30.

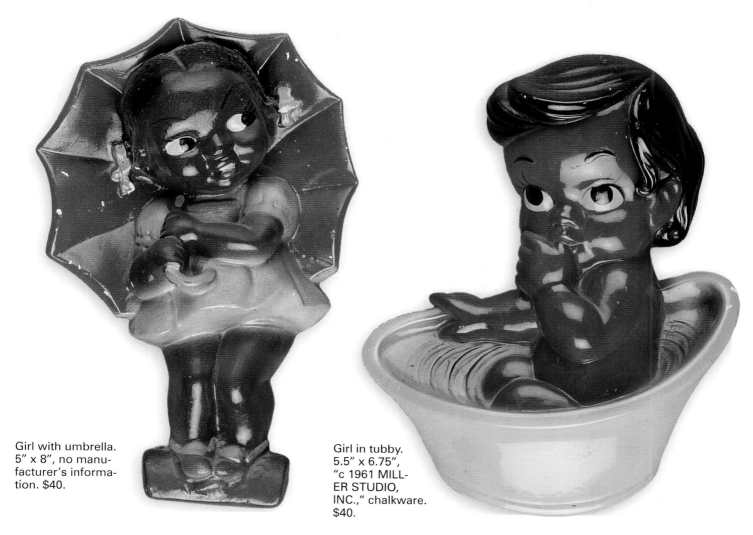

Girl with umbrella. 5" x 8", no manufacturer's information. $40.

Girl in tubby. 5.5" x 6.75", "c 1961 MILLER STUDIO, INC.," chalkware. $40.

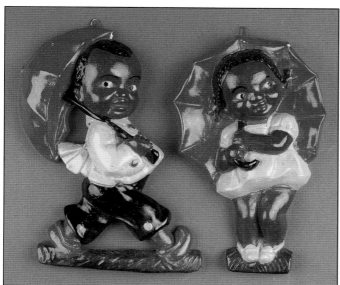

Kids with umbrellas. *Left:* Boy: 5.25" x 8", no manufacturer's information, chalkware. *Right:* Girl: 4.75" x 7.75", no manufacturer's information, chalkware. $40 each.

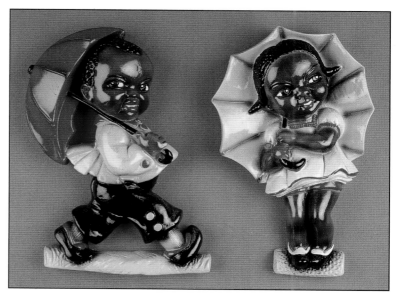

Kids with umbrellas. *Left:* 5.25" x 8", no manufacturer's information, chalkware. *Right:* 4.25" x 8.75", original sticker/label on back: "Hand Painted Royal Embassy.," chalkware. $40 each.

133

Items for Children

## Banks

Archeologists have located tombs from ancient civilizations that contained coins. Perhaps it was thought that those who passed would need money after death, but it reinforces the concept of saving or retaining coins.

Pottery containers to hold coins were given to European children in the 1500s. During the early years of the United States toy banks became popular as a new national currency of paper and coins was established.

The Bank for Savings in the City of New York became the first chartered bank in New York City in 1819. This ushered in a new mentality of saving one's money and boosted the use of toy banks.

Cast iron mechanical banks from the 1870s through the 1930s are among the most valuable. The banks featured here are "still" banks, a name that refers to the fact that there are no mechanics. The earliest still banks were shaped like buildings; figural banks followed. A variety of materials were used: pottery, tin, glass, cast iron, and chalkware. The examples clearly replicate the common stereotypes found throughout African-Americana: alligators, watermelons, huge lips, and mammy.

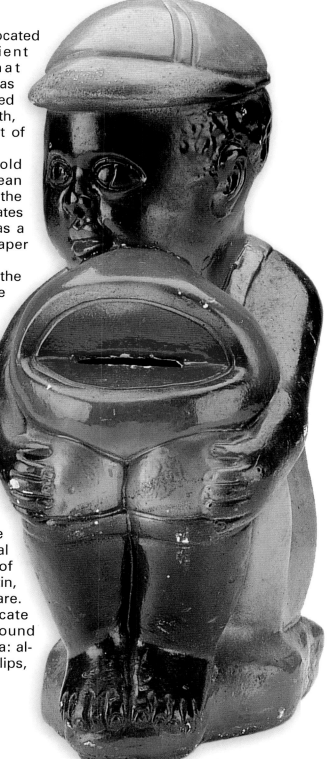

Boy with watermelon. 1.75" tall, no manufacturer's information, chalkware. $45.

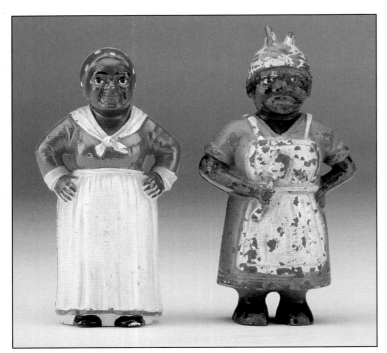

Two Mammies. *Left:* 5.5", no manufacturer's information, thought to be made in U.S.A. *Right:* 6" tall, no manufacturer's information, thought to be made in U.S.A. Cast iron. $100 each.

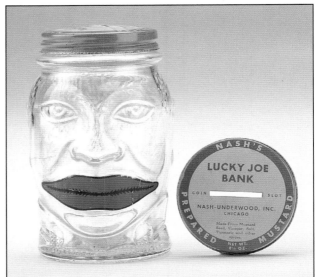

Nash's Prepared Mustard jars "Lucky Joe" banks. 4.5" tall, base embossed; "DESIGN PATENT No 1125884," glass with tin lid and paper lips. Mustard was packaged in a glass jar that transformed into a bank once the contents were consumed. Value is completely dependent upon the condition of the paper lips and screw-off lid. $25.

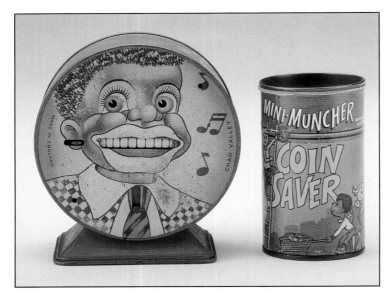

*Left:* 5" tall, Chad Valley Made in England, lithograph on tin. $80 as shown – faded and musical component as is; $250 if perfect. *Right:* Mini-Muncher Coin Saver, c. 1974 Nappe-Smith Div. Dart Indiana, cardboard with tin base and top. 18.

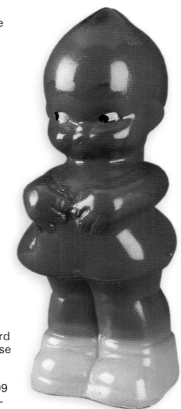

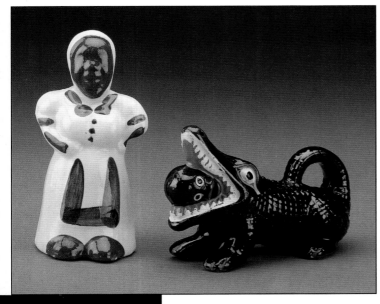

*Left:* Mammy. 6.25" tall, no manufacturer's information, thought to be made in America, pottery. $100. *Right:* Alligator eating a boy. 6" long, no manufacturer's information, thought to be made in Japan, redware with cold painted details. $150.

Kewpie. Kewpie, from the word "Cupid," was a creation of Rose O'Neill. Her illustrations of Kewpies were introduced to America in the December 1909 issue of *Woman's Home Companion.* This bank: 12.5" tall, no manufacturer's information, chalkware. $45.

Bells

Bells are considered one of mankind's first musical instruments and have been documented as early as the 400s BC in China. They are a universal item created in the materials at hand: pottery, wood, metal.

The uses and symbolism for bells varies tremendously by culture. The Chinese associated spiritual significance to bells, America's Liberty Bell evokes independence, and Christians used bells to summon worshipers.

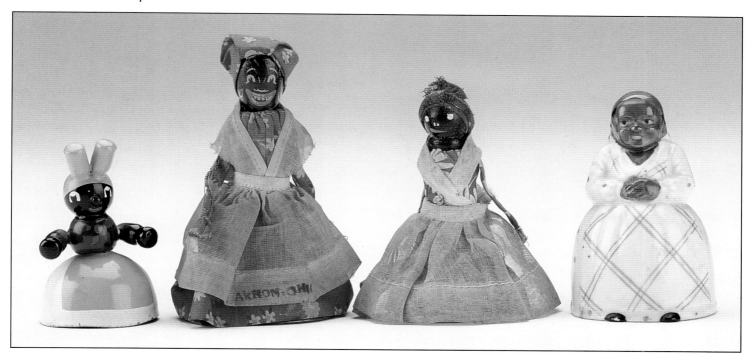

More recently bells have been used to ask for assistance whether in a shop or sick in bed, and to indicate the beginning or ending of a school day or class.

The examples presented here illustrate the variety of materials used within a relatively short period of time. The two in the middle were probably souvenirs from a southern location as they replicate other souvenirs featuring mammy in red cotton clothing. These souvenirs were marketed as "educational toys." Today one must ponder what exactly children learned or were expected to learn through the perpetuation of stereotypes.

Four Mammy bells. **Left:** 2.75" tall, no manufacturer's information, wood and metal. $15. **Second from left:** 4.25" tall, no manufacturer's information, wood, metal, and fabric. $20. **Second from right:** 3.5" tall, no manufacturer's information, wood, metal, and fabric. $15 **Right:** 3.5" tall, marked inside in orange: Theo Kinode, china. $65.

Boxed set: *My Favorite Picture Story Books.* Box: 7" x 6.5", copyright 1914 by Samuel Lowe Company, Kenosha, Wisconsin. Printed in U.S.A. The box indicates there should be five soft covered books, but only four books have survived: "Little Black Sambo," "Dick Whittington," "The Story of Thumbelina," and "Goody Two Shoes." Sambo has a full-color illustration on every right hand page and a small full-color illustration in the corner of the left hand page. Sambo, $50; other titles, $8; box, $25.

Scottish national Helen Bannerman, wife of a physician and mother of two daughters, was on a two-day train trip in India in 1898 traveling between Madras and Kodaikanal with her children. Bannerman conceived of the story of "Little Black Sambo" as a way to help her children pass the time. The book was initially published in England and then a year later in the United States. Was it a coincidence that the author's dark skinned character was named Sambo? This was a name already in use and associated with negativity as early as the 1700s in the Caribbean where it referred to individuals who were three-quarters black. By the middle of the 1800s Sambo further meant a lazy African male or little darky, either certainly a negative implication. The choice of the little boy's name has certainly been questioned as a racial slur, but one cannot be certain that Bannerman, as a woman from Scotland, would have been familiar with the insinuations of this name choice. After all, Bannerman and her daughters had been traveling in a region where "Sam" was often the first syllable of a boy's name.

The century-long controversy surrounding "Little Black Sambo" has also been bolstered with the various depictions of Sambo ranging from the blackest of black to caricatures that only mildly resemble a human. Version to version and illustrator to illustrator this little boy and his mother are usually portrayed in an extremely negative way.

For these reasons, "more than a century after its publication ['Little Black Sambo'] has been called "the most controversial children's picture book in history."[1]

It is worth validating the opinion and thoughts of an African-American author of children's books. Who better to assess

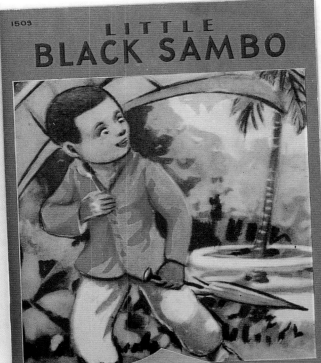

the impact of a children's book? "Julius Lester, an author of children's books, has a different view of 'Little Black Sambo.' In a phone interview from his home in western Massachusetts, Lester, who is African-American, recalls the mixed feelings he experienced after reading the book as a child. 'I felt kind of ashamed with the illustrations and the name,' Lester, who is 65, says. 'This was in the mid-1940s, and at that time, there weren't any books with positive images of black children. On the other hand, I loved the idea of eating all those pancakes,' Lester adds, his voice carrying a trace of that long-ago ambivalence. 'But the way black was treated made me feel bad.'"[2] Lester has published several rewritten, modernized versions of early children's literature that featured African characters in a negative way including an updated "Little Black Sambo."

"Little Black Sambo" had been removed from libraries and children's reading lists in the 1940s and 1950s, but at no point did this book go out of print in the United States. The 1990s saw a resurgence of interest in this vintage story despite being banned in some countries. In 2004 Handprint Books published "Little Black Sambo" and wave of anger, outrage, and disappointment followed. The publisher Christopher Franceschelli was interviewed by the Associated Press where he was quoted as follows: "We can't whitewash and erase history (but we can) forge a better understanding of it."[3]

Concern regarding the more recent interest of this book goes beyond children's literature. There are those who view this story as "overt racism."[4]

"In the past, librarian Cheryl Ashe of South Bend has argued that 'The Adventures of Huckleberry Finn' shouldn't be pulled from school shelves, despite its use of the n-word. 'When I see that black students get upset about the use of that word, I always defend the book. I would tell them, 'If they feel bad reading it, how do they think that Jim felt being called that all the time?' Ashe, who is African-American, says. She believes that 'any English teacher worth his or her salt' could help students navigate such sensitive material, put it in proper context and reach a better understanding. But she thinks that 'Little Black Sambo' is different, mainly because of its target audience. 'This is really a book written for, I'd say, very young children – it's really considered a picture book. My question is whether or not a child that age has the capability of understanding the whole ramifications of this book.' Ashe is clearly ambivalent about 'Little Black Sambo,' which she says depicts a courageous child. 'The story itself wasn't derogatory. ... But the pictures made him into stereotypes of African-Americans. ... I don't know why they couldn't have changed the title.'"[5]

It is important to note that Helen Bannerman utilized "little" and/or "black" in the titles of additional children's stories including, "The Story of Little Babaji," "The Story of Little Black Mingo," and "The Story of Little Black Quasha." Bannerman even has a "white" story, "The Story of Little White Squibba."

Dr. David Pilgrim, Professor of Sociology at Ferris State University says it best, "The book reflects, but does not exceed, the prevailing anti-Black imaging of her time."[6]

### Endnotes

[1,2,3,4,5] www.ferris.edu/jimcrow/links/newslist/sbend.

[6] www.associatedcontent.com/article/523531/litt_black_sambo_the_childrens_book.html

Three *Little Black Sambo* books. **Left:** "Magic Drawing Book," 7.75" x 10.5" no copyright date, The Platt & Munk Co., Inc. This is a soft cover dot-to-dot book that a child can complete and then color. $50 as found; $150 if in unused condition. **Middle:** 7" x 10", c. 1962 by SHIBA Productions, hard cover. $50. **Right:** 8" x 10", c. 1942 by The Saalfield Publishing Company Akron, Ohio, soft cover. $50.

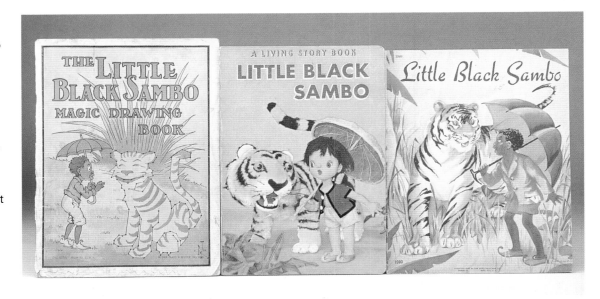

Three *Little Black Sambo* books, all soft cover. **Back:** This book is missing the cover but features ten pages of "Little Black Sambo" each with a huge full-color picture. **Front left:** 6.25" x 8", no copyright date, The Saalfield Publishing Company Akron, Ohio, New York. $65 in better condition (this book is sloppily repaired along the spine). **Front right:** 6.25" x 7.75", c. 1934 by Whitman Publishing Company Racine, Wisconsin. $50.

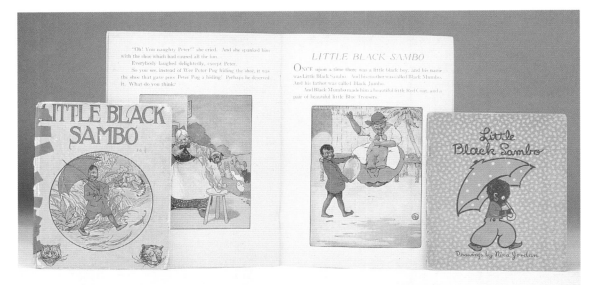

Two "Little Black Sambo" records. **Left:** Book and record, "FROM THE CATALOG OF MUSIC YOU ENJOY, INC., NEW YORK CITY." Cardboard folder opens and the record is in a pocket on the left and the book is on the right. 7.5" x 7.5", c. 1941. $75. **Right:** "LITTLE BRAVE SAMBO" which is a more recent recording that is more politically correct, Peter Pan Records, Newark, New Jersey, 7" x 8", 45 RPM. $25.

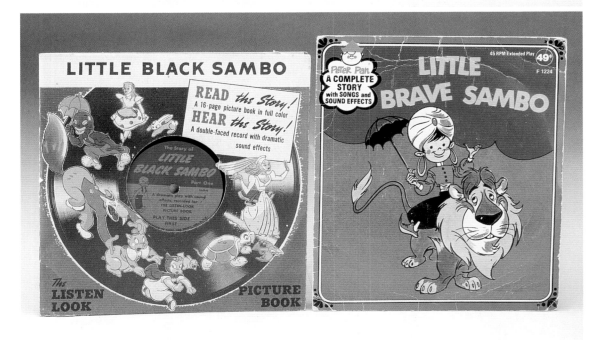

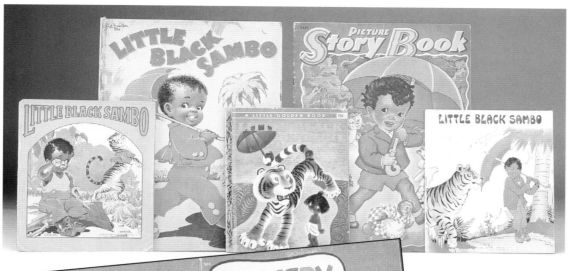

Five *Little Black Sambo* books. **Back left:** 9.75" x 13", c. 1942 by The Saalfield Pub. Co. Akron, Ohio, soft cover. $45. **Back right:** 9.75" x 13", c. 1943 by the Merrill Publishing Company Chicago, soft cover collection of stories including "Little Black Sambo" which is featured on the cover. $40. **Front far left:** 7" x 8.25", c. 1942 by The Saalfield Pub. Co. Akron, Ohio, soft cover. $55. **Front middle:** 6.5" x 8", c. 1949 by Simon and Schuster, Inc. New York 20, New York, hardcover. $50. **Front right:** 8" x 7" c. 1932 by The Platt & Monk Co., Inc. Note: This book was also printed in a 7.75" x 7" size. $50.

"NURSERY COMICS." 9.5" x 13", copyright 1940 by Whitman Publishing Company, Racine, Wisconsin. The image pictures the front and back cover of this soft covered book that contains one page comic depictions of familiar children's stories such as "Little Red Riding Hood" and "Little Black Sambo" who is pictured in the center of the back cover. $50.

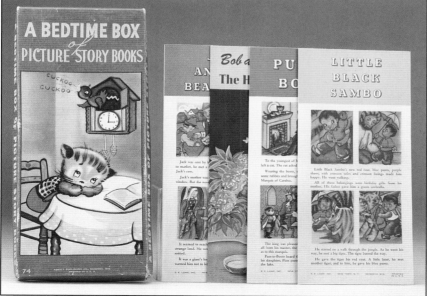

Boxed Set: "A BEDTIME BOX OF PICTURE STORY BOOKS." Box: 5.25" x 11.25", no copyright date, S.E. Lowe, Inc. New York, N.Y. Kenosha, Wisconsin. There are four soft covered books: "Little Black Sambo," Puss in Boots," "Bob and Betty the Helpful Twins," and "Jack and the Beanstalk." Within the pages of each of these books is another smaller story book. Sambo, $35; other titles, $5; box, $20.

"Stick-er Pictures" (Little Black Sambo is one of the featured stories). 10.5" x 13.25", c. 1941 by Merrill Publishing Co. Chicago, Illinois. The directions explain: "Cut out the colored pieces on the gummed paper. Match each colored piece to an outline picture on opposite page. Cut out colored borders and frame the edges of the black and white pictures. Wet each piece, one at a time, and stick in place." $25.

**HOORAY!
iT'S AUNT JEMIMA DAY:**
*A Coloring Book by Anne Sellers Leaf.* 8.5" x 11", c. 1963 Roy Knipschild & Company Chicago. This soft cover coloring book was given to children dining at Aunt Jemima's Kitchen Restaurant. The first of these restaurants was established in 1955 in Frontierland in Disneyland, California. Additional restaurants were opened throughout the United States, as well as in Canada and England. In 1963 the plan had been for this chain to become a global endeavor. $35 in unused condition.

*YACOUB LE PETIT NEGRO* and *Histoire d'un Negre et d'un Pelican*. Librairie Hachette Paris (France). Books written in French, loaded with full-color illustrations, hard covers, printed in 1924 and 1929. $80 each.

Three hardcover books. **Left:** *LITTLE JEEMES HENRY* by Ellis Credle, 7.5" x 9", c. 1936 by Thomas Nelson and Sons Eau Claire, Wisconsin. $25. **Middle:** *EPAMINDONDAS AND HIS AUNTIE* by Sara Cone Bryant, 6.5" x 8", c. 1907, 1935, 1938 by The Riverside Press Cambridge, Massachusetts. $50. **Right:** *TOPSY TURVY and the CLOWN* by Bernice G. Anderson, 6.75" x 9.25", c. 1935 by Rand McNally & Company New York, Chicago, San Francisco. $25.

*Little Pudding and the Baby Elephant* and *Little Pudding and the Drum.*
Printed in Great Britain by Collins Clear-Type Press, 7.5" x 5.75", no copyright
date, soft covers. $40 each.

Three hardcover books. **Left:** *Little Brown Koko* by
Blanche Seale Hunt, c. 1940 by American Colortype
Company Chicago and New York. $35. **Middle:**
*PETER'S Wagon,* by Betty Biesterveld, c. 1968 by
Western Publishing Company, Inc. Racine, Wis-
consin. $20. **Right:** *Little Brown Koko Has Fun* by
Blanche Seale Hunt, c. 1945 by American Colortype
Company Chicago and New York. $35.

Three books. **Left:** BELOVED BELIN-
DY by Johnny Gruelle, 6.25" x 9.25",
c. 1926 by The P.F. Volland Company
New York, Joliet, Boston, hard cover.
$25. **Middle:** "Little Blackie" by Piet
Broos; no copyright date, Sandle
Borther Limited, London, soft cover.
$40. **Right:** *SoJo: THE STORY OF
LITTLE LAZY-BONES* by Erick Berry,
c. 1934 by The Harter Publishing
Company. $25.

Harriet Beecher Stowe wrote *Uncle Tom's Cabin or Life Among the Lowly.* It was first printed in forty installments in the abolitionist weekly *Washington National Era* in 1851 and stirred such interest that a Boston publisher printed the story in total in

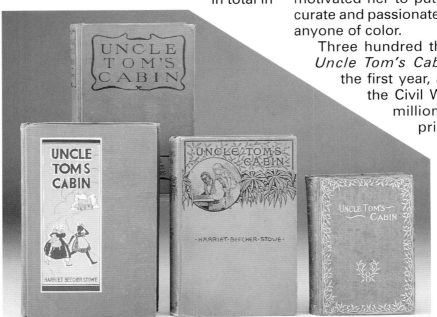

*Back:* just over 5" x just over 7.5", no copyright date, Grossett & Dunlap Publishers, New York, hard cover. $15. *Front left:* 5.5" x 8.5", no copyright date, Grossett & Dunlap Publishers, New York, hard cover. $15. *Front middle:* 5.25" x 7.75", c. 1889 Houghton, Mifflin and Company, Boston and New York, hard cover. $15. *Front right:* 4.25" x 6", no copyright date but penciled in the front of the book is: "Nettie Whitmore Xmas 1896," Donohue, Henneberry &Co., 407 Dearborn Street Chicago. $15.

counts of the anguish suffered by slaves and freed slaves as a teacher to former slave children. She also witnessed race riots and the terrors brought upon African-Americans by bounty hunters. These experiences and a deep moral conviction motivated her to put onto paper an accurate and passionate portrayal of life for anyone of color.

Three hundred thousand copies of *Uncle Tom's Cabin"* were printed the first year, and by the start of the Civil War more than two million copies had been printed with a distribution in thirteen languages. The wretched existence of slaves was revealed through the miserable life and untimely death of the main character, Uncle Tom. The role of those who hunted down escaped slaves was also clearly

1852. Stowe's goal was to bring attention to the plight of slaves, and the book was so affective that when President Lincoln met her he remarked, "So you're the little girl that started this big (Civil) war."[1]

"Today, the novel has been criticized for its stereotypical depictions of black characters, as well as its sentimentalism and moralism. But as problematic as some of the book's language and descriptions are, in the 1850s, *Uncle Tom's Cabin* evoked international sympathy for African-American slaves."[2]

The moralism woven throughout the book certainly is a reflection of Stowe's background. Her father was a Congregationalist minister who moved his family to Cincinnati, Ohio, in 1832. A river separated "free" Ohio from slaveholding Kentucky, and Stowe heard first-hand ac-

described; bounty was paid whether the slave or the slave's head was returned.

After the release of *Uncle Tom's Cabin* as a book, the story was presented as a theater production, and continued as such until 1913. The irony is that of the four touring companies two were completely white; the actors performed in blackface.

Today this book has become a collectible and several editions are pictured here. First editions are of the most value, and condition is important to value. The examples shown here offer a variety of reprint dates and versions rewritten for children.

**Endnotes**
[1, 2] http://www.africanaonline.com/slavery_toms_cabin.htm

OLD SLAVE HUTS AT THE HERMITAGE, SAVANNAH, GA.—72

Old slave huts at the hermitage, Savannah, GA.

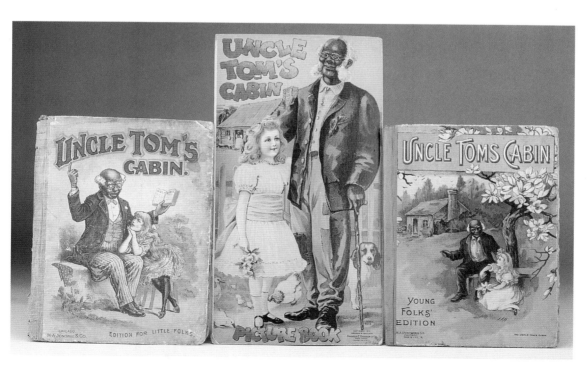

*Left:* "Edition for Little Folks," 7.5" x 10", no copyright date, Donohue & Co. 407-429 Dearborn Street, hard cover. $50. *Middle:* 7.5" x 13.75", c. 1913 by Graham & Matlack, Charles E. Graham & Co., New York, cardboard cover. $40. *Right:* "Young Folks' Edition," 7.5" x 10", no copyright date, Donohue & Co. 407-429 Dearborn Street, hard cover. $50.

## Dolls

From the earliest days of human creative efforts human-like forms were produced from the materials at hand. Often these images were for religious ritual, but thousands of years later these were created strictly for play.

The earliest African-Americana dolls are from the 1820s-1840s. Paper mache heads were formed and hand painted and added to fabric, saw dust, or other stuffed bodies. Wigs were not used on these early dolls, so whatever hair was to be present was molded with the head. By the middle of the 1800s glass eyes and wigs were added; the vast majority of the dolls were women. It is worth noting that the dolls replicated the actual roles of slave women: mammies, house workers, and so on. All of these dolls were produced with the darkest skin tones imaginable. The vast majority of manufactured dolls came from Thuringia, Germany.

Bisque china dolls became popular in the later years of the nineteenth century because this unglazed china created a more lifelike skin than glazed china. Moveable limbs and sleeper eyes became more commonly-seen and "real" hair was created with wool.

By the 1880s fabric

Folk art jointed lady. 6.5" tall, unknown creator, wood and fabric with metal joints. $150.

manufacturers were producing preprinted fabric dolls. One would cut out the doll and piece it together. Aunt Jemima offered a set of four of these dolls: Aunt Jemima, Uncle Mose, Wade Davis, and Diana Jemima in 1905 and again in 1910, 1924, 1929, and 1949. (*Black Dolls An Identification and Value Guide*, p. 57.) These dolls were acquired as a premium; one would make the required purchase and send off for the unstuffed fabric dolls. During this same time rag dolls were produced both as hand crafted objects and as toys mass produced in factories and marketed with names including "Pickaninny," "Mammy," and "Darky."

Topsy Turvy dolls were introduced during this period. These fabric dolls offered a black child and a white child with separate heads and arms but the torsos were attached with one persona always hidden in the skirt. Sometimes the dolls featured the same basic dress, but there were Topsy Turvy

dolls with a white child dressed in lace and finery while the African-American child was poorly clothed.

Composition dolls were developed in the early 1900s, and were largely an American phenomenon. A wood pulp substance used to create these dolls had been developed in Europe for doll bodies, but American manufacturers utilized it for doll heads as well. Production of these dolls continued for decades.

The use of rubber for doll making was also established at this time, and African-American dolls were made from this substance.

Richard Henry Boyd (1855-1912) was an African-American entrepreneur whose efforts included establishing a publishing company and the One-cent Savings and Trust Bank. He launched the National Negro Doll Company in 1904 with a goal of providing black dolls that would stimulate pride among the black girls for whom these dolls were made, and this venture continued until the 1950s.

Marcus Garvey helped to establish the Negro Factories Corporations in 1919. Among the variety of economic opportunities that were provided was a factory dedicated to the production of black dolls.

By 1920, different skin tones had been developed and black dolls were often available as souvenir items. Hair, glass eyes, and teeth were details that added to these dolls' appeal, but often the features were essentially Caucasian. African-American dolls from this period were liberated from their domestic/ slave roles and were sold with outfits similar to white dolls. Most European doll producers included black dolls as part of their wares and the availability of these examples is profound and diverse compared to previous decades.

During the 1920s many African-American dolls were made with three braids, one on top and one on each side of the head.

Dolls with metal heads were introduced in 1932 and the use of rubber increased.

More doll factories focusing on the production of African-American dolls were established from the 1930s through the 1940s. In 1950 the Jackie Robinson (1919-1972) Dodgers' baseball Hall of Famer doll produced by Allied Grand Doll Manufacturing Company became a toy that was successful across racial lines. One of these composition dolls in pristine condition was located online at the time of this writing with a price tag of $1,299.

A greater sensitivity to the needs of young African-American girls emerged in the 1950s as doll makers realized that simply coloring a white doll with black skin tones is unsatisfactory. One must embrace the physical characteristics that define the African-American heritage and have these reflected in the toys with which young girls play. It took a white woman, Sara Lee Creech (1917-2008) to successfully address this with the creation of a vinyl doll appropriately named Sara Lee. The implementation of vinyl for doll making provided a realistic quality. "Ms. Smith's obituary noted that the dolls were sold by Sears in the early 1950s, but Macy's and Saks Fifth Avenue 'refused to carry the doll for fear it would attract too many black customers.'" (http://www.herald-dispatch.com/opinions/x713394956.) Unfortunately it would be more than ten years before "anthropologically correct" African-American dolls were produced in earnest.

It is important to note that there were relatively few African-American dolls made when compared to the quantity of white dolls produced. The Summer 1929 Montgomery Ward Catalogue offered four dolls, all white with prices from $.49 to $2.48. Myla Perkins indicates that after the Fall 1934 Sears Catalogue no black dolls were again offered in Sears' catalogues until Fall 1955. (*Black Dolls An Identification and Value Guide*, p. 79.) It is interesting to note that the Fall/Winter 1964 Spiegel Catalogue offered thirty-seven dolls, all white, so even though manufacturers were finally addressing the needs of African-American children retailers were less than receptive to this initiative.

Wedding party: bride, groom, preacher. 2.75" tall, paper base stamped in purple "MADE IN JAPAN," celluloid with embellishments of chenille, paper, and other materials. Note: a white couple with a white preacher was also made. $25 each, $100 for set as finding these together is rare.

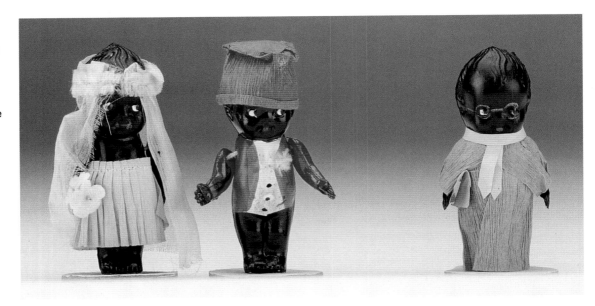

Girl and boy. 18" long, 1947 Simplicity pattern, hand crafted, fabric. $45 each.

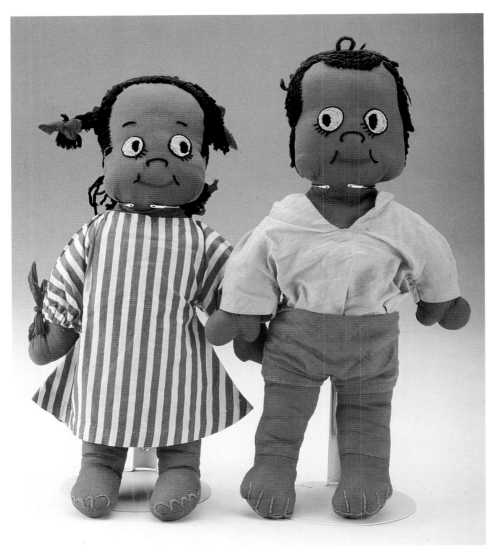

Norah Wellings (1893-?) began her doll making career in 1919 as a designer for British toy manufacturer Chad Valley Company. She established her own factory utilizing the efforts of relatives, including her brother Leonard, in 1926. The Victoria Toy Works Factory introduced their fabric dolls in 1927 with production continuing until 1959 when Ms. Welling's brother passed away. Although there were offers to purchase her factory and carry on her designs, Norah burned her tools, designs, and incomplete dolls thus abruptly and definitively terminating her legacy.

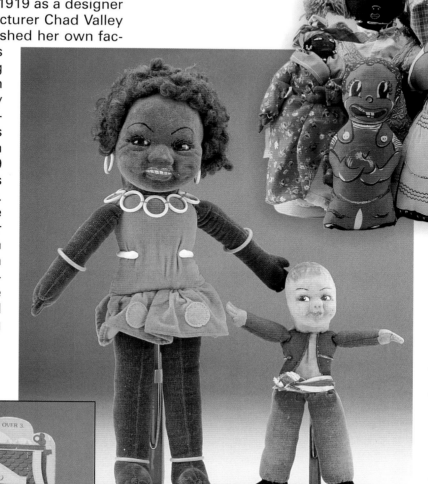

Five fabric dolls. **Back left:** 16" long, unusual to find gray hair, hand crafted. $45. **Back right:** 21.5" long, hand crafted. $25. **Middle left:** Island lady, 11" long, hand crafted on St. John, V.I. $5. **Front left:** Boy, 10", hand crafted from printed fabric. $10. **Front right:** Mammy, 15.5" long, hand crafted from printed fabric. $25.

Two Norah Wellings dolls. **Left:** 14.5" tall with bone rings as embellishment. $100. **Right:** 8" tall. $50.

Mattel produced the Honey Hill Bunch from 1975-1978. These 3"-4" tall cloth dolls had vinyl heads, rooted hair, and Velcro on their hands to hold hands or accessories. They were marketed separately and had a Club House. The characters were: Darlin, Hayseed, I.Q., Little Kid, Slugger (or Battie), Solo, Miss Chevus, Sweetlee, Curly Q, Irish Eyes, Spunky, Sunflower, Rickety Rig, and the dog Chum. (http://www.dollreference.com/mattel_dolls1970s.html.)

Honey Bunch Hill. Curly Q Doll: 5" tall, box: 4" x 1.75" x 9", Mattel, Inc. 1975, made and printed in Taiwan. Doll alone, $15; unopened box as pictured, $35.

**Left:** 13.5" tall, mark on neck: "10 HORSMAN DOLLS Inc 19C57," plastic with sleeper eyes. $25.
**Right:** 14.5" tall, mark on neck: "UD CO INC," plastic head and hands, fabric torso with zipper in back (there is some kind of mechanical aspect to the doll, but the zipper is jammed), fabric limbs, sleeper eyes. $25.

Edward Horsman began importing and distributing German dolls and other toys in 1865. In 1905 Horsmans' company established a subsidiary to produce their own composition dolls here in America under the auspices of his son, Edward Jr. By 1927 the doll factory had become deeply in debt. Regal dolls purchased Horsman in 1933 and rebuilt and restructured doll production, returning Horsman to a prestigious position, and in fact abandoning the Regal name in favor of the popular Horsman name. Production continued until World War II. As with many American manufacturers, Horsman devoted most of its facilities to the war effort by transforming its production from toys to other vinyl items: prosthetics and artificial hands for wounded veterans and medical provisions. Doll production resumed after the termination of the war and by the end of the 1940s Horsman was the largest manufacturer of plastic dolls in America.

Tierney's Traditional Toys & Gifts is still in operation in West Yorkshire, England; it began in 1893 with Paul and Susan Tierney. This couple developed a reputation for offering well-made doll houses, and other toys and gifts. Daughter Louise is involved in this endeavor, but it is unknown if she is the same Louise Tierney shown on the tag.

Corey. 11" tall, tag states: "Crafted with love by Louise Tierney Designs" edition C9 7/90-6/91, rubber head, hands, feet, fabric torso, and limbs, sleeper eyes. $25.

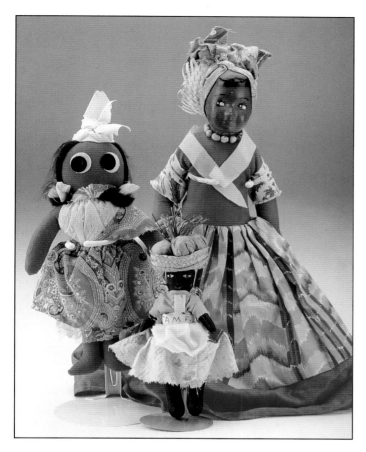

Three island natives. *Left:* 10.5" tall, no manufacturer's information. $8. *Middle:* 7.5" tall, no manufacturer's information. $8. *Right:* 10.5" tall, the dress is much longer than the doll, no manufacturer's information, composition head, everything else is fabric. $40.

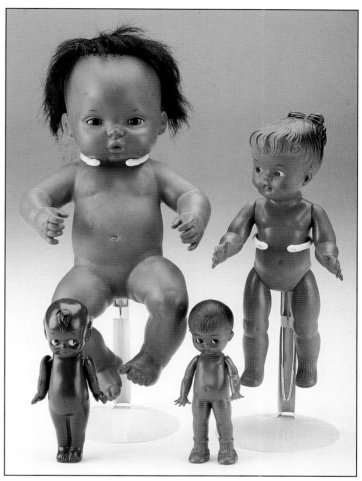

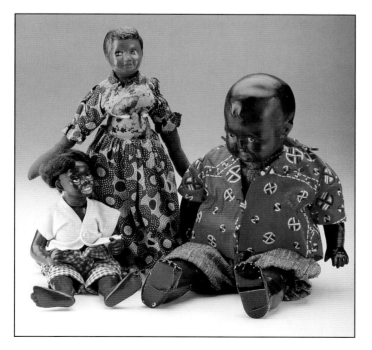

*Left:* 14" tall; back embossed: "STEPHANEE WOLL 1973," ceramic. $15. *Middle:* 15.5" tall, no manufacturer's information, composition head and neck, everything else is fabric. $40. *Right:* 19.5" tall, no manufacturer's information, composition head and limbs, fabric torso. $100.

This is the original sticker/label on the feet of the celluloid Kewpie doll.

Four undressed babies. *Back left:* 14" tall, back of neck marked: "c 1972 MATTEL INC MEXICO," this doll drinks from a bottle and then tinkles, rubber. 15. *Back right:* 10.5" tall, no manufacturer's information, plastic. $12. *Front left:* 6" tall Kewpie, back marked "JAPAN," celluloid. $35. *Front right:* 6" tall, no manufacturer's information, sleeper eyes, made in different shades of brown, plastic. $15.

Topsy Turvy doll. Topsy Turvy dolls offer a black child and a white child. There are separate heads and arms but the torsos are attached and one persona is always hidden in the skirt, 10" tall, no manufacturer's information, oil cloth. $35.

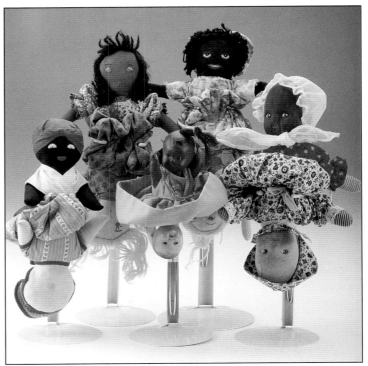

Topsy Turvy dolls. *Far left:* 11.5" tall, hand crafted. $10. *Second from left:* 11" tall, hand crafted. $10. *Middle:* 7.5" tall, no manufacturer's information, composition. $100. *Second from right:* 12" tall, hand crafted. $10. *Far right:* 11.5" tall, hand crafted using commercially produced faces. $25.

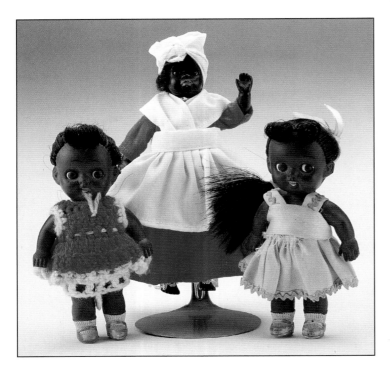

*Left:* "MY LOVELY 'TOPSEE'" doll. 5" tall, back marked: "62 MADE IN JAPAN," the original clothes have been replaced with hand crocheted clothes, rubber. A packaged Topsee doll is shown in the Toys section. $15. *Middle:* 6.5" tall, back marked: "M.B.C. N.Y.," china. $35. *Right:* "MY LOVELY 'TOPSEE'" doll. 5" tall, back marked: "62 MADE IN JAPAN," rubber. A packaged Topsee doll is shown in the Toys section. $20.

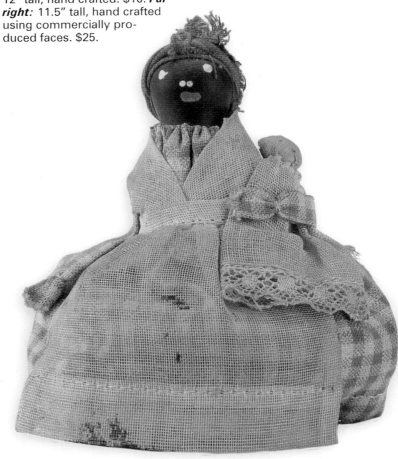

Folk art doll. 3.75" tall, hand crafted rubber and fabric with hand painted details. Mammy is holding a 1.5" tall white baby. $30.

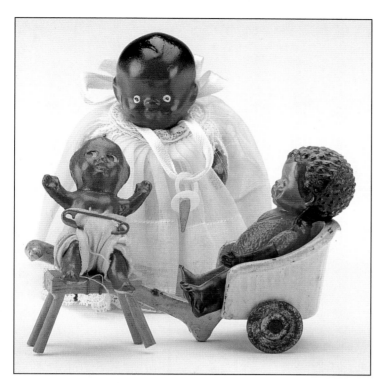

*Left:* 2" tall, no manufacturer's information, china. $25. *Middle:* 4" tall, back embossed: "JAPAN," china. $25. *Right:* 2.5" tall, back embossed: "JAPAN PATENT," celluloid. $35.

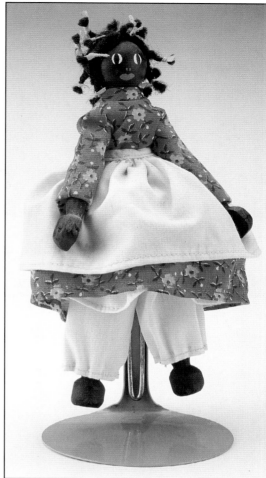

Modern folk art doll. 6" tall, no manufacturer's information, made from clothespins and fabric. $10.

*Below:* Modern clown. 6.75" tall, no manufacturer's information, china head with fur hair, everything else is fabric. $10.

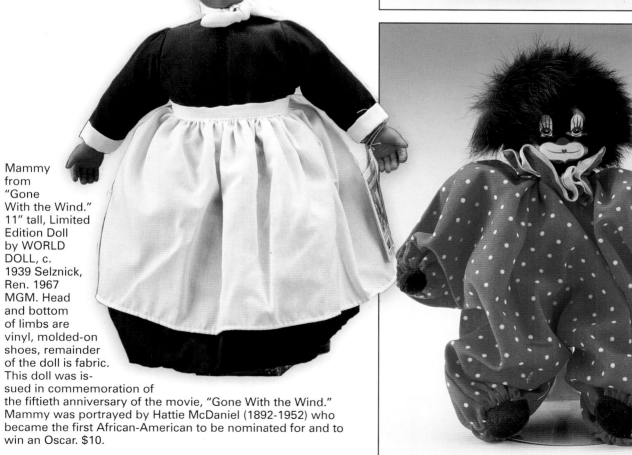

Mammy from "Gone With the Wind." 11" tall, Limited Edition Doll by WORLD DOLL, c. 1939 Selznick, Ren. 1967 MGM. Head and bottom of limbs are vinyl, molded-on shoes, remainder of the doll is fabric. This doll was issued in commemoration of the fiftieth anniversary of the movie, "Gone With the Wind." Mammy was portrayed by Hattie McDaniel (1892-1952) who became the first African-American to be nominated for and to win an Oscar. $10.

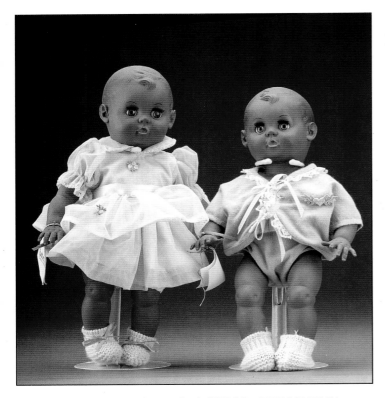

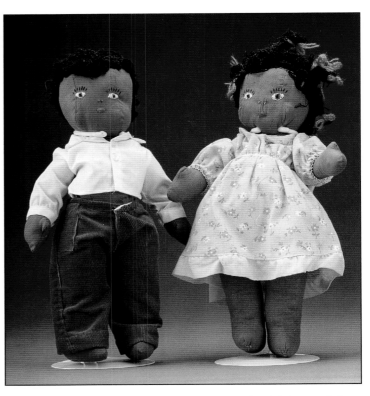

Girl and boy. 14.5", backs marked: "jESCO c1987 MADE IN CHINA," tags on wrists state: "Barbee's Dolls & Collectibles." $20 each.

Folk art dolls. 14" tall, hand crafted from fabric with button joints. $20 each.

Cabbage Patch Kids. 17" long, Original Appalachian Artworks, Inc. Cleveland, Georgia. Manufactured by Coleco Industries, Inc. Amsterdam, New York. $12 each; add $5 for original adoption paperwork.

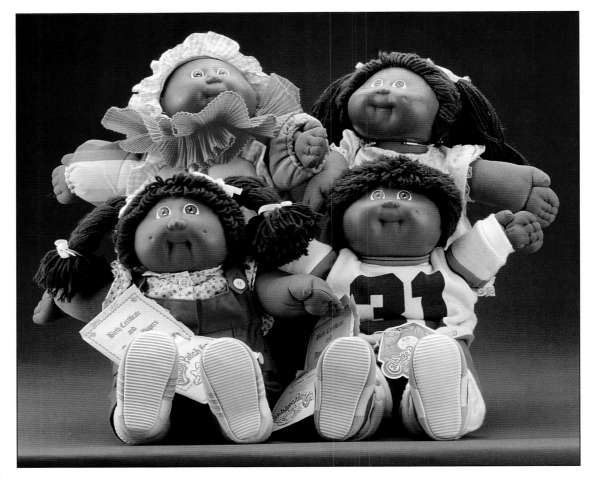

Xavier Roberts initiated the Cabbage Patch Kids empire with the creation of "Little Person" dolls in 1976. These hand sewn babies were made using a German sewing technique dating to the early 1800s called needle molding. Babies were adopted for $40, complete with adoption papers, and their popularity quickly grew. In 1978 Roberts and five friends established the Original Appalachian Artworks, Inc. and Little Person babies became a phenomenon with three million adoptions by 1983, the year Coleco purchased this enterprise. National marketing of Cabbage Patch Kids followed and these treasured dolls were eventually featured on the cover of *Newsweek Magazine* and on postage stamps. By 1990 more than sixty-five million Cabbage Patch Kids had been adopted.

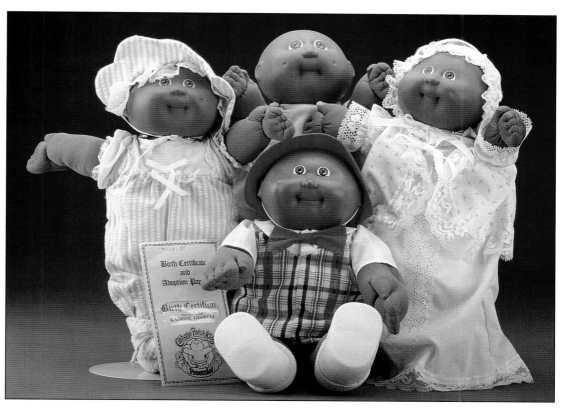

Cabbage Patch Kids. 17" long; Original Appalachian Artworks, Inc. Cleveland, Georgia. Manufactured by Coleco Industries, Inc. Amsterdam, New York. $12 each; add $5 for original adoption paperwork.

3" tall, IMPERIAL TOY CORP., HONG KONG, plastic. $5 each.

Cabbage Patch Kid. Original box, unopened. $40.

Four dexterity games. **Back:** 4" diameter, bottom of image marked with OJ in a diamond. This is a two-sided game; the side not pictured is marked "Made in Japan" with a game designed to place a clown's head on his shoulders. $50. **Front left:** almost 2" diameter, D.R.G.M. No 116769 with a mirror back. $35. **Front middle:** 1.25" diameter, no manufacturer's information. $30. **Front right:** almost 2" diameter, no manufacturer's information, mirror back. $30.

Skillets and Cakes. Box: 13.75" x 13.75" x 1", dice, and just over .5" diameter cardboard pieces; MILTON BRADLEY, Springfield, Massachusetts. No. 4170X, copyright 1946. "The object of the game is for each player first to get all of his fifteen cakes into his skillets, then to get them cooked." $65.

## Games

Exactly who, when, and where games originated remains clouded in uncertainty, but it seems fair to assume that the earliest peoples developed fun activities of some kind that evolved into more formal activities with rules and a goal – games.

Archeologists have determined that board games have been an element of civilized societies since 2000 BC and were enjoyed in ancient Greece and Rome. As Roman influence expanded throughout Europe, many aspects of Roman society were adopted, including playing board games.

When European influences reached global proportions, so did their traditions, dress, and religion. Included in this sphere of influence was playing board games.

The first successful board game in America was Monopoly.

The history of card playing is less clear, but it is assumed that card playing originated in China perhaps 600-900 AD. It is known that cards were played in British society by the mid-1400s. In fact, British Parliament enacted a law prohibiting the importing of foreign cards; all cards were required to be made in England.

Dexterity games, also called "patience games," were developed around 1880. Produced mostly in England, Germany, France, Japan, and America these would be placed in areas where people would be waiting to assist in the pleasant passage of time. While waiting for a doctor or a train one could entertain oneself by playing a compact, self-contained dexterity game.

Although some sort of tiddly winks game had been played in England since the mid-1800s, Bill Steen and R. C. Martin from Cambridge, England are credited for establishing the game as we know it today in 1954 with manufacturing commencing in 1955 by Marchant Games Ltd. A tiddly wink variation with an African-American theme is pictured.

Playtime TINNKY WINKS. Box: 8" x 11.5", J. Pressman & Co., N.Y.C. This game is a version of Tiddly Winks. Participants attempt to land their winks into the tin pan being held by the minstrel. $85.

Deck of cards. Box: 2.5" x 3.5", marked "212"; THE U.S. PLAYING CARD CO., CINCINNATI, U.S.A. Box and cards feature a female worker toting a basket full of cotton. She is depicted in a relaxed posture with a broad smile. $35.

Two boxes of Snake Eyes. The objective of this card and dice game is to be the first to turn all of your cards face down. There are two versions of this game, number 27, for 2-6 players and number 30, for 2-12 players. Phoebe Snow, a black washer-woman, is one of the characters on the cards. *Left:* Box: 7.75" x 14.5", c. 1957 by Selchow & Richter Co., New York, New York. $50. *Right:* No. 27; 7.5" x 11", no copyright date, Selchow & Richter Co., New York, New York. One can assume this is earlier than the other set. $50.

Turn Over Targets. Box: 14.75" x 7", no copyright date, Milton Bradley Co., Springfield, Massachu-setts. This game utilizes a gun that shoots corks at targets; two targets are black characters. $65.

Zoo Hoo. "A Puzzler Help Wash Get 'em Back." Box: 14" x 11.75", cardboard pieces inside: 13.5" x 11"; Manufactured by LUBBERS & BELL MFG. C. CLINTON, IOWA, U.S.A. Copyright 1924. According to the di-rections: "Three games in one…Played as a fascinat-ing fun game for children, played as a puzzling soli-taire game for grown-ups, played as a picture puzzle for tiny tots." $65.

AMOS 'N ANDY CARD PARTY. Box: 8" x 5.5", c. 1930 A.M. Davis Co.
Three score Pads and twelve Tallies are provided to equip anyone
hosting a card party. $65.

Old Maid cards. Sassiety Sal and Steppin' Sam are two of the characters in this deck.
Cards: 2.5" x 3.5", marked "c. W.P. Co." $25.

Sambo Five Pins. The Little Black Sambos are 10" tall and the box is 11" x 13" manufactured by Parker Brothers, Inc. in Salem, Massachusetts. 1921 copyright. The game includes five "pins" which are Sambo cut outs made in heavy cardboard with a wooden base and four wooden balls. This is a bowling game, and the object is to knock over the Sambo pins with the balls. $250.

Snake Eyes parts and pieces.

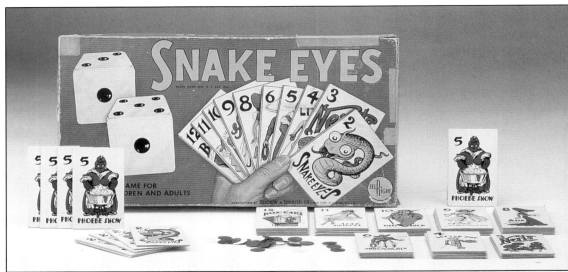

Charades cards. Cards: just over 1.5" x 2.5", Charade directions include: "Show how a hungry colored boy would go for roast chicken." "Go through the motions of a colored boy eating watermelon." $20.

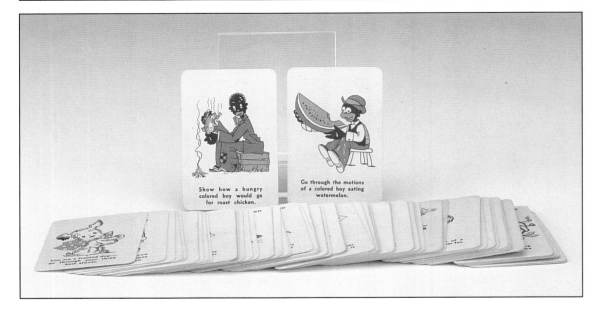

## Records

The first recording was produced in 1806 when Thomas Young (1773-1829) recorded the sounds of a vibrating tuning fork on a wax-covered rotating drum. As there had been no way to listen to these recorded notes no one was able to hear what he had achieved. No progress was made to that end for many decades, but in 1857 Frenchman Edouard-Leon Scott de Martinville (1817-1879) patented the phonautograph, a device that made images of sound. Like

telegraph technology. Charles Sumner Tainter (1854-1940), another American inventor who worked with Alexander Graham Bell (telephone/wireless sound technology) patented the graphophone in 1886 and Edison made improvements on his phonograph in 1887. One year later Emile Berliner (1851-1929), a self-educated Jewish immigrant from Germany, invented the gramophone which was capable of playing sound from a 7" disc that one

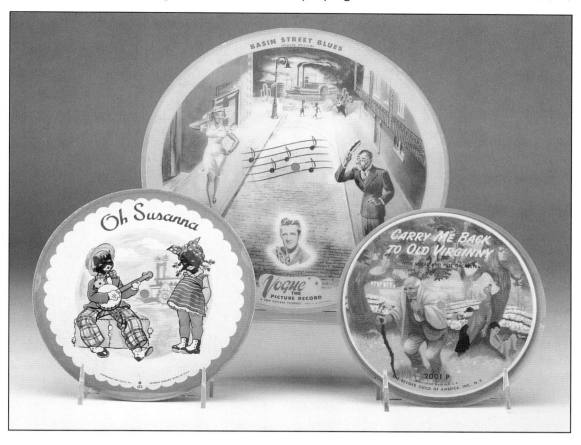

*Left:* "Oh Susanna" with "Chicken Chatter" on the reverse side. Almost 7" diameter. *Middle:* "Basin Street Blues" with "Sugar Blues" on the reverse side. 9.75" diameter. *Right:* "Carry Me Back to Old Virginny" with "Blue Tail Fly" on the reverse side. 6.25" diameter. $25 each.

Young's invention, this machine was unable to play back the sound. Twenty years later Frenchman Charles Cros (1842-1888) developed the paleophone which he contended would play sound back, however, due to a lack of financing his invention was never further developed.

American Thomas Edison (1847-1931) succeeded in recording and playing back sound in 1877 when experimenting with

would turn by hand at thirty revolutions per minute. These disks were conducive to mass production using rubber copies. Berliner's achievement created the start of the recording industry as a form of juke boxes were introduced one year later. (Juke boxes as we think of them were invented in 1927.) The utilization of electricity provided even rotations and freed the listener from manually operating the gramophone.

*Left:* "Little Brave Sambo." 6.75" diameter, narrated by John Bradford and Bobby Hookey. "Little Black Sambo" is now "Brave" Sambo as America becomes a bit more politically correct. *Right:* "Dixie" with "Yankee Doodle" on the reverse side. 6.75" diameter, The Sandpipers and Mitch Miller and His Orchestra. $8 each.

From this point the technology continued at a fast pace as shellac records became playable on both sides and Edison's cylinders were abandoned.

33-1/3 RPM (revolutions per minute) records were introduced in 1926 and stereo sound followed in 1931. Vinyl began to replace shellac in 1940 and eight years later Columbia merged 33-1/3 RPM with vinyl (called "vinylite") and their own turntable and the Long Playing or LP record was born capable of twenty-three minutes of sound per side. RCA Victor pioneered the "single," a seven inch, 45 RPM, record in 1949.

In terms of African-American history, it is worth noting that the first-ever jazz recording was in 1917. "Livery Stable Blues" and "Dixie Jass (sic) Band One Step" were released for the Victor Talking Machine Company, but there were no African-American musicians involved in this recording. The first commercially produced movie with sound and dialogue was the "Jazz Singer" released in 1928.

Vogue Picture Records were produced by Sav-Way Industries of Detroit, Michigan, between May 1946 and August 1947. The seventy-four issues which often featured obscure bands and singers were a huge hit not only because of the artwork, but because the recordings were of excellent quality. Despite the success, the company filed for bankruptcy after only one year of operation. There are six named Vogue illustrators responsible for the artwork on their picture records.

*mug*

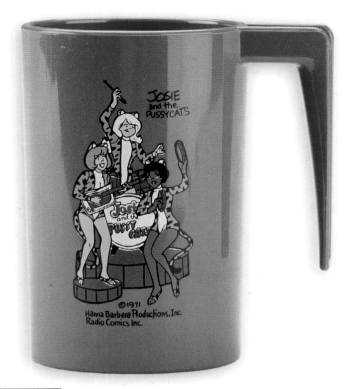

Josie and the Pussycats. 2.75" diameter, 4.25" tall, bottom embossed: "A-25," plastic. $5.

"Josie and the Pussycats" was created by Dan DeCarlo, Josie having been inspired by and named for his wife. A brief staple of Saturday morning cartoon programming, Josie and her pals traveled to actual international locations while dealing with dastardly villains and offering delightful music in thirty action-packed minutes. The initial episode aired on September 12, 1970 and sixteen installments followed. Pussycat Valerie was the first animated African-American character to be scripted as an intelligent and capable female on U.S. television.

# Soap

A history of soap is presented in the "Laundry Items" section.

On a personal note, I recall spending time at my Mom Mom's house in the late 1950s. She always provided shaped soaps and decorative packets of powdered bubble bath much to my delight. One can presume the items pictured here are from this time period.

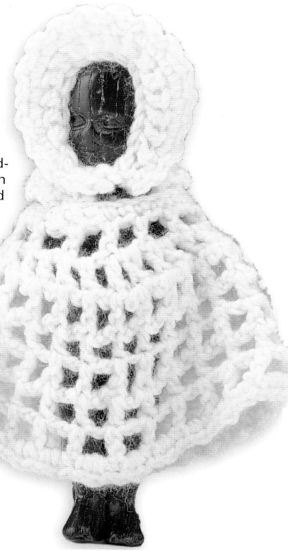

Baby. 4.75" tall, no manufacturing information, hand crocheted outfit. Note: a white soap baby was also made. $25.

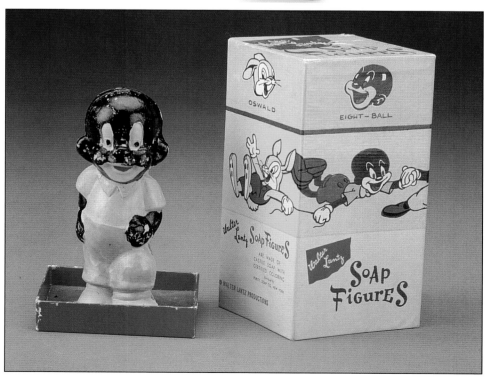

Eight-ball. Box: 3.25" wide, 6.5" tall; Castile soap: 5" tall. Purity Soap Company, New York. Walter Lantz soap, one of several featuring his cartoon creations. $100 with box.

Toys

The origin of the word "Dixie" is unclear, but Dan Emmett's song by that name came to be an anthem of the Civil War. When Jefferson Davis was inaugurated as the Confederate president in 1861, "Dixie" was performed. Many a soldier marched to his death to the tune of "Dixie."

Although Dixieland music is truly New Orleans in its roots with influences from many cultures, the Original Dixieland Jazz Band that was formed in 1917 under the leadership of Nick LaRocca (1889-1961) was entirely white. These musicians recorded the first ever Jazz recording, a sad irony.

This musical set is an assortment of kazoos, whose roots are in the ancient mirliton instruments of Africa, wind instruments made from a cow's horn with a vibrating membrane from a spider's egg. A version of these, the eunuk-flutes, was developed in Europe in the 1600s and by the 1700s similar instruments were being used in North American folk music.

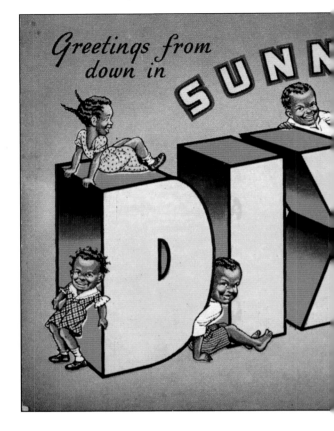

Below:
Dixieland Band. The box is 17" x 9", set no. 36 by SPEC-TOY-CULARS INC. Brooklyn, NY. The set includes a plastic violin, a plastic clarinet, and a plastic slide trombone, all of which are kazoos. A cardboard and wooden baton complete the set. What makes this collectible is the artwork on the box featuring a graphic by Wayne Gunther of a Dixieland Band: white folks in black face minstrel make up. $75.

The invention of the kazoo as we know it was by Alabama Vest from Macon, Georgia. In 1842 this African-American enlisted the expertise of Thaddeus Von Clegg, a German clock maker, although how these men were able to connect is lost in history. The first kazoo, which was metal, was demonstrated at the Georgia State Fair in 1842. (Is this why ear plugs were invented in 1843?)

The kazoo's patent was purchased and taken north. Emil Sorg took this to Michael McIntyre, a tool and dye maker from Buffalo, New York, in 1912. A year later McIntyre and Sorg parted company and McIntyre sought out Harry Richardson, an owner of a metal factory, to produce these instruments. In 1916 kazoos were offered for sale by The Original American Kazoo Company which remains the only facility in America to manufacture metal kazoos.

37

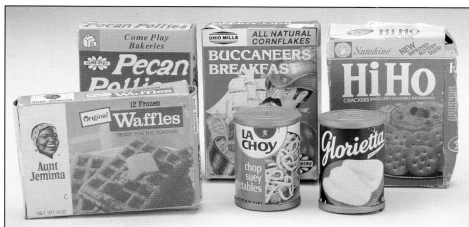

Aunt Jemima Waffles Box (and others) from Grocery Store Play Set. history of Aunt Jemima is provided in the Introduction. 4.5" x 3.25" x 1.25", cardboard. $10.

The first game produced by the Frantz Manufacturing Company of Sterling, Illinois was a baseball game in 1919. A football and golf game followed and then a series of wooden pull toys, starting with a puppy. Hustler Toy Company was established as a subsidiary around 1925 and by the end of the decade they had acquired Toylander Corporation also from Sterling, Illinois. Wooden toys made from poplar trees in Arkansas were largely designed by Clare A. Wetzel and his name is found on many of the more than 100 items created. Hustler Toy Company continued until 1934 when they changed from wooden toys and began producing metal strap-on roller skates until c. 1970.

Pull toy: man and horse. 11" long, 4" across, 5.25" tall, HUSTLER TOY COR-PORATION, STERLING, ILLINOIS, (original trade mark sticker remains), wood with metal and rope. When pulled, the man's arms and the horse's head move up and down. $200.

Although this toy is marked "Lindstrom Corporation," the original name of the company was The Lindstrom Tool, Die and Gauge Company owned by Frank L. and Ada Lindstrom. Incorporated in 1916 the business was renamed The Lindstrom Tool & Toy Co. in 1925 and specialized in tin and pressed steel mechanical toys and games including wind up cars, boats, sewing machines, and more. Like many manufacturers they ceased operations during World War II but did reopen after the war's end. The item shown here is typical of Lindstrom's earliest toys and shows an African-American woman in a stereotypical role.

Daniel Decatur Emmett (1815-1904) is credited for the creation of the minstrel persona and minstrel shows. A gifted song writer, ("Dixie," "Old Dan Tucker," and many more) Emmett was inducted into the Songwriters Hall of Fame in 1970. Dan was already a violinist when, at the age of 17, he enlisted in the Army. During his brief time he was able to hone drumming and fife skills. He was discharged when the Army discovered he was underage, and his next employment was in 1835 with the Spalding and Rogers circus where he learned the art of "Negro impersonation" and began composing "Negro themed" songs. He joined the Cincinnati Circus Company and in 1840 while touring in Virginia, Dan met "Ferguson," a banjo player who he persuaded to join the circus. Within a year Dan, too, was playing the banjo. He moved to New York where he became known as "The Great Southern Banjo Melodist" and then "The Renowned Ethiopian Minstrel." He was, at this time, coloring his face black for his performances. He became associated with other musicians: Dick Pelham, Bill Whitlock, and Frank Brower, and they become a performance troupe that became known as "The Virginia Minstrels."

A new form of entertainment had been born and soon minstrel bands of four to six white men colored with burnt cork or black grease paint were performing cruel parodies of African-Americans as they traveled all over the country. Prior to this black faced performers had been a part of American entertainment for several decades, but the combination of the black face, Dixieland music, and highly offensive and insulting humor defined the minstrel show. Three reoccurring characters often depicted by minstrel bands were Jim Crow, a lighthearted slave,

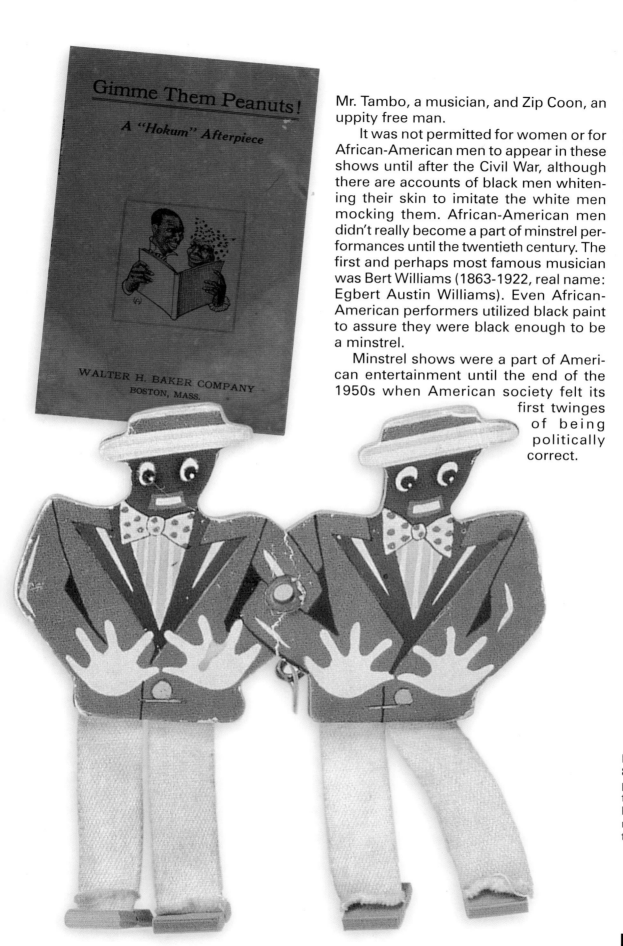

Mr. Tambo, a musician, and Zip Coon, an uppity free man.

It was not permitted for women or for African-American men to appear in these shows until after the Civil War, although there are accounts of black men whitening their skin to imitate the white men mocking them. African-American men didn't really become a part of minstrel performances until the twentieth century. The first and perhaps most famous musician was Bert Williams (1863-1922, real name: Egbert Austin Williams). Even African-American performers utilized black paint to assure they were black enough to be a minstrel.

Minstrel shows were a part of American entertainment until the end of the 1950s when American society felt its first twinges of being politically correct.

"Gimme Them Peanuts" A "Hokum" Afterpiece copyrighted 1921 and 1922 by Walter Ben Hare.

Dancing Minstrels. Base: 8.5" long, 5.5" wide thin plastic, minstrels: 4.25" tall cardboard with fabric legs and plastic feet, no manufacturer's information. $75.

Wechsler and Abraham department store opened in Brooklyn, New York, in 1865 by Abraham Abraham and Joseph Wechsler. In 1888 the Strauss family obtained a general partnership with Macy's department store and five years later they bought out Joseph Wechsler's share of Wechsler and Abraham. The new store became known as Abraham & Strauss. The Ferdinand J. Strauss Company produced tin toys for the Abraham & Strauss department stores.

Louis Marx had been an employee of The Ferdinand J. Strauss Company but was fired in 1919. He went on to establish his own toy empire along with his brother David. Three years later The Ferdinand J. Strauss Company developed economic issues and Marx purchased the company along with some patents including the Alabama Minstrel Dancer.

The contributions of German inventors has been explored in several places within this book including clockwork development and the production of metal/tin toys, so it should be no surprise that the Alabama Coon Jigger was made in Germany.

The use of the word "Coon" is worth exploring as it is certainly associated with only negative feelings. As discussed, Zip Coon was one of the original three minstrel characters. Perhaps coon is derived from raccoon, but more likely its roots are from the Portuguese word "barracoon," meaning prisoner in a cage. This is the same word that is the basis for "barrack" and "barrier." (http://www.blackvoices.com/black_news/canvas_directory_headlines_features/_a/coonin-resurfaces-at-howard-u/20061113083809990001_) There is an obvious connection to the concept of a barrack, barrier, prisoner in a cage, and the role of a slave; when a white man used the word "coon" he referred to his African-American slave.

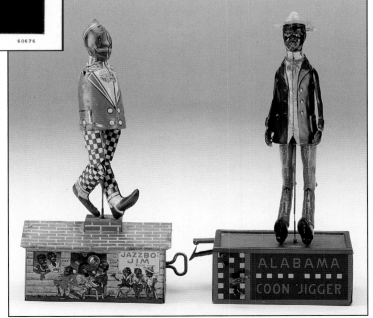

Wind-up toys: Jazzbo Jim and Alabama Coon Jigger. *Left:* Jazzbo Jim. Base: 4.75" x 3", 10" tall, The Ferdinand Strauss Corporation, New York, patented October 1921, tin. There are other versions of this toy including one with two tin figures, the second being smaller with a violin. $300 if perfect, this one is missing his arms. ***Right:*** Alabama Coon Jigger Base: 4.75" x 3.25", 10.5" tall, Made in Germany, patents from 1903-1912, tin. $300.

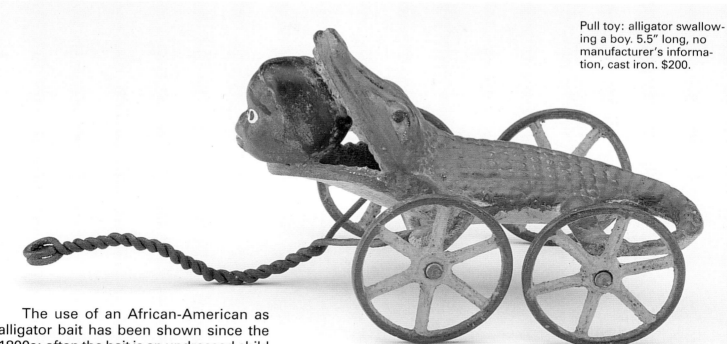

The use of an African-American as alligator bait has been shown since the 1800s; often the bait is an undressed child or baby. Unfortunately, alligators devouring people of color continued in products manufactured as recently as 2000. There are many examples of this "relationship" throughout this book.

Jacob Marx, the father of Louis Marx (the founder of Marx toys), named his wooden toy manufacturing business after himself. Many of the early Jaymar Specialty Company toys from the late 1920s and 1930s were poseable wooden figures with cloth covered rubber cords inside. In an era of hand painted details Jaymar figures had stamped on facial features. Production continued until 1990 with an emphasis on characters such as Betty Boop, Popeye, Daffy Duck, Amos, and Andy through the 1950s. Wooden puzzles and pianos became the main products after World War II.

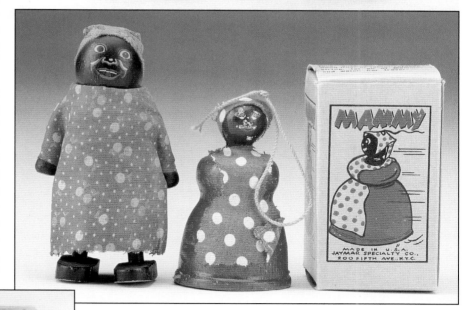

**Pull string out of Mammy's hat. Place Mammy on a smooth surface, such as plain hardwood floor or table, release string, let go of Mammy, and watch her travel.**

Two Mammies, one with original box. *Left:* 4.25" tall; no manufacturer's information. Walker designed to move on ramp, wood with fabric. $65. Box: 2" x 2" x almost 3.5", Mammy: 3" tall, JAYMAR SPECIALTY CO., 200 FIFTH AVE., N.Y.C.," wood with fabric and string. Toy, $85; box, $25.

Side panel explains how to use the Mammy toy.

From 1937 to 1977 Castle Films produced 16mm and 8mm movies for home entertainment. The subjects were varied: news, cartoons, horror films, westerns, travelogues, and more. "Amos 'N' Andy" represent two of the many famous names associated with this company.

"Amos 'N' Andy" debuted on radio station WMAQ in Chicago on March 19, 1928. Amos Jones and Andy (Andrew Hogg) Brown, the African-American

Movies: "Little Black Sambo" and "Amos "N" Andy." Cardboard boxes: just over 5" square. Little Black Sambo: 8 mm, Castle Films, Inc., part of the "Fairy Tale Collection," $85. Amos "N" Andy: Official Films, #237 Rasslin' Match. Box marked: "YAS SUH! FUN FO' ALL DE FAMBLY!" $45.

Tiger. 6" tall, DREAM PETS Product of Taiwan. Original paper tag states: "Sambo's Tiger Created Exclusively For Sambo's BY R. DAKIN & COMPANY SAN FRANCISCO PRODUCT OF TAIWAN ROC #06-3034." $12.

characters, were actually Freeman Gosden and Charles Correll, two white men who succeeded in delivering the longest-running radio program ever. It was never stated outright that these characters were African-Americans, but their stereotypical dialect left no doubt with the listeners. The show was broadcast for fifteen minutes a day, five days a week and had achieved national syndication through NBC within a year and continued for almost three decades.

In 1930 Freeman Gosden and Charles Correll released a movie appearing in black face entitled "Check and Double Check." Although the movie and the radio show might be considered slow

moving if not downright boring by today's standards, both were hugely successful. Amos and Andy returned in their second and final movie, "The Big Broadcast" in 1936.

"Amos 'N' Andy" was introduced to television in June of 1951 on CBS. Gosden and Correll produced the show, but Amos was portrayed by Alvin Childress and Andy was brought to life by Spencer Williams, Jr. CBS broadcast seventy-eight thirty minute episodes until June 1953 and syndication continued until 1966 despite the controversial nature of the show and the growing sensitivity of the viewing public.

The success of these characters brought an array of spin-off products including toys and cartoons all of which sustained the stereotypes presented on the radio, silver screen, and tube.

The history of Sambo's Restaurants is provided in the introduction. This tiger would have been a gift shop purchase from a Sambo's Restaurant.

The company that created the tiger, Dream Pets, was established in 1957. R. Dakin and Company received a package from Japan and the filler used to protect the actual merchandise was six small stuffed animals created from velveteen scraps. Dakin was delighted with these little sawdust-filled gems that the Japanese called Dream Pets. Although now known for stuffed animals, in the 1950s Dakin's signature product was guns. However, after acquiring the Japanese factory that created Dream Pets everything changed and by the late 1970s more than 2,000 different pets had been produced.

The Dream Pets line is considered to be a huge influence on the growth of the popularity of stuffed animals.

Playskool was begun in 1928 by two women, teachers, who understood the importance of playing for a purpose and not just simply playing. This was a new concept for its time, but one we now completely embrace. The earliest Playskool toys were a folding wooden desk that held blocks, crayons, and clay, a doll house, and a cobbler's bench.

The Depression caused financial difficulties for the company which, by 1940 had experienced five different owners. It was Manuel Fink and Robert Meythaler who finally resolved the fiscal issues and established Playskool as a major producer of quality educational toys. Milton Bradley Company purchased Playskool in the late 1960s and Hasbro acquired Milton Bradley in 1984.

Three plastic figures. *Left:* Caveman, 3.5" tall, embossed on legs: "c 1987 PLAYSKOOL INC., MADE IN CHINA H-15." $4. *Middle:* Military Man, 6.5" tall, no manufacturer's information. $8. *Right:* Caveman, 3.5" tall, embossed on legs: "c 1987 PLAYSKOOL INC., MADE IN CHINA." $4.

*"It was work hard, git beatins and half fed ... The times I hated most was pickin' cotton when the frost was on the bolls. My hands git sore and crack open and bleed."*–Mary Reynolds, Slave Narrative from the Federal Writers' Project, 1936-1938 (http://www.slaveryinamerica. org/history/hs_es_cotton.htm)

The history of African-Americans is woven into the fabric of our American heritage, and that fabric was made of cotton.

Cotton is a very labor intense crop and until the exploitation of slave labor it was not cultivated in large quantities. In 1790 only 1.5 million pounds of cotton were produced. Slaves had already become a part of America, beginning in 1619 (see the introduction of this book) but it was Eli Whitney's invention of the cotton gin in 1793 that allowed cotton to become a viable crop as it simplified the process of separating cotton seeds from fibers. However, cultivation was another issue and that was solved by slave labor. In 1795 cotton production had topped eight million pounds and the growth accelerated at a phenomenal rate. By 1860, just before the Civil War, cotton production was almost two billion pounds. The southern plantations supplied cotton for the fabric mills in the north, supported ships to transport the cotton, and purchased food from growers in the Midwest. Those of white skin reaped high profits as America's economy became entwined in these fibers. The increased production is directly associated with the growing slave population. In 1790 there were 1.2 million whites and over 600,000 slaves in the southern states; by 1860 there were 8 million whites and almost 4 million slaves who were beaten, whipped, and exploited beyond anything we can imagine.

As a souvenir of a southern vacation one was able to bring home cotton, the ultimate southern crop. A contented African-American – after all he is eating watermelon – might be included. It is not the image of the field worker bent over working in the heat for eighteen hours that we are to associate with cotton, but rather the happy pickaninny lost in the joy of a piece of watermelon.

Of course, this was years ago and American society has come a long way. To acknowledge Black History Month in 2007, several national retail chains offered cotton balls at a special sale price.

Watermelon-eating child on bale of cotton and bale of cotton. Bale: 2.5" x 3.5" x 1.75", bisque child: 2" tall, no manufacturer's information, even on the original box. Marked: "I Am From DIXIE MINIATURE COTTON BALE Souvenir New Orleans, La." Plain bale: 2.25" x 2.5" x 1.25", no manufacturer's information. These were marketed as "educational" toys. Bale with child, $30; plain bale, $5.

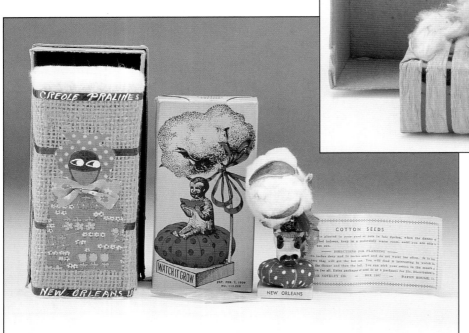

Cotton themed "educational" toys. **Left:** bale of cotton in original box. Box: 3.25" x 3.25" x 7", marked "CREOLE PRALINES NEW ORLEANS LA, PAT NO. 98472," cotton, burlap, and fabric. $30. Box of cotton. 1.25" tall bisque boy with watermelon on a pincushion, sitting on piece of wood with a cotton bloom towering above. Overall: 4.5" tall, mailer box: 3" x 2.5" x 5.5", Joseph Hollander Novelty Co., Box 2107, Baton Rouge, LA. Feb. 7-39. No. 113226. End panel of box states: "This Box Contains A Cotton Novelty Plant the Seeds And Watch the Cotton Grow." $65.

Tinkling Tots. 4" tall, no manufacturer's information. Remove rubber hats and fill plastic bodies with water. When the hat is returned to the head and squeezed the boys tinkle from the anatomically correct location where there is a small hole, plastic and rubber. $20 each.

The use of puppets is almost as old as humankind as they were a part of many tribal rituals having developed from the masks that the participants wore. Archeologists have determined that puppets were used in ancient Egypt, Greece, and Rome.

The use of marionettes probably originated in China as a method of sharing news. The marionette became a tool for sharing negative information that might have incited a ruler to the point of demanding the execution of the human delivering the news. This third party approach kept emotions more stable and most likely saved lives. By the 1400s marionettes had become a form of entertainment which continued for three more centuries. Performance troupes traveled throughout China to entertain while intertwining the dialogue with political news and gossip. As these puppets weren't human they were able to get away with behaviors not permitted by actors and dancers.

As the art of puppetry migrated from China changes in design and utilization occurred. The Turks were the first puppeteers to add waist movements to marionettes. European royalty enjoyed the entertainment of jesters, jugglers, and puppeteers. Before the Middle Ages puppet troupes of priests and monks traveled to share the message of Christianity. In fact, the word "marionette" translates to "Little Mary" from the use of these missionaries retelling the birth of Jesus. By around 1400 the church abandoned this method of sharing the gospel but puppetry had entertained so many that it had become a viable form of entertainment throughout Europe.

Hand puppets followed about two centuries later, and puppetry continues to be an amusing distraction for children everywhere.

It is not unusual to find black and white figures offered together as with these clowns. Effanbee produced several black and white marionette sets.

Clown marionettes. 13" long, no manufacturer's information, wooden heads and feet, cardboard, and fabric with strings. Black clown, $50; white clown, $25.

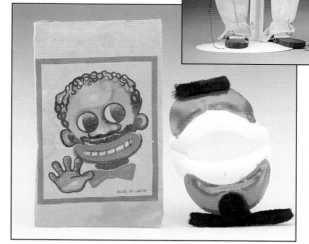

Lips, moustache, and beard. Paper bag, 2.5" x 4.25"; lips, 2" x 3"; bag marked: "OCCUPIED JAPAN," celluloid and chenille. $20.

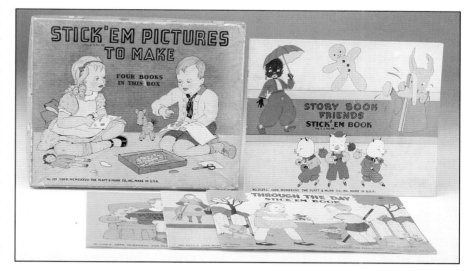

"STICK 'EM PICTURES TO MAKE." Box, 9.5" x 11.5", THE PLATT & MUNK CO., INC., MADE IN U.S.A., No. 129 copyrighted 1937. There are four books that have pieces to cut and paste to the blank pages also bound in the books. "Story Book Friends" includes Little Black Sambo. $65 box set. The Platt & Munk Company published children's books and manufactured puzzles from about 1920-1960.

Sawyer's VIEW-MASTER and Reels. View-Master: 4.25" x 3.75", marked "Portland-Ore." Shown with insert indicating store where this was originally purchased: W.F. Drehs/543 Court Street/Reading, Penna. FT-**8** LITTLE BLACK SAMBO, copyright 1948. Seven scenes from the story which is included as a 3.25" x 3.5" booklet. Viewer, $12; Sambo reel, $5; Story booklet, $5.

Mask. 7" x 5.25", no manufacturer's information, fabric. $20.

William B. Gruber had developed a camera that was capable of taking stereo images. Harold J. Graves was the president of Sawyer's Photographic Services. In 1938 they combined their expertise and launched Sawyer's View-Master in Portland, Oregon in 1939. Up until this time technology had progressed no further than the stereograph viewer which provided a single image at a time. This new viewer offered seven different images in a single reel.

Their product played an important role in assisting the Allied victory of World War II. View-Master reels were created that provided aircraft and artillery identification.

Until 1950 reels were sold individually, but eventually their library of titles had grown to such an extent that reels were grouped together.

The Tru-Vue Company offered serious competition with Sawyer's, so in 1951 they purchased Tru-Vue and acquired the Walt Disney licensure of his characters. In 1966 they were purchased by GAF and several other acquisitions and mergers followed, but their product is still being manufactured at this writing and they maintain the close relationship with Walt Disney Studios.

Known also as "jig dolls" or Les gigueux, Steppin' Sam is a relatively newer example of an old wooden dancing toy. With early roots beginning in the mid-1800s in the United Kingdom, street performers would entertain pedestrians in London. A jig doll was granted a patent in England in 1907 although the oldest one known was exhibited in London at the Great Exhibition in 1851.

Although the example shown here was a child's toy, the original jig dolls were used by adults for their own pleasure and for those who might be watching.

Alexander Parkes (1813-1890) created the first plastic, Parkesine, which was introduced at the 1862 Great International Exhibition in London. This organic material created from cellulose could be heated, molded, and shaped. Celluloid, invented by John Wesley Hyatt (1837-1920) in 1868 and used here, is created by combining cellulose and alcoholized camphor. This new material is most recognized for its utilization as photographic film.

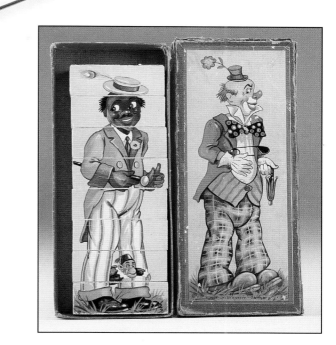

Steppin' Sam. Board: 3.5" x 20", Sam: 9.5" tall, wire: 15" long, no manufacturer's information. Sam is wood with metal pins that allow flexibility at his joints. A white version was made. $30.

Puzzle blocks. Box: 3.5" x 8.25", marked "Made in Western-Germany." Eight wooden blocks are decorated with paper on four sides, and correct alignment will result in the creation of four different figures. $65.

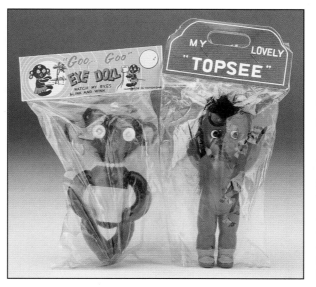

Celluloid figures. *Left:* Rattle. 6.25" tall, back embossed "JAPAN." *Right:* Drummer. 8.75" tall, back embossed "JAPAN." Written on drum: "HELLO WHITE BOY." $85 each.

Two packaged dolls. *Left:* "Goo Goo EYE DOLL." Doll: 5" tall, package: 7" long, marked: "Made in Hong Kong," plastic. $25 as packaged. *Right:* "MY LOVELY 'TOPSEE." Doll: 5" tall, package: 7" long, marked: "Made in Japan." Two more of these dolls are pictured in the Dolls section, rubber. $25 as packaged.

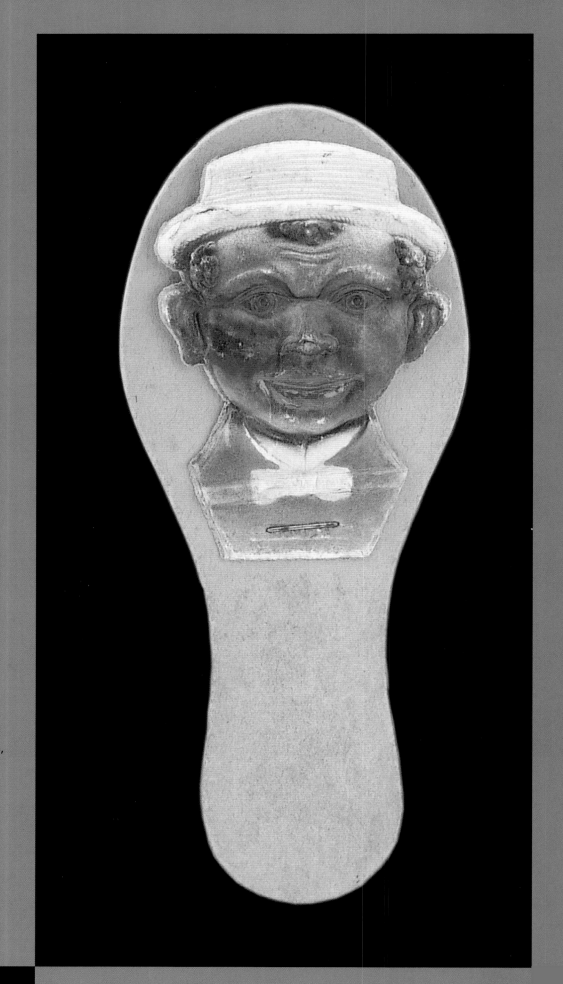

Noisemaker. 3" x 7", no manufacturer's information, wood with cardboard faces, two-sided. $45.

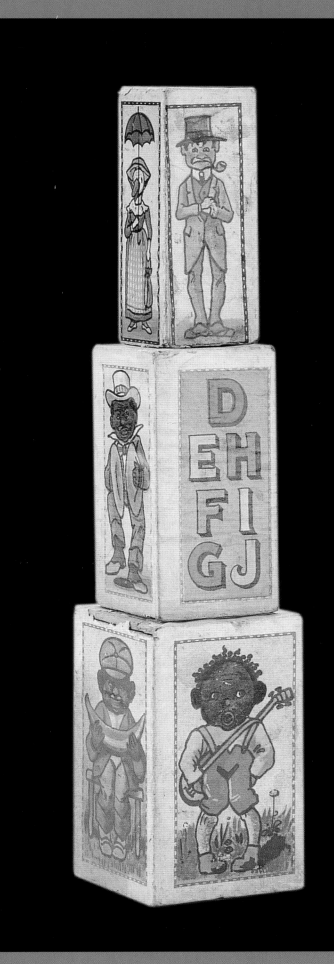

Stacking blocks. *Bottom/largest:* 2" x 2" x 3.25", no manufacturer's information. *Middle:* 1.5" x 1.5" x 3.25", no manufacturer's information. *Top/smallest:* 1.25" x 1.25" x 3", marked "GERMANY" inside. $50.

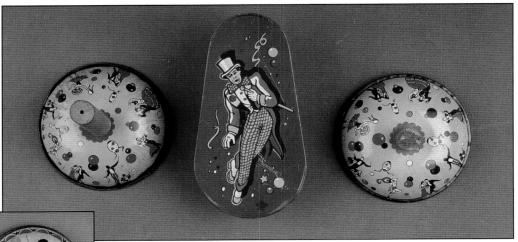

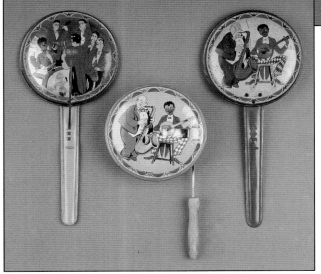

Noisemakers. *Left:* 8" tall, marked "MADE IN GERMANY," tin with wooden clapper. $30. *Middle:* 6.5" tall, marked "GERMANY," tin with wooden handle. $35. *Right:* 8" tall, marked "MADE IN GERMANY," tin with wooden clapper. $30.

Noisemakers. Circa 1940s-1950s for use on New Year's Eve.
*Left:* 3.5" diameter, 2.5" long wooden handle, marked "U.S. METAL TOY MFG. CO. N.Y." *Middle:* almost 5.5" long, marked "U.S. METAL TOY MFG. CO. N.Y." Found with wood and plastic handles in a variety of colors. *Right:* 3.5" diameter, 2.5" long plastic handle, marked "U.S. METAL TOY MFG. CO. N.Y." $10 each.

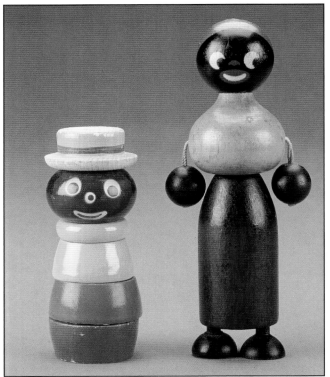

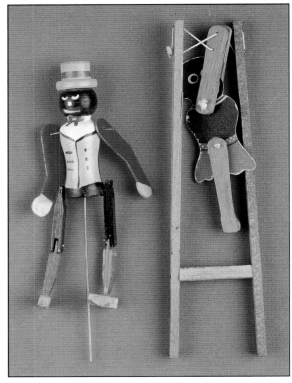

Wooden baby toys. *Left:* 5" tall, no manufacturer's information, bottom stamped: "1272." *Right:* 7.5" tall, no manufacturer's information. Note: early toys such as these would have utilized lead based paints. $35 each.

*Left:* Hinged Figure: 6.5" tall, no manufacturer's information, wood with plastic arms. $35. *Right:* Acrobatic Native: 7.25" tall, stamped "JAPAN," wood with string, figure is paper. $35.

# Train Figures

The technology of Scotsman James Watt (1736-1819) brought about real change to the steam engine and moved mankind from an agrarian society to an industrial one. When his patent expired, Richard Trevithick (1771-1833), like many scientists of the time, sought to make significant changes to the steam engine. Trevithick was able to construct the first locomotive which was used in a mine in South Wales.

Trains came to America in the late 1820s and were integral in Western expansion and the economic development of a growing nation particularly after successfully crossing the entire East-West expanse in 1876.

Naturally the fascination of the real machinery led to the creation of miniatures for child's play. Initial train toys were wooden pull toys, many being home crafted, but factory-made metal trains followed. The clockwork technology that had been applied to other metal wind-up toys was applied to trains, and wind-up toy trains were available by the end of the 1800s.

German-made battery operated and electric trains were introduced around 1900. As electricity became more available the concept of an electrically-powered toy gained acceptance. The first American-made battery operated train was produced by Joshua Lionel Cowen (1877-1965) in 1901. (Cowen's last name was actually "Cohen" but he changed his name in 1910.) By 1953 his Lionel Corporation had become the largest toy manufacturer in the world as he brought the world of trains to American homes in different sizes and configurations that celebrated the culture and scientific advancement of the times.

The figures in this section are miniatures of men one would have seen working at a train station or in a train. They offer a reflection of American society when African-American men were often relegated to service jobs such as baggage handlers and porters, although not all of these toys were specifically made for Lionel trains.

Baggage handler. 3.5" tall, no manufacturer's information, suitcase on right is removable and is often missing, metal. $50.

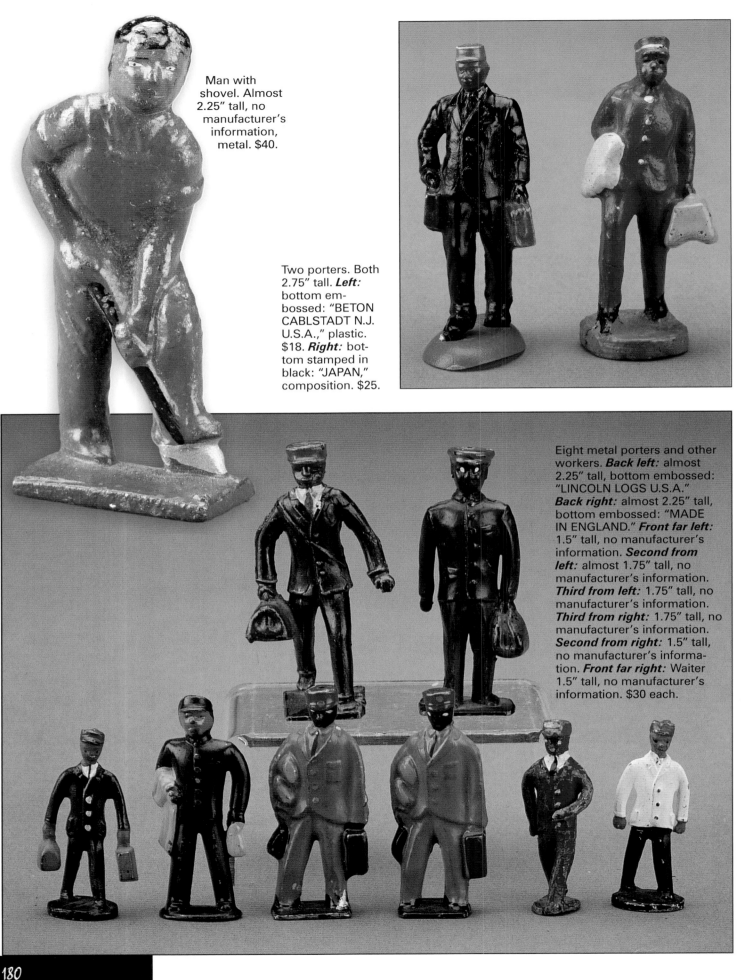

Man with shovel. Almost 2.25" tall, no manufacturer's information, metal. $40.

Two porters. Both 2.75" tall. *Left:* bottom embossed: "BETON CABLSTADT N.J. U.S.A.," plastic. $18. *Right:* bottom stamped in black: "JAPAN," composition. $25.

Eight metal porters and other workers. *Back left:* almost 2.25" tall, bottom embossed: "LINCOLN LOGS U.S.A." *Back right:* almost 2.25" tall, bottom embossed: "MADE IN ENGLAND." *Front far left:* 1.5" tall, no manufacturer's information. *Second from left:* almost 1.75" tall, no manufacturer's information. *Third from left:* 1.75" tall, no manufacturer's information. *Third from right:* 1.75" tall, no manufacturer's information. *Second from right:* 1.5" tall, no manufacturer's information. *Front far right:* Waiter 1.5" tall, no manufacturer's information. $30 each.

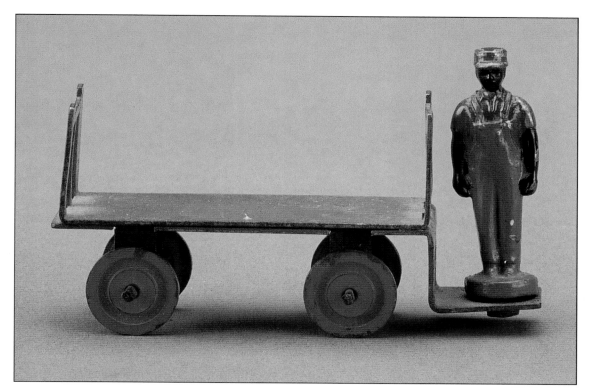

Baggage cart and man. 3" long, 0.75" deep, 1.75" tall, no manufacturer's information, metal. $40.

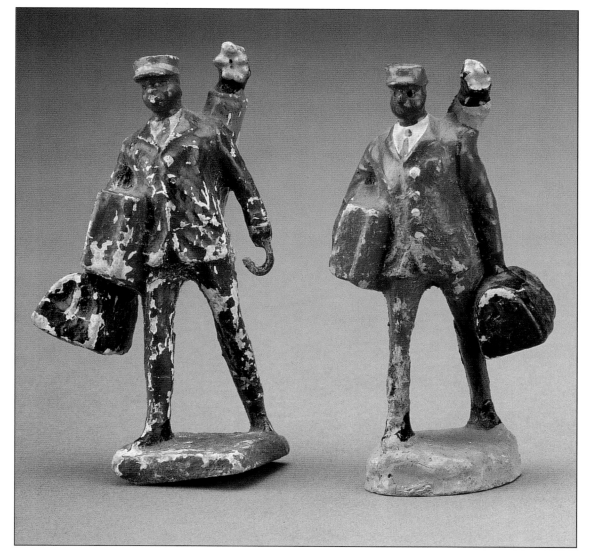

Two porters. **Left:** 3.25" tall, square base embossed: "Japan." Note the hook in his hand where a lost suitcase would hang, composition. $20, worn condition, $50 complete and in pristine condition. **Right:** 3.25" tall, oval base embossed: "JAPAN," composition. $30.

Product Packaging

Today we are savvy enough to recognize the intricacies of product packaging and visual images regarding consumer response. There are websites that offer assistance regarding colors and peoples' responses to color: http://www.joehallock.com/edu/COM498/preferences.html provides favorite and least favorite colors by age and gender, and http://iit.bloomu.edu/vthc/Design/psychology.html shows the correlation of colors and moods. Advertising agencies are hired to exploit this information with the ultimate goal of persuading consumers to spend their money on the product or service being advertised.

The use of African-American stereotypes in advertising is as old as slavery itself. Three hundred years ago images for advertising were created simply to catch the eye of a reader of an advertisement or the shopper in a store. In an American society that was dominated by white males representations were designed to stir the interest of this demographic, but as women became more influential in the distribution of household wealth, advertisements and packaging was also designed to tempt them into spending money.

The image of a mammy, chef, African-American child, or other black individual became commonplace in a vast variety of products. Ethnic exaggerations were designed to imbue product recognition while instilling a sense of quality assurance.

To emphasize the importance of packaging consider the following suppositions and statements from http://www.xocreate.com/blog/2007/07/psychology-of-breaking-category.html.

How would you feel if…

… your ketchup came in a can? Sure, you would be different on the shelf, but consumers expect the package (a bottle) to be a functional part of using the product.

… paperclips came in a pouch? We see plenty of products sold in pouches these days (sauces, snacks, cleaning tablets) but would you take that package over the cheaper folding carton box that we are all accustomed to seeing?

… your ice cream came in an aluminum container? For some reason that just hurts my teeth. You would definitely stand out in the freezer but it would not make sense to the consumer and therefore would remain sitting there looking shiny.

This chapter is more representational than comprehensive. It provides a glimpse of the packaging that relied on exploiting African-American stereotypes on products not pictured elsewhere in this book designed specifically for the Anglo-Saxon demographic. Marketing to the African-American population didn't begin in the United States until 1940 after an article written by an officer of the Los Angeles Urban League was published in "Business Week" indicating how mainstream media was overlooking the potential of the "Negro."

Luzianne Coffee container. Wm. B. Reily & Company, Inc. New Orleans, Louisiana, one pound can, 4.25" diameter, 5.25" tall. $35.

Pralines: maison blanche, New Orleans, LA 70112. 10.25" x 4" x 5.25", cardboard. $15.

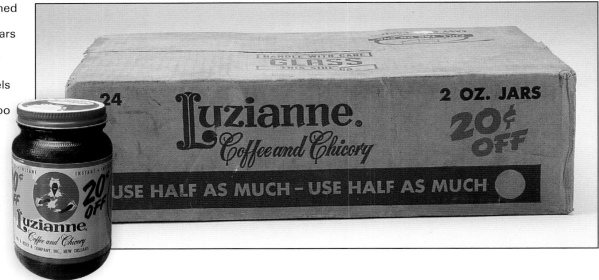

Luzianne Coffee, unopened case. 16" x 10.5" x 5", contains 24 two-ounce jars of Luzianne Coffee and Chicory by Wm. B. Reily & Company, Inc., New Orleans, with paper labels dated 1953. Jars, $35 each; unopened case, too rare to price.

This is the type of jar that is packed inside the unopened case.

Byrd Cookie Company tins. *Left:* BENNE BITS, 6" square container. *Middle:* BENNE CANDY, 6" diameter container. *Right:* BENNE WAFERS, 6" square container. $10 each.

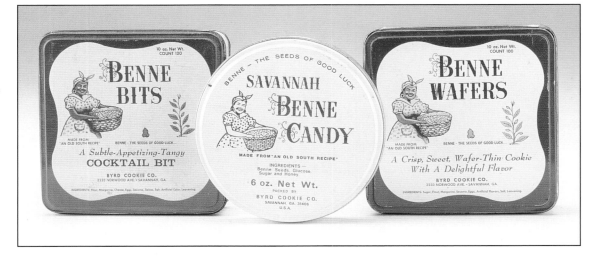

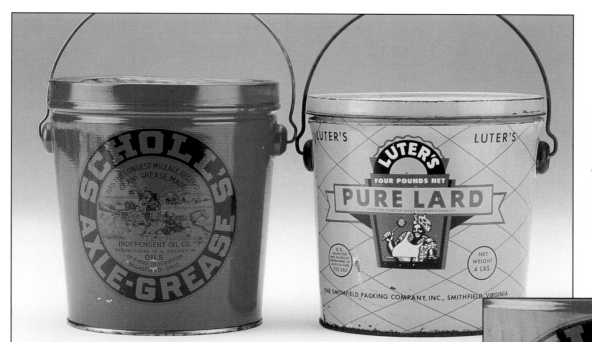

Two tin bale-handled metal containers. *Left:* SCHOLL'S AXLE-GREASE. 6.75" tall, made in Mansfield, Ohio. *Right:* LUTER'S PURE LARD. 6.25" tall, four pounds, The Smithfield Packing Company, Inc., Smithfield, Virginia. $50 each.

Close up of graphic on axle-grease container.

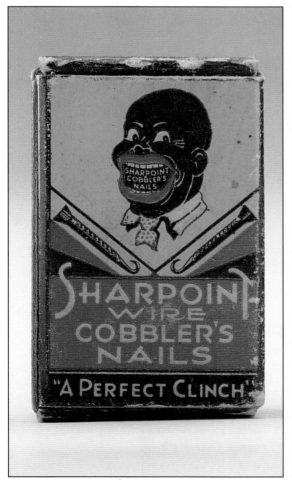

*Left:* SHARP-OINT WIRE COB-BLER'S NAILS. Just over 1" across, 1.75" tall, Chas. F. Baker & Co. Inc., Boston, Mass., card-board. *Right:* SOLIDHED THUMB TACKS. 1.25" across, no manufacturer's information, wood with paper label. $25 each.

Two Aunt Jemima products. *Left:* Corn Bread Mix, original price: $.35. Just over 1" x 6" x 8.5". $20. *Right:* Buckwheat, Corn, & Wheat Flour. 2" x 4" x 6.5". $50.

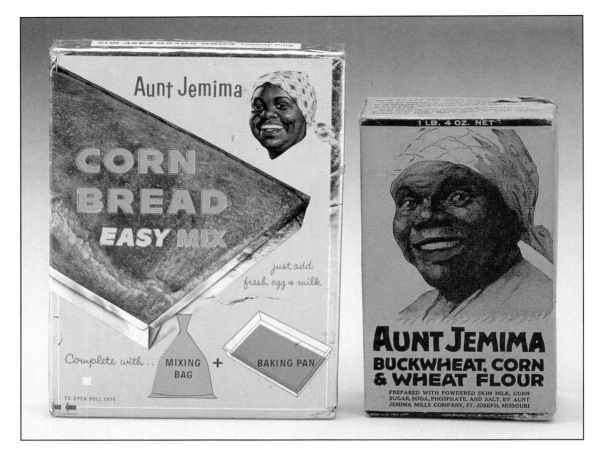

Luzianne Coffee containers. Wm. B. Reily & Company, Inc. New Orleans, Louisiana. *Back:* two pound can with paper label on one side and decorative motif on other (paper label pictured in front right position), 5" diameter, 6.5" tall. $35. *Front left:* three pound can with bale handle, 6" diameter, 7.5" tall. $70. *Front middle:* one pound can 4.25" diameter, 5.25" tall. $45. *Front right:* two pound can revealing the paper label; the other side has the decorative motif seen on the can in the back. 5" diameter, 6.5" tall. $35.

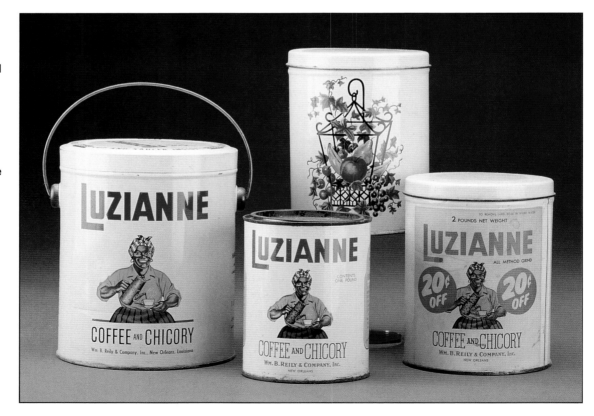

Three lithographed tins. *Left:* SOUTHERN BISCUIT CO., Inc. Richmond, Virginia. 10" diameter, just over 3" deep. $15. ***Middle/back***: "TINDECO." 4" diameter, 1.75" deep; embossed on back "Atlantic City Souvenir" Boardwalk Scene. $30. *Right:* Goose chasing boy. 6" diameter, 3.5" deep, no manufacturer's information. $20.

Two hair care tins. Both tins 3" diameter, 1.25" deep; APEX BEAUTY PRODUCTS, BELLEVILLE 9 N.J. U.S.A. *Left:* Hair Pomade. *Right:* Glossatina. $15 each.

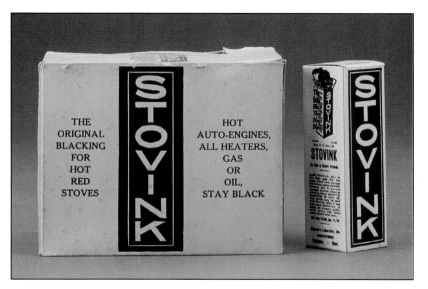

Case of STOVINK. One dozen 1.5" x 1.5" x 5.25" cartons of Stovink bottles; Johnson's Laboratories, Inc. Manufacturers Worcester, Mass. The top of each carton includes U.S. patent dates of May 19, 1908 and Jan. 11, 1910. "The Only Black That Stays Black STOVINK Is Not a Stove Polish Apply Stovink only to iron that gets hot, but apply when cool, starting fire at once, and as Stovink becomes hot it passes through various colors to a lasting black which it is impossible to burn off. Any polish may be used over Stovink after it has been once heated hot. It takes an elegant polish, saves labor and helps make stoves look neat." Each carton with unopened bottle, $40; case box, $40.

Woodward's Molasses Candy crate. 13.75" x 22" x 9" deep hinged wooden box with a paper label on one end and inside the lid. $80.

This is the paper label found inside the Woodward's Molasses Candy crate lid.

The Putnam Nail Company of Boston, Massachusetts trade card.

Those spiteful feet are newly shod,
With PUTNAM NAILS, forged from the rod.
(OVER.)

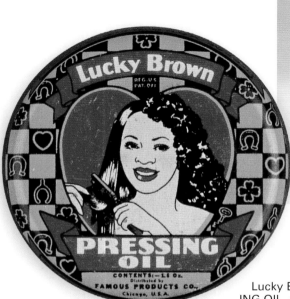

Lucky Brown PRESS-ING OIL. 2.5" diameter; FAMOUS PRODUCTS CO., CHICAGO, U.S.A. $25.

Gold Dust carton. 20" x 20" x 12" tall. Carton designed to hold twenty "large size" packages. Box manufacturer: Robert Gair Company; Peirmont, New York. A "21" on the box manufacturer information may indicate the production year as 1921. The box was shipped to Warren Wholesale Grocery Company in Warren, Pennsylvania. $150.

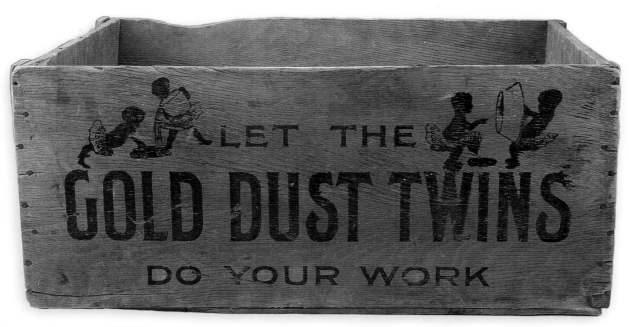

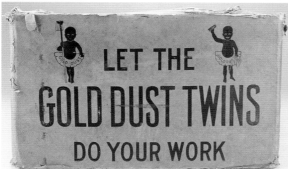

Gold Dust crate. 19.25" x 27.5" x 12" tall; no manufacturer's information regarding the source of the crate. There is no information indicating the package size that was packed within this container which may be pre-1900. $300.

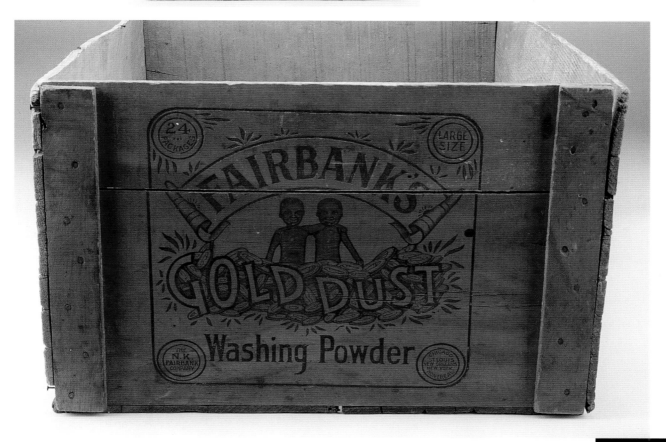

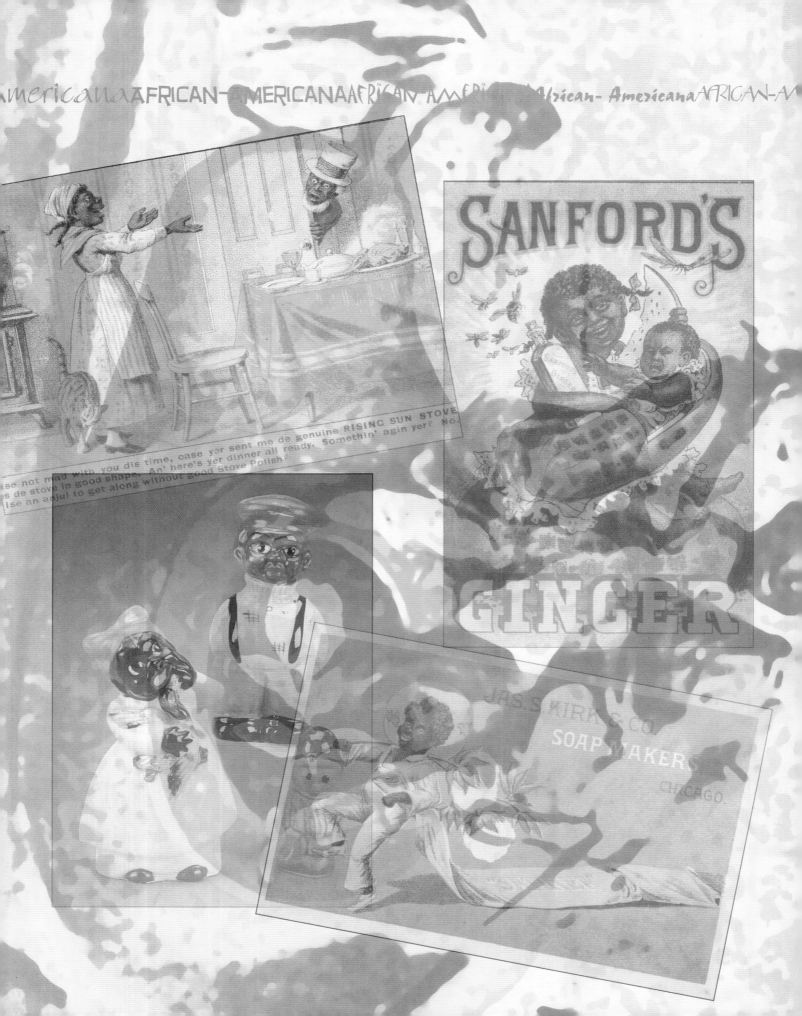

# Bibliography:

## Books and Booklets

Aunt Jemima's Magical Recipes, 1952.
Aunt Jemima New Temptilatin' Recipes, 1949.
Congdon-Martin, Douglas. *Images in Black: 150 Years of Black Collectibles*. Atglen, Pennsylvania: Schiffer Publishing Ltd., 1990.
Gibbs, P.J. *Black Collectibles Sold in America*. Paducah, Kentucky: Collector Books, 1990.
Janson, H. W. *History of Art*. Englewood Cliffs, New Jersey and New York: Prentice-Hall, Inc. and Harry N. Abrams, Inc., 1979.
Morton, Ruth. *The Home and Its Furnishings*. New York: McGraw Hill, 1953.
Perkins, Myla. *Black Dolls An Identification and Value Guide*. Paducah, Kentucky: Collector Books, 1993.
Spangler, Earl. *The Negro in America*. Minneapolis: Minnesota: Lerner Publications Company, 1966.
Weatherman, Hazel Marie. *The Decorated Tumbler*. Springfield, Missouri: Glassbooks, Inc., 1978.

## Websites

http://aarf.com
http://afe.easia.columbia.edu
http://antiquescollectibles.suite101.com
http://antiques.lovetoknow.com
http://blackinformant.com
http://blog.eogn.com
http://books.google.com
http://c5.zedo.com
http://childrensbooks.about.com
http://chnm.gmu.edu
http://chrisbrady.itgo.com
http://cnx.org
http://cotbn.blogspot.com
http://ctdollartists.com
http://encarta.msn.com
http://encyclopedia.farlex.com
http://ezinearticles.com
http://german.about.com
www.glutenfreeda.com
http://history.sandiego.edu

http://houseplants.suite101.com
http://iit.bloomu.edu
http://infodome.sdsu.edu
http://inventors.about.com
http://it.stlawu.edu
http://kathmanduk2.wordpress.com
http://kimmykay.tripod.com
http://lcweb2.loc.gov
http://library.thinkquest.org
http://marvmackey.com
http://memory.loc.gov
http://news.yahoo.com
http://onlinedictionary.datasegment.com
http://palimpsest.stanford.edu
http://reviews.ebay.com
http://sunniebunniezz.com
http://toys.about.com
http://tudorhistory.org
http://usinfo.state.gov
http://vanillagarlic.blogspot.com
http://virtualpet.com
http://web.mit.edu
http://www.3dstereo.com
http://www.africanaonline.com
http://www.alternet.org
http://www.amazon.com
http://www.americanheritage.com
http://www.ammax.org
http://www.answers.com
http://www.antique-antiques.com
http://www.antique-china-porcelain-collectibles.com
http://www.antiquified.com
http://www.arcytech.org
http://www.artistictileandstone.com
http://www.associatedcontent.com
http://www.atlantaantiquegallery.com
http://www.auctionbytes.com
http://www.auntjemima.com
http://www.authentichistory.com
http://www.bachlund.org
http://www.bbc.co.uk
http://www.bellamymansion.org
http://www.bklyn-genealogy-info.com
http://www.blackvoices.com
http://www.botham.co.uk
http://www.bushwhacker.org
http://www.businessweek.com
http://www.cabbagepatchkids.com
http://www.ccgs.com
http://www.cigaraficionado.com

191

http://www.civilization.ca
http://www.collectics.com
http://www.cookspalate.com
http://www.coonchickeninn.com
http://www.cnn.com
http://www.creamofwheat.com
http://www.cubby.net
http://www.dollinfo.com
http://www.dollreference.com
http://www.drloriv.com
http://www.dvdverdict.com
http://www.eatmt.org.uk
http://www.edenkazoo.com
http://www.engineeringsights.org
http://www.essortment.com
http://www.evalu8.org
http://www.ext.nodak.edu
http://www.fds.com
http://www.ferris.edu
http://www.finalcall.com
http://www.findagrave.com
http://www.foodtimeline.org
http://www.forestonline.org
http://www.franklincountycitizen.com
http://www.geocities.com
http://www.gormangiftgallery.com
http://www.hasbro.com
http://www.herald-dispatch.com
http://www.history.com
http://www.hollywoodcollectibles.com
http://www.horsmandolls.com
http://www.ideafinder.com
http://www.imdb.com
http://www.industryplayer.com
http://www.jimcrowhistory.org
http://www.joehallock.com
http://www.justforhim.com
http://www.kazoos.com
http://www.laundry-and-
    dishwasher-info.com
http://www.laundrylist.org
http://www.lib.unc.edu
http://www.library.ucsb.edu
http://www.madehow.com
http://www.mccormick.com
http://www.metafilter.com

http://www.metmuseum.org
http://www.midohiocollectibles.com
http://www.modenabalsamic.com
http://www.museum.tv
http://www.musicals101.com
http://www.myconfinedspace.com
http://www.nativeground.com
http://www.neponset.com
http://www.odjb.com
http://www.ohiohistorycentral.org
http://www.oldandinteresting.com
http://www.oldimprints.com
http://www.oldwoodtoys.com
http://www.perfumes.com
http://www.philadollmuseum.com
http://www.plantcultures.org
http://www.projectb.com
http://www.proz.com
http://www.redhotjazz.com
http://www.replacements.net
http://www.rhboydpublishing.com
http://www.roadtomandalay.com
http://www.scoot.co.uk
http://www.slaveryinamerica.org
http://www.spiceadvice.com
http://www.stashtea.com/teapots.htm
http://www.suite101.com
http://www.teapots.net
http://www.teddybears.com
http://www.thc-toys-hobbies-crafts.com
http://www.thefreedictionary.com/cruet
http://www.themarxtoymuseum.org
http://www.thomasedison.com
http://www.tiddlywinks.org
http://www.tnstate.edu
http://www.tradecards.org
http://www.trivia-library.com
http://www.tvparty.com
http://www.upscale.utoronto.ca
http://www.viewmaster.co.uk
http://www.walloworld.com
http://www.walteromalley.com
http://www.wonderbread.com
http://www.worldwar1.com
http://www.xocreate.com
http://www.zingermansroadhouse.com